About the Author

Photo by Jude Dillon

Lisa Christensen is an intrepid hiker, freelance art historian, writer, and one-time Associate Curator of Art at the Glenbow Museum in Calgary. While working at the Glenbow, Lisa often found herself thinking of the Rocky Mountains so beautifully depicted in many of the museum's paintings. And when she hiked in those same mountains, the reverse was true. This inspired her "trail guide to art" approach for mountain visitors and art lovers, beautifully presented in two volumes, the award-winning *A Hiker's Guide to Art of the Canadian Rockies* (1996 Banff National Park Award, 1997 Henry Kriesel Award for Best First Book, 1997 Book Publishers Association of Alberta Trade Title of the Year, 1997 Inaugural W. O. Mitchell Book Prize) and *A Hiker's Guide to the Rocky Mountain Art of Lawren Harris* (Mountain Exposition Award, 2000 Banff Mountain Book Festival; shortlisted for the 1st Annual Grant MacEwan Author's Award).

Advocating a "boots on" approach to communication about the art that depicts the scenery of the Canadian Rockies, Lisa feels that a firsthand, personal understanding of place is an important factor in developing a full appreciation of Canadian landscape art. For more than a decade, Lisa has followed the routes taken by Canadian artists through the Rockies to research her popular books.

Lisa lives in Calgary and is presently the Curator of Art at the Whyte Museum of the Canadian Rockies in Banff, Alberta.

For permission to reproduce works of art, reprint text, and publish photographs, by all artists, authors, and poets in this volume, grateful acknowledgement is made to holders of copyright, publishers, and representatives thereof. Every reasonable attempt has been made to identify and clear such copyright. If notified, the publisher will be pleased to rectify any omissions at the earliest opportunity.

Front cover image *Morning, Lake O'Hara*, 1926, J. E. H. MacDonald, Collection of The Sobey Art Foundation (vantage point 1 on map)
Cover and Interior Design by Articulate Eye Design, based on a design by Cathie Ross, Glenbow Museum
All scans by St. Solo Computer Graphics
Edited by Geri Rowlatt
Proofread by Ann Sullivan

The publisher gratefully acknowledges the support of The Canada Council for the Arts and the Department of Canadian Heritage.

THE CANADA COUNCIL | LE CONSEIL DES ARTS
FOR THE ARTS | DU CANADA
SINCE 1957 | DEPUIS 1957

We acknowledge the financial support of the Government of Canada through the Book Publishing Industry Development Program (BPIDP) for our publishing activities.

The author gratefully acknowledges the support of Masters Gallery Ltd., Calgary.

Printed in Canada by Friesens

03 04 05 06 07 / 5 4 3 2 1

National Library of Canada Cataloguing in Publication Data

MacDonald, J. E. H. (James Edward Hervey), 1873–1932.

The Lake O'Hara art of J.E.H. MacDonald and hiker's guide / Lisa Christensen.
 Includes bibliographical references and index.
 ISBN 1-894856-17-1
 1. MacDonald, J. E. H. (James Edward Hervey), 1873–1932—Journeys—British Columbia—O'Hara Lake. 2. MacDonald, J. E. H. (James Edward Hervey), 1873–1932—Diaries. 3. O'Hara Lake (B.C.)—In art. 4. Landscape painters—Canada—Diaries. I. Christensen, Lisa. II. Title.
ND249.M25A2 2003 759.11 C2002-911545-0

Published in Canada by
Fifth House Ltd.
A Fitzhenry & Whiteside Company
1511, 1800 - 4 St. SW
Calgary, Alberta, Canada
T2S 2S5

First published in the United States in 2003 by
Fitzhenry & Whiteside
121 Harvard Avenue, Suite 2
Allston, MA 02134

THE LAKE O'HARA ART
OF J. E. H. MACDONALD
AND HIKER'S GUIDE

LISA CHRISTENSEN

FIFTH
HOUSE

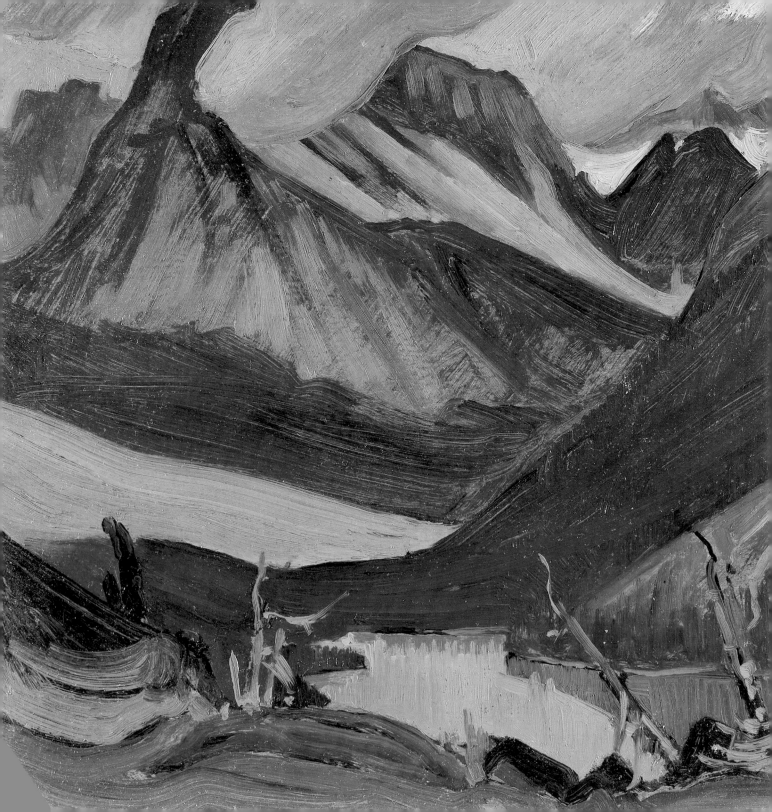

For my children, Peter, Anna, and Matthew,

who constantly remind me that the tiny rocks on the lakeshore

are as engaging as the peaks.

Lake O'Hara, Cloudy Weather, c.1926
oil on panel
Art Gallery of Greater Victoria
(vantage point 2 on map)

TABLE OF CONTENTS

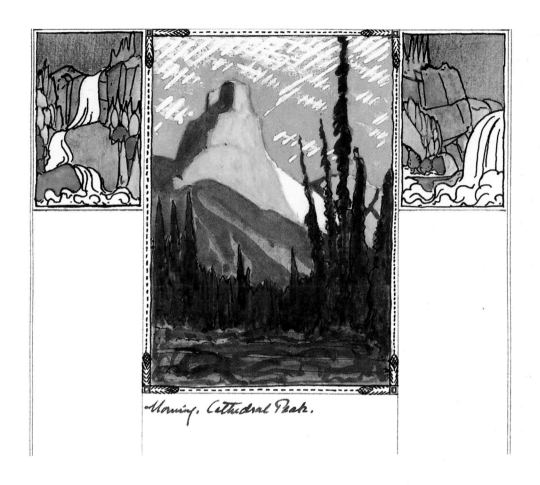

Morning. Cathedral Peak.

Morning, Cathedral Mountain, 1924–26
watercolour and coloured inks on wove paper
National Gallery of Canada
(vantage point 3 on map)

This book acknowledges the following authors' previous research and publishing concerning J. E. H. MacDonald: Hunter Bishop, Paul Duval, Charles C. Hill, Catharine M. Mastin, Joan Murray, Nancy Robertson, Bob Stacey, Leslie G. R. Wheatcroft, Bruce Whiteman. Other authors who address MacDonald's mountain works in a broader context are also acknowledged and listed in the bibliography. Outdoors writers who have guided hikers to Yoho National Park include Don Beers, Brian Patton and Bart Robinson, Graeme Pole, R. W. Sandford, and Jon Whyte. Thanks for the directions.

Research assistance was provided by Merilee Atos, who searched libraries and archives across the United States and Canada, Sherry Anne Chapman, who transcribed MacDonald's longhand journals, and Nancy Cope, who checked facts endlessly in the final stages.

Invaluable assistance was provided by my family and friends, who hiked with me, looked after my kids, and wandered around—endlessly it sometimes seemed—in the woods looking for things. Nancy and Liz, David and Peter, Randle, you were all of great help.

Assistance with the location of artworks was key and provided by many individuals, particularly art dealers and auctioneers: Doug MacLean of Canadian Art Gallery, Canmore; Romana Kaspar and Daniel Lindley of the Collector's Gallery, Calgary; Geoffrey P. Joyner of Joyner Fine Art Inc., Toronto; Alan Klinkhoff of the Galerie Walter Klinkhoff, Montreal; Doug Levis of Levis Fine Art Auctions and Appraisals, Calgary; and Rod Green of Masters Gallery Ltd., Calgary.

Registrars, archivists, conservators, and curators at a number of institutions across the continent answered many questions and provided details on the works from their collections. Lindsay Moir, Senior Librarian, Glenbow, was especially helpful, as were Don Bourdon and Lena Goon, Archives of the Whyte Museum of the Canadian Rockies in Banff; Ann Tighe, Art Gallery of Greater Victoria; Christine Braun, Art Gallery of Hamilton; Liana Radvak and Felicia Cukier, Art Gallery of Ontario; Randall Speller, E. P. Taylor Reference Library, Art Gallery of Ontario; Catherine Crowston and Bruce Dunbar, The Edmonton Art Gallery; Ron Marsh, Glenbow; Judi Schwartz, Hart House, University of Toronto; David Carpenter, Harvard University Art Museums; Linda Morita, the McMichael Canadian Art Collection; Marie-Claude Saia, Montreal Museum of Fine Arts; Lynda Corcoran, Musée d'art de Joliette; Raven Amiro, National Gallery of Canada; Lisa Tillotson, The Nickle Arts Museum; The Sobey Foundation; Susan Cochrane, Library Coordinator, Southern Alberta Art Gallery; Christy Telford, Tom Thomson Memorial Art Gallery; Janette Cousins Ewan, University College Art Collection, University of Toronto; Danielle Currie and Holli Facey, Vancouver Art Gallery; and Demetria Manier Heath in Austin, Texas. Correspondence and conversation with curators and art dealers were particularly helpful: to Rod Green, Charles Hill, Brent Luebke, Doug MacLean, Catharine Mastin, Christopher Varley, Leslie Wheatcroft, thanks for your time.

Many private collectors generously allowed their works to be included in this book. To Darryck & Inez Hesketh, Ivan Ivankovitch, Alan and Eric Klinkhoff, and a number of collectors who wish to remain anonymous, thank you.

Thanks to the staff at the trail office in Yoho National Park and the Friends of Yoho National Park, who checked facts, introduced me to key people, and helped shape the book. Bruce and Alison Millar, Carmen Haase, and Charly Gasser at Lake O'Hara Lodge were instrumental and, at times, inspirational when the book seem doomed to remain on my desk alone; thanks especially to Bruce Millar for reading the manuscript. Praise to all the staff at Lake O'Hara Lodge, who made three days one March a perfect heaven. To Randle Robertson and Charlie Hill, thank you both for your enthusiasm and support. To Geri Rowlatt, a pleasure to edit with, thanks for your careful attention to detail. To Charlene Dobmeier and Liesbeth Leatherbarrow, publisher and editor, respectively, at Fifth House Ltd., thank you for making this book finally happen!

The colour illustrations in this book were made possible by the generous funding provided by Masters Gallery, Calgary, and by numerous individual Friends of Masters Gallery across Canada. Sincere thanks to these people for their contribution to this project.

And finally, thanks to J. E. H. MacDonald, for receiving that which only Lake O'Hara can give and leaving Canadians with a legacy of images depicting this remarkable place.

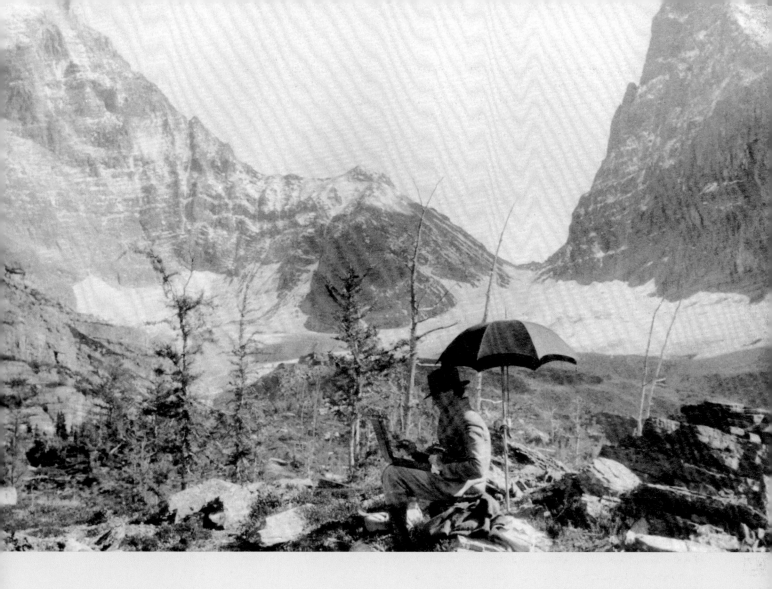

J. E. H. MacDonald painting at Opabin Lake, undated
George K. K. (Tommy) Link Photograph
Archives of the Whyte Museum of the Canadian Rockies

THE KEY TO ALL HIS PAINTING IS TO BE FOUND IN HIS TEMPERAMENT. MACDONALD WAS A POET TO HIS FINGER-TIPS: THE SAME KIND OF POET HE WAS A PAINTER—NOT A CLEVER RHYMSTER, OR THE SUAVE SONNET-WRITER, BUT A POET IN HIS APPROACH TO THE WORLD AND TO LIFE ABOUT HIM.

—E. R. Hunter in *J. E. H. MacDonald*, 1954

In the autumn of 1924, the Canadian landscape painter James Edward Hervey (J. E. H.) MacDonald travelled from his home in Toronto by train to the tiny region of Lake O'Hara, in Yoho National Park, British Columbia. MacDonald was on a painting holiday. He wanted new scenery, some solitude, and a change of pace. He was also looking for a broader view of the country that he and his fellow Group members had lauded on canvas in their nationalist plea for homegrown Canadian art.

In the two decades preceding MacDonald's trip to Lake O'Hara, the painters who would become the Group of Seven had met and begun to coalesce as a unified artistic voice. Through association in the newly formed (1908) Arts and Letters Club, they met within the stimulating company of other creative individuals to discuss, think, talk, paint, write, argue, and explore ideas pertaining to the arts in Canada.

Born in 1873 near Durham, England, MacDonald immigrated with his family to Canada in 1887. He married Joan Lavis in 1899, and one son, Thoreau, who would become an accomplished artist in his own right, was born in 1901. Thoreau's reflections on his father's life and work are an important voice in the story of MacDonald senior's fascination with Lake O'Hara.

MacDonald suffered from recurrent and undefined illnesses in his life, perhaps repeated strokes, perhaps a nervous breakdown. Terms such as "frail" and "of weak constitution"

appear often in accounts of his life. He had a complete collapse in 1917, the details of which were recounted by Thoreau, sixteen years old at the time, in a 1937 essay: *In November 1917 we had to rent our home at Thornhill and moved to a small and rotten rickety house at York Mills, directly opposite Pratt's grist mill. The night after moving while all was still in disorder my father had a complete collapse and was unable to get up for many months ... During the summer of 1918 M. (MacDonald) slowly recovered and by fall he was able to accompany Lawren Harris, Dr. MacCallum and Frank Johnston on their first trip to Algoma.*[1]

Considering all the circumstances of the year 1917, and taking into account both MacDonald's personal and public life, his role as a father, friend, and family provider, and his highly visible position of artist and teacher, numerous reasons for such a collapse are evident, with extreme exhaustion compounding the repeated illnesses. The terrible events of the First World War

Mountain Solitude (Lake Oesa), 1932
oil on canvas
Art Gallery of Ontario
(vantage point 4 on map)

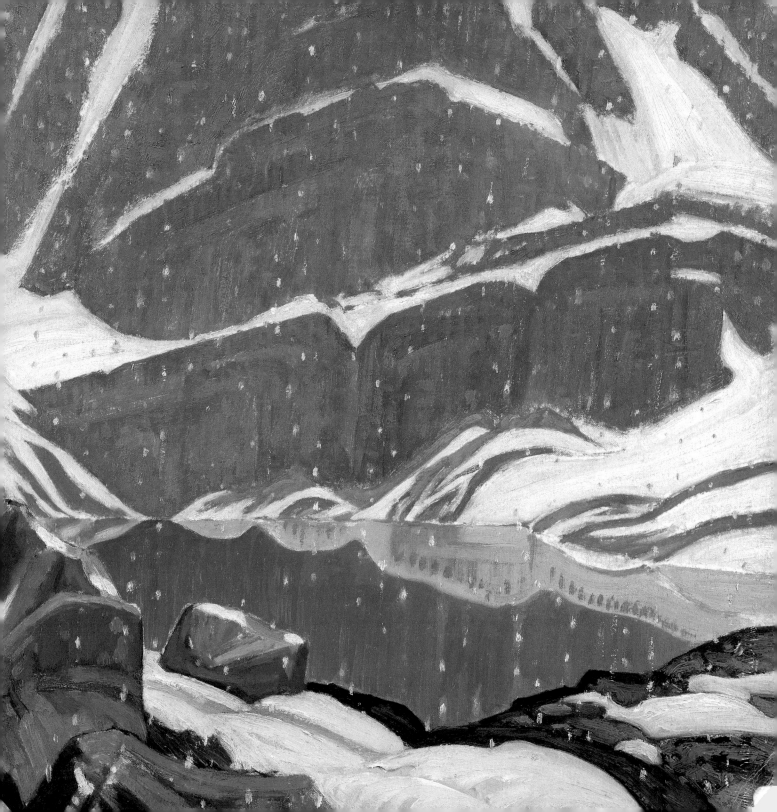

shocked and depressed many people. MacDonald felt the trauma of loss and death in the families of his closest friends and colleagues. His finances had fluctuated with the tenuous wartime economy. In 1911, he had left a successful career as a commercial designer for an uncertain one as a controversial painter and had struggled financially ever since. He had a family to support, a responsibility he took very seriously. His continued poor health compounded as the Group of Seven formed and began to exhibit. The media attention that the Group garnered was considerable. Although there was a great deal of support for the Group and its efforts in painting and exhibiting, there was also negative reaction. For MacDonald, in particular, the negative press was significant.

Few of the painters in the Group of Seven were able to make a living through their painting. Lawren Harris alone was wealthy and did not rely on income from his art to support himself. MacDonald was forced to return to salaried work as a summer instructor at the Ontario College of Art in 1917 and would become (acting) principal there in 1928. Time for painting was infrequent, and the Lake O'Hara trips were the most precious of his time off. This was when he could paint purely for his own ends, not as a teacher trying to convey something to a student, not as a designer working on a project, not as an artist producing work for an exhibition, but as a creative individual in pursuit of the realization of his own ideas.

MacDonald was a reserved, kind, and gentle man whose reticent nature and uncertain health were often confused. A. H. Robson, his employer at the Grip, would hint at the two sides of MacDonald as he observed them during MacDonald's time in his employ: *This tall, thin designer, with his halo of red hair, his love of Henry Thoreau, Walt Whitman, and lyric verse, did not take part in the tramping tours and sketching excursions of the other members of the staff. Perhaps his physique was too frail, but more likely it was his retiring temperament. He was self contained, and preferred working out his own problems by himself.*[2]

MacDonald's mental and physical health while at Lake O'Hara, however, is in complete contrast to his health at other times. He is happy, fit, and strong while in the mountains. From the locations of his sketches, it is clear that he was a robust hiker and that he climbed to high vantage points to sketch in all kinds of weather and over a wide variety of ter-

rain. He acknowledges being tired, and that the terrain was difficult, yet his days were extremely full, and his hiking times indicate his abilities:

Journal Entry: Wednesday, 2 September 1925
... Quite strenuous getting up to Oesa for the tenderfoot climber. Made sketch of Lefroy from top of Moraine, and after lunch went on up toward Oesa. After sketch went on right to Oesa and tried to get to foot of Abbot Pass at head of lake, but walking on scree was too tiring. Saw composition for Oesa and hope to go again. ... The rock-walk trip very tiring. Time about 1 hr.

Lake Oesa is a tough day's hike for the average person, over today's clearly visible and forgiving trail. Scrambling over the scree to the foot of Abbot Pass is rough and uneven, a sliding foray into frustration. There was no maintained trail in MacDonald's day. Note, as well, the date of MacDonald's journal entry—2 September—within the dates of the overall trip. The first time out each season is always the toughest. As well, MacDonald had come from Toronto's elevation of less than 200 metres above sea level[3] to the

lakeshore elevation of 2,018 metres at Lake O'Hara. And finally, note that he was fifty-two years old at the time.

Although convalescence was never stated nor observed by MacDonald himself as a reason for his repeated visits to Lake O'Hara, his euphoric enthusiasm for the mountains obviously comes from his feeling of complete well-being while there. In his journals, he regularly mentions the condition of his "inner man," the assessments of his own state of mind and personal well-being. His inner man's wellness fluctuates uncertainly at the outset of the trips and then improves rapidly as he approaches the mountains. Finally, upon settling in at Lake O'Hara, his inner man's turmoil is no longer mentioned, replaced instead by exclamations of joy and elation, and comments that his days **"Made one feel like Henry David Thoreau and [want to] stay up all night roaming the mountains."**[4] MacDonald remembered this feeling acutely over the first year after the initial trip, and anticipated a renewed sense of vigour and vitality upon reaching Lake O'Hara again the second year. He writes in his 1925 journal: **"Travel not so comfortable as last year.**

The inner man out of control, but all's well."[5] Simply knowing he was headed to Lake O'Hara was good for him. He remarks the next day: **"The inner man better, blessings on him and may be continuing in the same ..."**[6] Arriving at O'Hara was even better. The references to the inner man disappear entirely, and comments indicating that he felt **"... at height of being and enjoyed everything completely"**[7] replace them.

MacDonald was affected positively by the mountain environment; perhaps he felt the "climber's high." This is a term for the well-documented range of positive feelings—ranging from a generalized feeling of wellness to a rather extreme giddy happiness—that people often get at altitude.[8] Unlike the physically weakening effects of altitude on the body, altitude elation is psychological and quite another matter. Like altitude sickness, which happens at much higher elevations, altitude elation has little to do with your health or fitness; you are either susceptible to it or you are not. For MacDonald, the effects were extremely positive. The combination of a complete change of scene, sunlight, cold air, less oxygen, and the joy of being in the mountains with other people who shared that same joy were all healthful changes in his life. Additionally, the conditions of cold, sunlight, newness, and being at high altitude are all conditions thought to alleviate the symptoms of depression.[9] MacDonald's fond affection for O'Hara was due as much to his improved mental health while there, as it was to how he felt about what he saw and painted there.

MacDonald was not known to be a religious individual: *I never remember him going to church, though he liked to hear the bells and he felt he owed the churches something on that account. He thought any service sounded best from outside ...*[10] His admiration of the poets Robert Burns, Walt Whitman, and Henry David Thoreau (H. D. T. in MacDonald's writings) forms the basis of many of his philosophical principles. Burns, with his sense of humour and his painful, if intermittent, striving for self-betterment, was his favourite poet.[11] Whitman's free verse and rhythmic innovations set a benchmark for style in MacDonald's own poetic endeavours. Whitman's desire for self-determination also struck a resonant chord.

Thoreau's love of the quiet beauties of nature and desire to preserve them were in accord with MacDonald's own sympathies. All of these shaped his outlook. Henry David Thoreau, often cited as his favourite poet, is important to this discussion as he was MacDonald's travel reading.[12] A copy of a book of Thoreau's verse went with MacDonald on every Lake O'Hara trip. Grounded in the ideals of these writers, for MacDonald, spending time in close harmony with nature was a critical need. At a time of ill emotional health, this need was heightened, and the natural world was the likely source of restitution to which he would turn.

MacDonald's first trip to Lake O'Hara had a profound effect on him. This is evidenced in his writings, the most critical of which, for the purpose of a mountain discussion, was the memoir of that first trip, "A Glimpse of the West." Penned in longhand as a lecture to be delivered to his students at the Ontario College of Art, it was written in late September or early October of 1924 and published in *The Canadian Bookman* in November of that year. He speaks poetically throughout it, referring to "colour spots" and "colour bands" in his "memory picture," and enthusiastically chides that *every Canadian east of Sault Ste. Marie ... [should be sent] to the west as a post-graduate course in patriotism.*[13] A substantial portion of this lecture is used as quotes accompanying the illustrations in this book.[14]

MacDonald's travel journals are equally critical to this discussion. They are private records of the journey, heavily interspersed with poems.

But more important than the letters, more vivid than the journals, and more evocative than any recalled description are MacDonald's oil sketches from Lake O'Hara. These works are charmingly painted mountainscapes that attest to the beauty MacDonald found at Lake O'Hara. They are records of MacDonald's efforts as a student of the mountainscape, attempts to capture the varied weather, light, and atmospheric qualities of O'Hara. The reader should bear in mind that these were MacDonald's working sketches, that most were in his possession at the time of his death, and that they were his visual notes for larger paintings: The artist nearly always refused to part with his sketches, since he used them in painting his larger pictures.[15]

CLIMB THE MOUNTAINS AND GET THEIR GOOD
TIDINGS. NATURE'S PEACE WILL FLOW INTO YOU AS
SUNSHINE FLOWS INTO TREES. THE WINDS WILL
BLOW THEIR OWN FRESHNESS INTO YOU, AND THE
STORMS THEIR ENERGY, WHILE CARES WILL DROP
OFF LIKE AUTUMN LEAVES.

—John Muir in *Footloose in Ranges of Light*, 1871

J. E. H. MacDonald painted over one hundred on-the-spot sketches during the seven years he visited Lake O'Hara. These were his field works, not intended for exhibit, but as reference for future large works. These sketches form the core of this guide and are its inspiration.

MacDonald's larger-format canvases painted in his Toronto studio after returning from O'Hara contrast strongly with the on-the-spot sketches. They combine memories of favourite sketching places and specific atmospheric conditions, all filtered through the pleasurable recollections of his visit. The canvases are the end result of an artist using his sketches as reference to create a work that expresses what he felt to be the best elements of the entire experience.

Lake O'Hara is a tightly configured paradise, and a region of only 160 square kilometres is discussed in this book.[16] A map appears on page 11; its number key system suggests the best spot on a currently established trail from which to view the scenes painted by the artists. Once you are oriented to the region, it becomes apparent that many of the scenes can also be viewed from other vantage points. Familiarity with the place names of the region will allow you to take in as many of the scenes through MacDonald's eyes as possible. Suggestions for alternate viewpoints are made periodically throughout the text, and in many cases, the possibilities are quite obvious.

Cathedral Mountain, for instance, which can be seen from many locations at Lake O'Hara, recurs often in the paintings. Use the titles of the works to help you see them from proxy locations. A few works from outside the Lake O'Hara region are accompanied by full-trail information.

Roughly seventy-five years have passed since the works discussed in this book were painted. Although the mountains have changed little over that time, the forest has changed a great deal. The supression of forest fires in the national parks has restored the region, especially along the access road and Cataract Creek Valley, to a rolling carpet of green. The burnt timber visible in many of MacDonald's sketches is overgrown, as are many of the open areas that he painted from or included in his compositions. The now overly mature forest presents some difficulties, as in numerous cases, trees now hide the exact views that MacDonald painted. As well, the trails at Lake O'Hara have changed a great deal since MacDonald visited in the 1920s. The Lake O'Hara Trails Club and Parks Canada have worked exceedingly hard over the last fifty years to limit meandering trails

over delicate meadows and toward viewpoints. Respect their work and strive to preserve it. As well, Lake O'Hara is blessed with the trail-building handiwork of Tommy Link and Lawrence Grassi, the latter being the architect of the magnificent stone steps that lead, with perfectly placed and sturdy footing, to Lake Oesa and Lake McArthur.

Lake O'Hara is the subject of several books, both trail guides and histories, all of which are listed in the bibliography. Despite the comfortable facilities at O'Hara, remember you are still in the backcountry. Weather, as evidenced by the many stormy skied scenes MacDonald painted, is unpredictable and unforgiving. Always take a fully stocked pack—even on a short summer hike. Good boots and raingear, sunscreen, and adequate food and liquids are essential.

Visiting Lake O'Hara is truly a privilege, one that entrusts you to take due care of this mountain Eden. The trail quotas are in effect to enhance your experiences, not to keep you from going. Follow the mantra of the backcountry traveller: Take only pictures, leave only footprints.

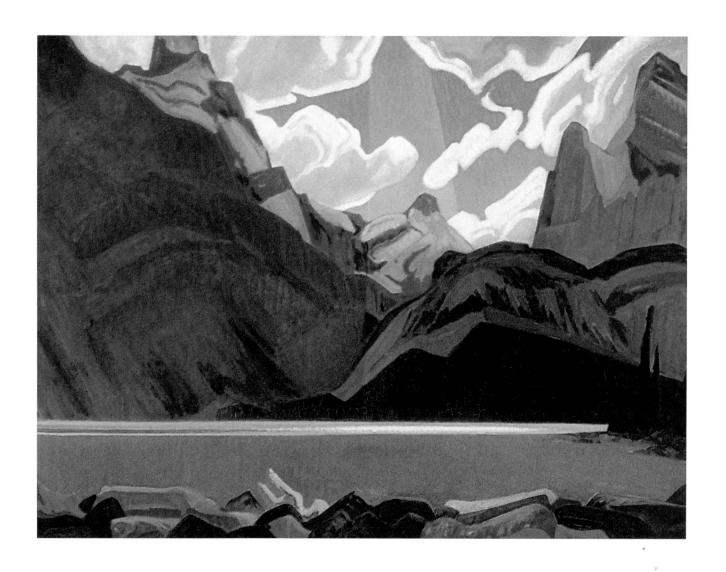

Clouds over Lake O'Hara, 1930
oil on canvas
Musée d'art de Joliette, Québec
(vantage point 5 on map)

BUT I WAS BOUND FOR LAKE O'HARA, WHICH HAS EVEN A GREENER SOUND, AND THOUGH I GOT A GLIMPSE OF LITTLE BROWN CABINS AT WAPTA WITH ORANGE CURTAINS AND GOLDEN YELLOW BEDSPREADS WAITING THE VISITOR, I HAD TO GO.

—from J. E. H. MacDonald, "A Glimpse of the West," 1924

In 1886, British Columbia's Yoho region became a national park, when a 10-square-mile area at the base of Mount Stephen was set aside by the Canadian government. Centrally located in the Alberta/B.C. Rocky Mountain corridor, it celebrates the peaks of the eastern side of the Continental Ranges just west of the Alberta boundary. A 1901 expansion added the land included in today's maps. The evocative name of Yoho—a Cree expression of wonder and amazement—and many of the other original place names were applied officially by Samuel E. S. Allen, a mountaineer, Yale graduate, and philologist who visited Lake O'Hara four times between 1891 and 1895. In addition to the Native names, other place names commemorate people and places associated with the Rockies and world events of the time.

The Canadian Pacific Railway (CPR) was instrumental in the development of tourism in the Rockies. As Lake O'Hara gained a reputation for climbing and for its remarkable beauty, more long-term accommodation for tourists was required. And so, in 1911, the CPR built a small, single, bunkhouse-style log building, now called Wiwaxy Cabin, in the meadows below Mount Schäffer. More construction followed, with outlying log cabins built nearby to provide private accommodations, a step up from the bunkhouse. In 1919, the CPR added a larger, lodge-style building, now the Elizabeth Parker Hut, to serve as a dining room and communal hearth. Together, these buildings comprised the Lake O'Hara Bungalow Camp. MacDonald stayed here in 1924 and 1925, and even after the more luxurious lodge was built, regarded the original camp, and the meadows around it, with great affection, referring to it as "the old camp" in his journals and revisiting it often, both physically and in his art.

One of the main attractions at Lake O'Hara was mountain climbing, a sport in its "golden age" in Canada in the 1920s. Climbers required a base from which to mount attempts on the nearby summits of the Yoho and Bow Ranges. The Bungalow Camp made an excellent base for the famous Swiss Guides and their clients. The CPR brought the Guides to Canada in a brilliant public relations move to attract amateur mountaineers to the Canadian Alps and to ensure their safety. The first recorded climbing fatality in the Rockies had occurred in 1896, when Phillip Abbot fell to his death from Mount Lefroy. The Guides' presence addressed this concern and added allure and confidence. The Swiss architectural chalet-style of lodging found throughout the Rockies and the promotion of Canada's mountains as being like "fifty Switzerlands all in one" are rooted in the coming of the Guides.[17]

For six seasons, this Bungalow Camp, also called the Log Cabin Camp, was the centre of activity at Lake O'Hara. Its popularity increased quickly and, in the fall of 1925, the CPR began construction on the present Lake O'Hara Lodge. The new lodge had nine[18] private rooms, and over the winter of 1926–27, all of the original private cabins were sledded from the alpine meadows to the shores of Lake O'Hara, where they sit today. These one-room spruce cabins are appealing hideaways, with an ambience all their own. MacDonald stayed in a number of these on his visits to O'Hara after 1926. The original 1911 and 1919 structures, Wiwaxy Cabin and the Elizabeth Parker Hut, remain in the meadows.

MacDonald's horse trips to the Lake O'Hara region from Hector Station at Wapta Lake roughly followed the Cataract Brook Trail, 13.5 kilometres up the valley, heading south through the swampy Narao Lakes and on into the Duchesnay drainage basin. The trail is little used now, as most travellers to O'Hara take the bus in. A pilgrimage following the old pack route is an engaging way to spend a day, as long as you still have time to devote to Lake O'Hara itself.

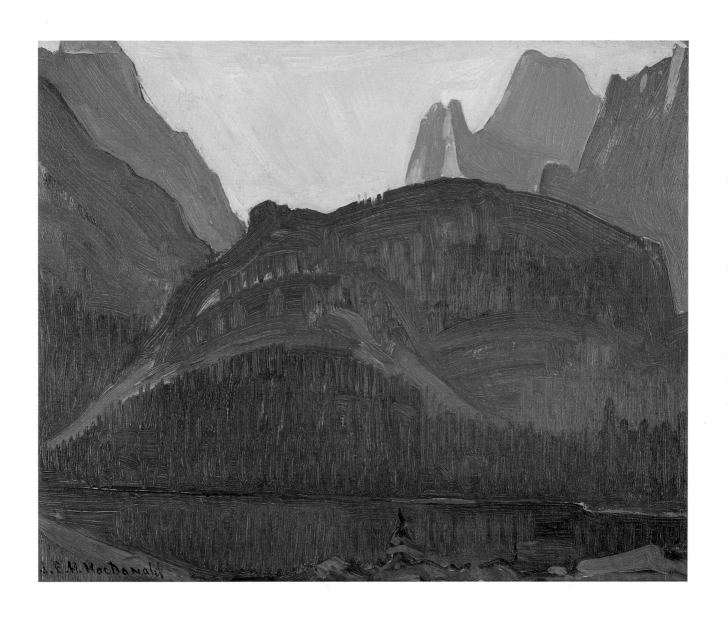

Morning Lake O'Hara, c.1926
oil on panel
Private Collection, Calgary
(vantage point 6 on map)

To visit Lake O'Hara, you have several options. The ultimate is a stay at wonderful Lake O'Hara Lodge. The hosts, food, and ambience are outstanding. You can take a brief foray into lodge-style living at afternoon tea in the main dining room, even if you are staying elsewhere. Reserve well in advance as the lodge is extremely popular. In winter you must ski in and carry your own gear. For shorter winter stays, a day's trip up the road and back, with a lunch reservation at the lodge, is a great ski. Contact Lake O'Hara Lodge for further details and rates.

There is one backcountry campground, which takes reservations from mid-June to the end of September through Parks Canada on a three-month advance system. This popular and well-maintained campground has secure food storage, covered cookhouses, pit washrooms, and a washing station. Contact the Field, B.C., Parks Canada Information Centre for reservations.

The Elizabeth Parker Hut and Wiwaxy Cabin, collectively referred to as the Elizabeth Parker Hut, are a short distance away from Lake O'Hara Lodge and provide communal shelter, sleeping, and cooking facilities. Contact the Alpine Club of Canada (ACC).

The Le Relais Day Use Shelter serves tea and excellent baking. You can also purchase maps and books and attain all sorts of information on the area, such as trail and weather reports and wildlife closures. Free interpretive talks are scheduled in the summer evenings at Le Relais. A pay phone is also located here.

Abbot Pass Hut sits at 2,926 metres in the rugged notch between Mounts Lefroy and Victoria. Built by the Swiss Guides in 1922, it is made entirely out of rock hewn on the site. The hut commemorates Phillip Stanley Abbot, who fell from Mount Lefroy in 1896. It is a remarkable structure in an inhospitable place, and a National Historic Site as of 1997. For many years, it was the highest habitable, permanent structure in Canada.[19] The new biffy, constructed by volunteers during the summer of 2002, has, arguably, the best view in the Canadian Rockies.

To reach all of the above, there is a bus that ferries people up the 11-kilometre access road, except during the winter months. You must have a reservation and the required permits to go in overnight. These regulations are fully enforced in order to maintain the trail quotas in effect at Lake O'Hara. Day hikers require only a bus reservation; if you are up for it and desperate to go, but have no bus reservation, you can always hike up the Cataract Brook Trail or the bus road, spend the day, and hike out again.

If you are coming from a distance, accommodations are available in Field, British Columbia (Yoho National Park), and in Lake Louise, Alberta (Banff National Park). The nearest campground is Kicking Horse, just west of Field.

Getting there:
On the Trans-Canada Highway, heading west toward Field, British Columbia, or east toward Lake Louise, Alberta, watch for a signed turnoff to Lake O'Hara, 1.8 km east of Wapta Lake, or 9.7 km west of Lake Louise. A short road crosses railroad tracks and branches right into a series of parking lots. There are pit washrooms, a trail kiosk, a telephone booth, and a bus shelter. This is where the bus will pick you up—or where you can begin your hike or ski. Be there 25 minutes prior to your trip; the bus keeps a tight schedule, and someone without a reservation is often ready to take your place! A Parks Canada representative will check you in and inform you of trail conditions and wildlife closures.

Lake O'Hara Lodge
Photo by Phil Hein

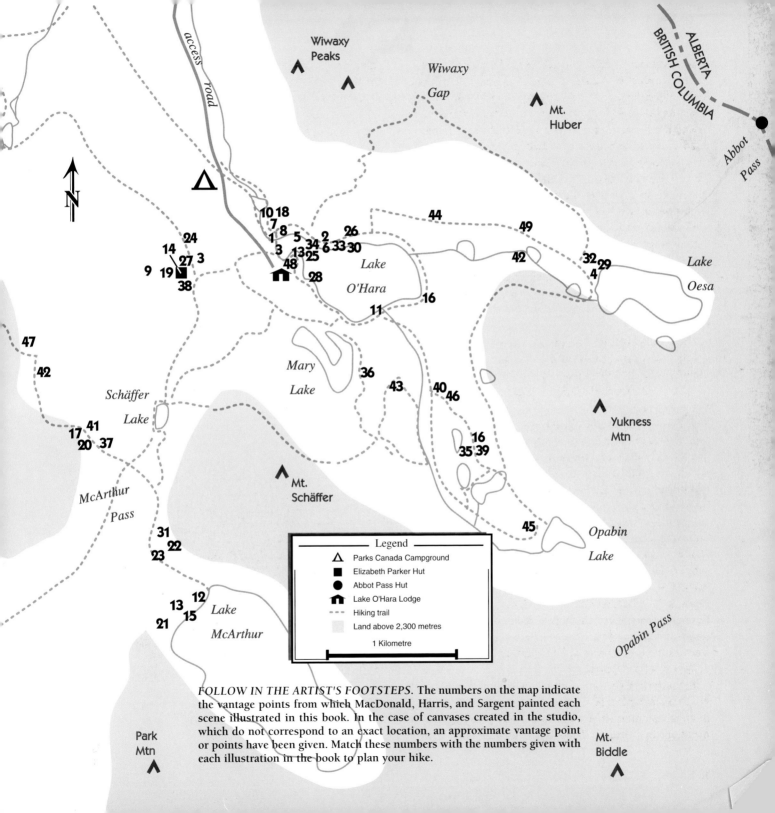

FOLLOW IN THE ARTIST'S FOOTSTEPS. The numbers on the map indicate the vantage points from which MacDonald, Harris, and Sargent painted each scene illustrated in this book. In the case of canvases created in the studio, which do not correspond to an exact location, an approximate vantage point or points have been given. Match these numbers with the numbers given with each illustration in the book to plan your hike.

I HAVE BEEN CAMPING, ONE HAS TO DO THAT
HERE, THERE IS NOTHING TO PAINT NEAR THESE
ENORMOUS HOTELS ALONG THE CP RAILWAY. I AM
OFF AGAIN IN SEARCH OF SOME ALPINE NIGHTMARE.

—John Singer Sargent to Mary Hale, 1916

WATERFALLS AND WATERCOLOURS

Necessary to any discussion of the art history of Lake O'Hara are the paintings by American portraitist and landscape painter John Singer Sargent. Sargent visited Lake O'Hara at the invitation of Brewster Transport in 1916. He camped on the shore for an extended time and painted a masterpiece of mountainscape, depicting the view toward the Seven Sisters Falls across Lake O'Hara.[20] The scene roused him sufficiently to *have declared Lake O'Hara to be superior to Lake Louise in both colour and setting.*[21] This work became so well known that the spot was named for him. His sketch illustrated here has little in common with his larger and more famous oil, but much in common with MacDonald's style of approach to the landscape. It is freer, less controlled, more responsive, and more emotive than the oil. The watercolour is ethereal, a misty dance of colour and light. The oil is omnipresent, solidly demanding our attention.

A WORD ABOUT WATERCOLOUR

Watercolour depictions of rainy days and wet effects in the mountains have the ability, due to the nature of the medium, to communicate the idea of wetness through their actual physical properties. The difference between watercolour painting and oil painting is complete. Watercolour, almost always used on paper, is a fluid, less-controlled manner of painting, with no room to redo anything. It is quickly done, transparent (unless an opaque medium or binder is first added to the paint), and does not build up any texture on the surface of the paper (known as the "support" in art jargon). In the forest and lake areas, Sargent's work was executed with a wet, or "loose," brush, which means quite a lot of water and a little bit of pigment. Extremely loose watercolours can be painted on pre-wetted paper. Working wet on wet, the pigment particles flow freely and, even when dry, have a characteristic stained or wet look to them. By contrast, in Sargent's sketch, the rocky slope and the lower edges of the glacier were executed dry, that is, mostly pigment and very little water. The result is the opposite to wet on wet, as the paper absorbs most of the water, leaving the pigment roughly where the artist placed it. This "flow" is the key to watercolour painting.

Other watercolour techniques were employed in Sargent's sketch. The directional lines, scratched into the paper to indicate the texture of the rocks, were made with a sharp tool, perhaps the brush-handle tip, after the paint dried. The foreground logs, floating in the water of the near shore's edge, were also added after the underpainting—or wash—had dried, as were the rocks on the spit that cuts across the centre of the lake. The white of the glacier is actually the white of the unpainted paper. Only the areas of grey shadow and darker snow in this region of the work are actually painted. By varying his use of these techniques, Sargent's forest on the far shore appears wetter than the body of water in front of it, a funny irony of the painting.

Watercolour paint has advantages over oil paint for backcountry sketching. The materials weigh less: paper is substantially lighter than wooden panels, and pigments come dry and in cakes. Watercolour sketches dry very quickly and can be stacked, rolled, and packed more easily. But, overall, watercolour results in a much softer feeling in the finished work. Even strongly executed watercolours, with heavy pigmentation and dense colour, read as soft compared to oil paintings, simply due to the nature of the medium.

Fragility is watercolour's greatest disadvantage. Paper is much more easily damaged than wood or canvas and can be completely ruined by water spots or badly faded by sunlight. Historical artworks in watercolour depicting Lake O'Hara that are in good shape, like this charming little sketch, and on support of good-enough quality that it has not yellowed over time, are rare finds.

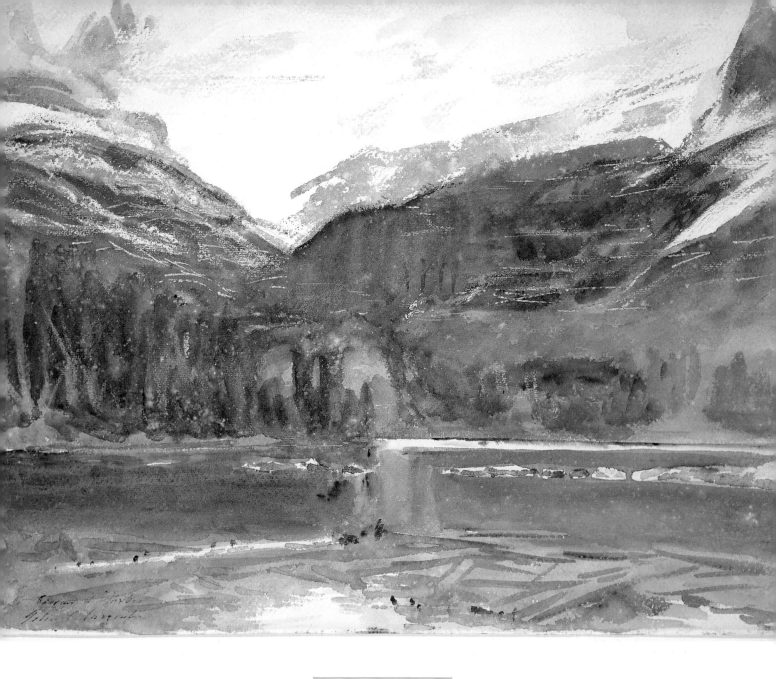

John Singer Sargent
Lake O'Hara, 1916
watercolour and graphite on white wove paper
Fogg Art Museum
(vantage point 7 on map)

I GOT TO THE BEAUTIFUL LAKE O'HARA LYING IN A RAINBOW SLEEP,

UNDER THE STEEPS OF MOUNT LEFROY AND THE WATERFALLS OF OESA.

AND THERE I REALIZED SOME OF THE BLESSEDNESS OF MORTALS.

WE MAY REACH OUR HAPPY HUNTING GROUNDS AND RETURN AGAIN,

IF WE TAKE THE RIGHT TRAIN. FOR NINETEEN DAYS I WANDERED

IN THE NEIGHBOURHOOD OF O'HARA. I SAT AND SKETCHED HER BEAUTY.

I LOOKED AT THE EMERALD AND VIOLET OF HER COLOUR.

IT IS EMERALD AND MALACHITE, AND JADE, AND RAINBOW GREEN,

AND MERMAID'S EYES, AND THE BEADS OF SAINT BRIDGET,

AND THE JEWELS OF PATRICK'S CROWN, AND ANYTHING ELSE

THAT THE DELIGHTED IMAGINATION CAN ASCRIBE TO IT.

—from J. E. H. MacDonald, "A Glimpse of the West," 1924

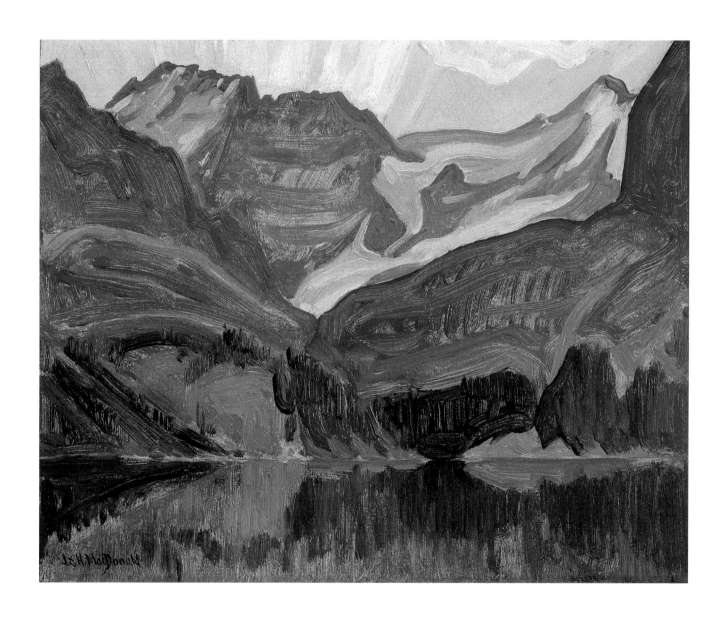

Early Morning, Lake O'Hara and Mount Lefroy, 1929
oil on board
Private Collection
(vantage point 8 on map)

"Sketching: The First Outdoor Sport"

Leisure, nature study, Enjoyment

Equipment: A few tools, some enthusiasm and an open mind

Colours: about eight, a small box, stool or rocks

Umbrella: Light in the mountains strong ...

Drawing for the oil sketch: brush in the outline, then wash in,
highlights strong

Don't photograph the subject. Give only the characteristic details essential to the composition. Speed helps in sketching just as in sprinting. Try to grasp the idea of your subject quickly, and then put it down before you can form any doubts about it. Get the effect, it goes quickest, the objects remain and can be studied at leisure if need be. Try to have an idea in your sketch as well as a view. A profile is the limit of a solid mass, even though that solidity has the different qualities of cloud and rock. Design from nature rather than copy her. You will find a general trail in the lines and masses under varying details. Bring that out ... Trees grow and clouds float but Art has a world of her own where science is not so absolute. Drawing is the bones of Art, painting is the guts. Drawing is analytic, painting sympathetic.

—from J. E. H. MacDonald lecture notes, undated

O'HARA IN OILS

Although J. E. H. MacDonald worked in pencil, gouache, watercolour, and pen and ink when designing, when he sketched at O'Hara he always worked in oil paint. From various archival sources, we have a good idea of his sketching outfit and approach to working out of doors. We know he always carried a heavy Ulster (raincoat) folded over his arm, wore a hat to shade his eyes, and carried a collapsible, long-handled umbrella, which he stuck into the ground for shade and protection from the elements. In good weather, he sat on a rock, on his Ulster, and made tea in an old lard pail. In poor weather, he sought shelter in the large rocks of O'Hara's glacial tumbles, settling in protected troughs and cavities, where he would build a fire and make his tea. He painted, apparently, with stubby, worn brushes,[22] which he wiped on a nearby tree bough, instead of bothering with a rag. Notes for an undated lecture that focused on his techniques for sketching out of doors tell us not only about the equipment and supplies he used, but also about his methodical approach to subject. Titled "Sketching: The First Outdoor Sport,"[23] the notes date from after his initial mountain trips, as he refers specifically to some problems of painting in the Rockies. By looking closely at the resulting sketches, we can see that he followed his own advice: among other things, he kept his colours minimal and his focus in each sketch specific and clear.

MacDonald's sketches were painted on wooden panel, canvas-covered board, paperboard, and pressed board (today's masonite). In many of them, we can clearly see his working method. No primer or ground colour is used. The image is roughed in using pencil on a bare support in simple lines to indicate shape and pattern. Rather quickly and very sparingly, colours, usually about eight, are then applied. The paint is thin and almost transparent in places, thicker and slightly opaque in others. Often, the support shows through the pigment and, in places, becomes an integral component of the finished sketch. Oils dry much more slowly than watercolours, taking several days to completely dry, and areas in a sketch can be reworked easily. Colours can be mixed on a palette, for an almost infinite variety of hues, or blended directly on the surface of the work. Conversely, the artist must wait for the paint to dry sufficiently before applying an additional layer of colour that is to remain distinct from the undercoat. If the first colour is still wet, the new colour, if overly worked, will blend with the underlying shade. We know, and can see by the sketches, that MacDonald used thinner in his oils. Areas of greater emphasis were sometimes painted with thicker paint, straight from the tube. Occasionally, he went back into the sketch after it had dried somewhat, adding stronger highlights here and there. According to how he describes them in "Sketching: The First Outdoor Sport," he kept to the rules of his game.

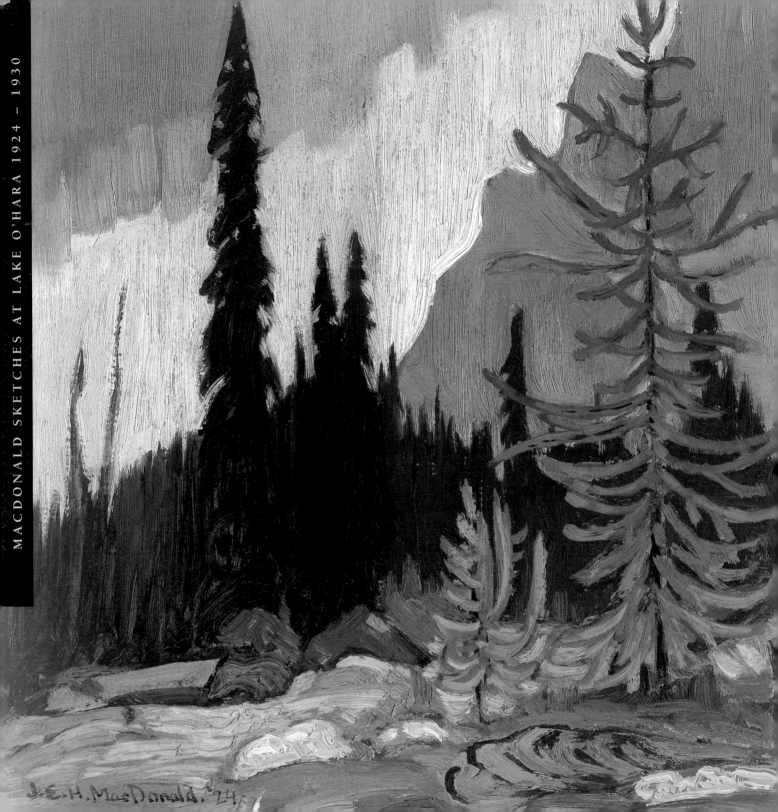

J.E.H. MacDonald. '24.

So it unrolled itself for nineteen days and then the city called again and one had to come down into the valley and over the prairies and back to the level streets where men who consider themselves Canadian live out their lives.

In his book about the national parks, Enos Mills says: "The seasons for visiting national parks are spring, summer, autumn, and winter," but most of us are lucky if we can follow his further advice "visit the parks when you can stay there the longest." And I might quote that other grand old American mountaineer, John Muir, "The mountains are fountains not only for rivers and fertile soil, but of men. Therefore we are all in some sense mountaineers and going to the mountains is going home."

—from J. E. H. MacDonald, "A Glimpse of the West," 1924

Rain, Lake O'Hara Camp, 1924
oil on board
Collection of Walter B. Tilden
(vantage point 9 on map)

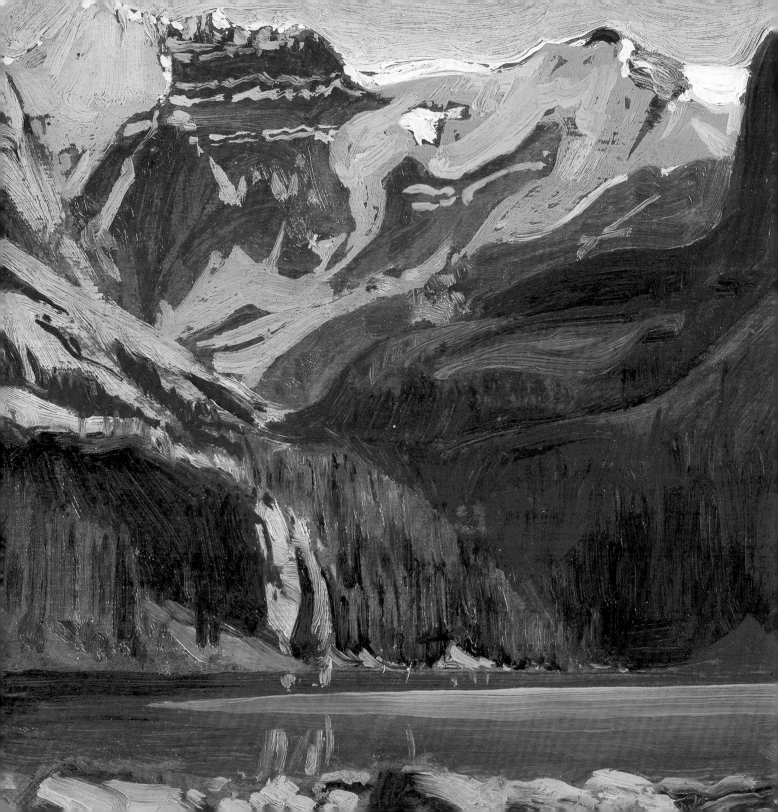

FIRST IMPRESSIONS AT LAKE O'HARA CAMP – 1924

Sometimes the red gods give a push as well as a shove, and so

I found myself landed in a Rocky Mountain valley for a few days

this summer. I was on a sketching trip—let me put down in rapid fashion

some of the colour and pictures that come into my mind as I thank

the red gods for their bounty. ... The mountains are veiled in my memory

as they first appeared, with an afternoon sun breaking a sky of

heavy grey cloud, and below the clouds and along the horizon,

firmer clouds which kept their shape and seemed more solid. And we

had to admit that these were our Rockies of romance. And the night

came down on them and we were led into them unseeing in the darkness.

I adventured at Banff in looking for a lodging for the night,

and as I lay down in a bed and listened to the mountain wind in the

poplars my little city soul patted itself romantically, for I was

sheltered at a cottage named Beaver Lodge, Muskrat Street.[24]

The implications are a little wet and chilly perhaps, but how Canadian!

—from J. E. H. MacDonald, "A Glimpse of the West," 1924

Morning, Lake O'Hara, 1924
oil on canvas
Private Collection
(vantage point 10 on map)

Taking extended sketching trips into wilderness regions was by no means unknown to MacDonald. Since 1909, he had taken regular sketching trips to wilderness regions in eastern Ontario and Quebec and to Georgian Bay on Lake Huron. He sketched with Lawren Harris, whom he met in 1911, in Mattawa and Timiscaming, Ontario, on Georgian Bay, and in 1913, in the Laurentians in Quebec. In 1914, MacDonald sketched for the first time in Algonquin Park, encountering scenery that would form the basis of some of his most revered works; he also sketched in the Gatineau Hills and Cascades of Quebec, as well as at Minden, Ontario, and St. Jovite, Quebec. In 1915, he began sketching in his own backyard, and started to paint *The Tangled Garden*, a critical work in his career. A monumental moment in Canadian art history occurred with its completion and exhibition a year later; the attention he gave to a tangled, rather messy corner of an ordinary garden caused an uproar. How could such a minor and unremarkable subject be worthy of a painting? His attention to the unpicturesque would become a thread in much of his later painting and a binding cord in his O'Hara work. In 1918, together with Lawren Harris, Franz Johnston, and Dr. MacCallum, he took the first of the infamous "boxcar" trips, working out of a railway boxcar, outfitted for living with beds and a stove and moved from siding to siding every few days by the CPR in Algoma. Two subsequent trips occurred in the spring and fall of 1920. In 1921, he sketched in southern Ontario, in the village of Coboconk and at the Gull River, and in 1922, he visited Nova Scotia. Although he returned to some of his familiar sketching grounds in Ontario in 1923, particularly Coboconk and Georgian Bay, between 1924 and 1930, all of his sketching time was spent in the Lake O'Hara region.

Then comes the morning journey from Banff to Wapta Camp, with all the track-side wonders of the Bow Valley, where we went from side to side of the observation car twisting our necks up to Castle Mountain and the other mountains of the guide book, while a Booker Washington porter described them intelligently and completely for us. And at last one could shake hands with the mountains. Here was blue Wapta Lake, or is it Malachite or emerald or rainbow green? These are the terms people use. Let any one of them conjure up the finest colour your mental eye can picture, you cannot overdo it. Rainbow-green seems to me the best. It has the soft quality of light and change and variation of intensity which comes nearest to the feeling of the mountain lake color.[25]

Seeing Lake O'Hara for the first time must have been a landmark moment for MacDonald. Its beauty often strikes visitors, even those returning for a regular annual visit over many years. But in 1924, with no modern conveniences and few people, that first impression must have been one of staggering mountainous beauty. After the long train trip from Toronto, his horse-pack trip up Cataract Brook, unpacking the horse, and settling into the Bungalow Camp, he would have been rewarded with his first look at the region bathed in the late evening light that August in the Rocky Mountains brings.

Filled with anticipation, MacDonald had nineteen days to explore and paint. The scenery was endless, and he was free to go where he chose. It seems that he sketched alone, for the most part, acquainting himself with the region and seeking out places where the view suited him and where he could sit comfortably while sketching, a priority for him. Fellow painter J. W. Beatty recalled how *J. E. H. MacDonald used to hunt for a shady, comfortable place, sit down, and then look for something to paint.*[26] A seasoned outdoor painter, MacDonald returned repeatedly to the same places to work, often stashing supplies in rock caches to ease his load. He was a quick sketcher; his son Thoreau recalled later that *on sketching trips he tried to make two a day and this he thought the finest pleasure in life for his idea of Heaven was painting in wild country.*[27] At O'Hara, when conditions were right, he painted as many as four sketches a day: early morning, morning, afternoon, and late afternoon or evening. His sketches tell us how much he explored and where he went, and they chart the variations in weather and atmosphere he attempted to capture. His journals give a great deal of detail about the activities of each day:

Had lunch at my favorite lookout towards Oesa, beside the waterfalls and with the fine valley and Oesa in front. The little harebells numerous, beautifully delicate ... Made sketch of Oesa. Grey effect (Simplify foreground but detail fairly correct). Found

my oil bottle left there last year. It seems incredible that it should have stayed in the same place through winter snows and spring rains. Apparently the main flow does not come down here. The bottle was glued to the ground. ... Color of upper lakes very fine. Light green blue. O'Hara not so colorful on level but marvelous from above. Quality of color very puzzling. Must try to get it down in accurate notes.[28]

Morning, Lake O'Hara, 1924, is the classic depiction of Lake O'Hara, the one most often rendered by visiting artists. Looking south and slightly east across the lake, the Seven Sisters Falls are in the shadows. Sunlight bathes Mount Lefroy's glaciers, Allen Glacier and Glacier Peak, in brilliant white. Hints of this sunlight hit the uppermost peaks and synchronize with the near-black forest and rock faces below. The lake is a still, grey-green sliver of mala- chite. It is the postcard view of Lake O'Hara and truly worth its fame. It was likely one of the first scenes that MacDonald would have sketched, an easy walk from the Bungalow Camp through a rolling and open valley.

Lake O'Hara trails in 1924 were nothing like they are now. Lawrence Grassi and Tommy Link did not begin serious trail building until the 1940s. The Swiss Guides had staked out routes up and around to Lake Oesa and Abbot Pass, and the Alpine Club of Canada had explored Lake O'Hara since the early 1900s, but in terms of good footing for the non-alpinist loaded with sketching gear, the paths were intermittent at best. MacDonald's journals make numerous references to following goat paths and rough tracks, climbing up creek beds, and walking across scree. From the sketch titles known to be from 1924, most of his work that year seems to have been done in the alpine meadows and nearby shores of Schäffer and Mary Lakes; in some sections of the shores of Lake O'Hara; on the lower slopes of Odaray Bench, the closest high vista in proximity to the Camp in the alpine meadows; on the east trail to Opabin Plateau, built in the early 1920s[29]; at Lake McArthur, reached by a meander through McArthur Pass; and on the trail to Lake Oesa, used by climbers and the Swiss Guides to reach Abbot Hut and climb the adjacent peaks. The Guides had fitted some of the more dangerous cliff sections that

barred access to Oesa with spruce and fir ladders. MacDonald managed these ladders *with a backpack strapped on aft and a paintbox and portable easel fore.*[30] These regions are now accessed by established trails, some in the same locations, others along new routes, yet all lead to spectacular views, and it is fitting that so many of them were MacDonald's haunts.

MacDonald got to know the places well: *These are the names of some of the mountain people who stand about O'Hara: Lefroy, Victoria, Huber, Wiwaxy, Cathedral, Ringrose, Hungabee, Oderey [sic]. My picture jumbles as I think of them.*[31] Occasionally, his place names jumbled as he titled his sketches; a few works known to be from 1924 are titled incorrectly by him. MacDonald loved the hanging valleys at Lake O'Hara. Looking at a panoramic photograph of the region, it is clear that his favourite sketching locations were all at roughly the same elevation—slightly over 2,200 metres—in the second balconies of Lake O'Hara's concert hall.

From MacDonald's sketch- ing activities at O'Hara, clearly he was much more robust and adventurous than he has been generally por-

trayed to be. Much of this misconception seems to be rooted in the frequent remarks made, for whatever reason, by A. Y. Jackson. Numerous times, he dis- counts MacDonald's abilities: *He could not paddle a canoe, or swim, or swing an axe, or find his way in the bush.*[32] Yet, by looking at his sketches, we can see that he climbed to great heights and explored extensively at Lake O'Hara. He rowed boats on wind- blown lakes in foul weather, fixed broken cabin doors, and climbed steep gorges by using the creek bed, as there was no trail, all loaded with sketching gear and, most often, alone. Certainly Jackson was a more capable woods- man, but MacDonald was by no means an incapable one.

AND THERE WERE GREY COLD DAYS WHEN ONE HEARD THE ECHOES OF CHAOS AND COLD NIGHTS ON THE UPPER SLOPES, AND THE SPIRIT OF DESOLATION WAFTED COLDLY ABOUT THE ROCK-SLIDES AND ONE FOUND THE SIGHT OF EVEN A LITTLE OLD DRIED HORSE DUNG A CONSOLATION AND AN ASSURANCE. ON SUCH DAYS, AND OFTEN IN CALM STILL WEATHER ONE FELT THAT THE MOUNTAINS ARE NOT COMPLETED. THE BUILDERS ARE STILL AT WORK; STONES COME ROLLING AND JUMPING FROM THE UPPER SCAFFOLDING AS THE GODS OF THE MOUNTAIN CHANGE THEIR PLANS. IN THESE GREAT PLACES ALL THE FUNCTIONS OF NATURE ARE ON A BIG SCALE AND THE MATERIAL WORKINGS OF THE FROST AND WIND AND RAIN AND SUN ARE CLEAR TO US.

—from J. E. H. MacDonald, "A Glimpse of the West," 1924

Continuing on around the lake, past the Seven Sisters Falls and turning north toward the present-day lodge, a second view back toward Cathedral, this time showing Deception Peak (a false peak of Mount Stephen) and its glaciers, is an essay of green and orange. Despite the prominence of the mountains in this work, of greater interest is the surface of the lake. The windblown water reflects a muddled version of the two peaks and some of the orange sky above. MacDonald has depicted the action of moving water on the surface of the lake nicely; it is a difficult subject that never sits still, but he had much practice with this same theme in his Algoma works and had mastered it there. The surface of Lake O'Hara is a constant dance of colour patterning, as the deep and cold waters, surrounded by peaks of varying heights, are stirred by the wind as it tumbles down from up high, rolls across the lake, finds itself against another peak, and turns back, having nowhere to go. These wind gusts jostle and fight with one another, stirring the water's surface and creating an ever-changing tapestry of reflection, movement, and colour. The brushwork in the mountains and sky is equally agitated, furthering the windblown feeling in the sketch.

I am especially drawn to MacDonald's depictions of mountain weather; they instantly evoke memory, affection, sensation, and experience. I realize that this connection is very personal and that, whether one is consciously aware of it or not, our surroundings shape us. Visually familiar aspects of a painting, even those of a very subtle nature such as the colour of the sky or the texture of a forest, are more easily perceived, and therefore welcomed and understood, when there is a reference point in the mind of the viewer. For example, a picture of a riot of Ontario fall colour, no matter how chaotic, tangled, or unreadable, will fall on more receptive eyes belonging to people who are familiar with that place, that riot, that colour. Accordingly, the qualities of a rainstorm at altitude in a wide mountain amphitheatre may seem to be contrived to unaccustomed eyes, whereas those who have been in such a storm will find it to be an accurate record of light, colour, and atmospheric conditions; they might perhaps even find the works evocative.

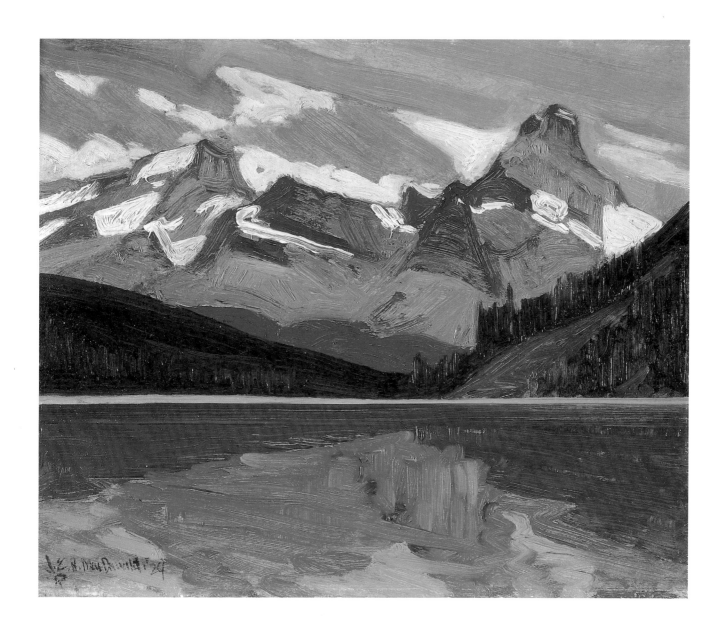

Lake and Mountains, 1924
oil on cardboard
National Gallery of Canada
(vantage point 11 on map)

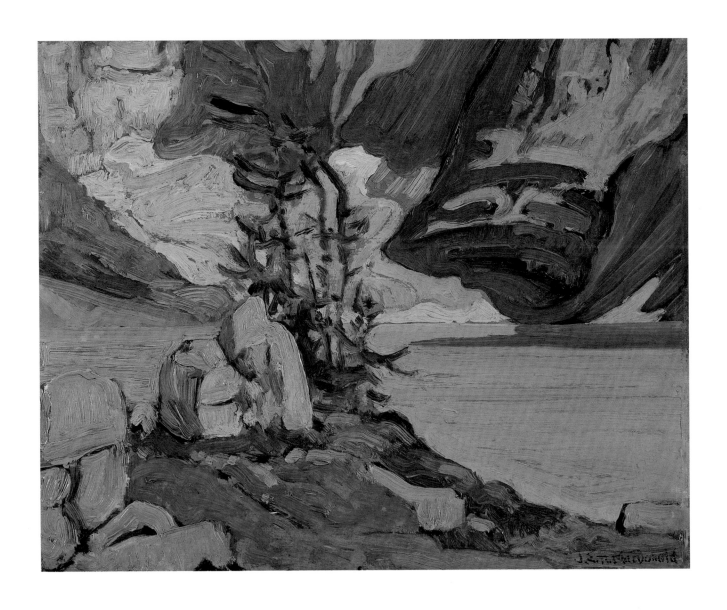

Lake McArthur, Lake O'Hara Camp, 1924
oil on panel
McMichael Canadian Art Collection
(vantage point 12 on map)

AND AS ALL GOOD THINGS GO IN THREE, O'HARA HAS TWO SISTER LAKES TO SPREAD OUT THE EFFECT OF HER CHARMS A LITTLE EASEFULLY TO US—OESA AND MCARTHUR; OESA, A LITTLE EMERALD SISTER WHICH HUNGABEE MOUNTAIN NURSES IN A GREAT GLACIAL HALL OF SOMBRE ROCK, AND MCARTHUR, A BIGGER SISTER, MORE AUSTERE, SITTING IN A REMOTE MOUNTAIN AMPHITHEATRE.

—from J. E. H. MacDonald, "A Glimpse of the West," 1924

Lake McArthur is bounded on the north by an open shore made of huge slabs of rock, which were once part of the lower slopes of Mount Schäffer. Now, beneath your feet, they have been cracked and torn by ancient glacial action and the erosion of each subsequent season's cycle of freeze and thaw. They form the immense dam that cradles the cobalt waters of the lake. Once you come out of the forest and onto the open trail in the hanging valley, you have to hike some distance across these massive rocks before you reach McArthur's blue waters. MacDonald captures the feeling of visual anticipation that hikers have while approaching the lake. This feeling, of cresting the trail to the lake and seeing the water, only to discover, as you continue to walk, that the shore is still some distance away, strikes me each time I go there.

One of the most appealing places at Lake O'Hara is the high alpine cirque that holds Lake McArthur. MacDonald painted the lake itself and a number of views from the shoreline and nearby meadows numerous times. He was especially interested in the patterning and colour of McArthur with snow, eagerly anticipating a day when he could paint the blue lake surrounded by white.

McArthur is a still, deep blue lake, not blue-green like so many glacially fed lakes are. Our perception of colour, which we see as wavelengths of light in the colours that are reflected back to our eyes by whatever they hit, is especially interesting at Lake McArthur. The shorter the wavelength of light, the smaller the particle that reflects its colour best. Green light has a short wavelength, blue light has a shorter one still. Lake McArthur's water has very fine glacially ground rock flour in it. Very fine particles in very pure water reflect the shorter wavelengths back to our eyes—blue. The more coarse the rock flour (that is, the bigger the bits of glacial silt), the longer the wavelengths and therefore the greener the colour. Lake depth also plays a role, as the particles settle further down in the water. Add to this the action of wind, the day's weather, cloud shadow, and the air quality through which we view the lake and we have enough variations to change the spectrum of blue we see, providing an amazing display of water colours. At deep Lake McArthur, with its finely ground and evenly suspended silt, we see a darker blue than at most high altitude lakes, a shade which, together with the yellow of a larch, the buff pink tones of Mount Biddle, and the paler blue of the sky, is particularly striking. Add to this the additional contrast of fresh white snow and you have a colour-balanced, perfectly composed scene.

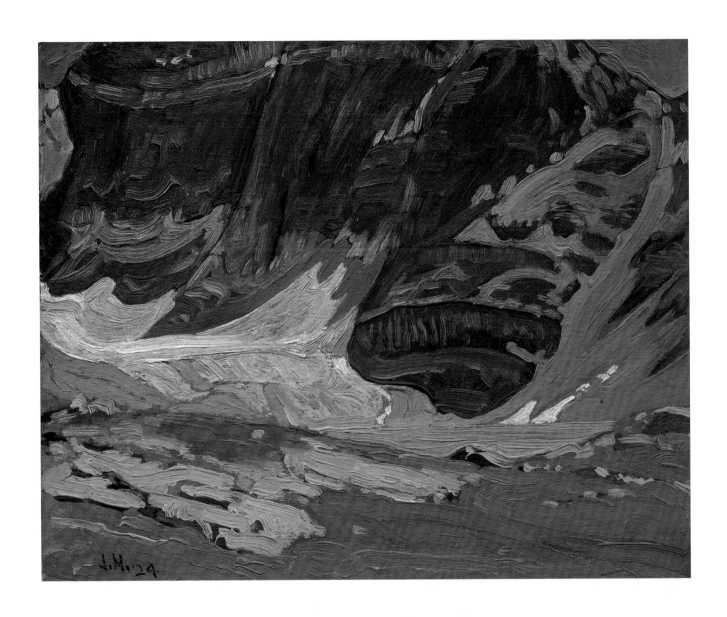

Lake McArthur, 1924
oil on board
Private Collection
(vantage point 13 on map)

I HAVE WATERFALLS AND GLACIERS, AND MOUNTAIN BROOKS AND MEADOWS, AND ROCK-SLIDES AND SNOWY PEAKS … AND AS THE GREAT THINGS HAVE THE LITTLE THINGS IN PERFECTION, SO WERE THE FLOWERS ABOUT MCARTHUR, FOR INSTANCE, THE LITTLE COMPLETELY CLOSED BLUE GENTIANS TWO OR THREE INCHES HIGH, BLOOMING AS THE FRESH SNOW SANK BACK INTO THE CRISP MOUNTAIN GRASS, WITH A SOLITARY BEE BUZZING NUMBLY OVER THEM.

—from J. E. H. MacDonald, "A Glimpse of the West," 1924

MacDonald discovered Lake McArthur shortly after he found his footing at Lake O'Hara Camp, and sketched there several times in that first year. *Lake McArthur, Yoho Park, 1924,*[33] is a gem of a sketch, a sunlit snowy day on the shore of a turquoise lake. *Lake McArthur, 1924* is set from a perspective close to the ground, indicating that MacDonald was sitting low, his habit in poor weather, out of the elements, rather than high on an exposed rock as he might in fair weather. During uncertain weather, he often followed the lead of the mountain animals he so keenly observed and took shelter deep in the boulders. *He was unexpectedly practical and capable at manual work and for all his limitations as a woodsman he understood the wild country and recorded it as well as any.*[34] At Lakes McArthur and Oesa, and on the Opabin Plateau, he found open cavities under a rock tumble, big enough for several people, or a protected spot in the lee of a massive rock, out of the wind. He would reuse these locations, stashing wood to keep dry for a future fire, hiding a cache of raisins in a metal tin, leaving an oil bottle under a rock to lighten his

paint kit. This way, he could return when poor weather prevailed, assured of minimal comforts and, with this, the increased likelihood of completing a sketch.

MacDonald once again depicts a small detail of a panoramic vista, focusing on a tiny segment of a rather imposing and expansive scene. His mountain sketches most often take this approach; they are not about summits and peaks, but about other, lesser details. To try to capture it all, even a single peak, in a small-format sketching panel was not in his stylistic approach. This is sometimes seen as a failing in his mountain works. In fact, the contrary is the case. This approach is his greatest success. He depicted the minor details of the mountain landscape with sincere interest and a keen desire to understand their workings. The monumental mountains served as background to the study of a rocky slope or a corner of a lake, precisely and prudently studied: his rocks have weight, his clouds contain snow and rain, his alpine lakes are cold. He approached every subject thoughtfully, in an effort to know it. As with the 1916 painting *The Tangled Garden*, he senses in the small-scale details of the

O'Hara landscape subject matter worthy of painterly attention. He is working through problems in many of his O'Hara sketches, how to depict the scrawny limbs of a larch tree, how to convey the depth of the blueness of McArthur's waters. *The feeling of being overwhelmed at first is sometimes notable in MacDonald's work when he faces a change of country. It is not because an acquired mannerism fails him under new conditions; it is rather the artist's honesty in facing a new problem.*[35]

His attention at Lake McArthur was captured by details—patterns of shoreline against water, the edge of the peaks against a brooding sky, light hitting snow, shadow staining rock a particular colour, the contrast of pink rock and blue lake. The success in *Lake McArthur, 1924*, lies in the wonderfully deep blue shadows beginning to creep over Biddle Glacier. A cold indigo, they convey the chill of glacial air and the approaching evening. The shadows themselves tell us the shape of the peaks above, which MacDonald has not included in the sketch. These shadows, through their shape and colour and their depth, reveal the absent peaks.

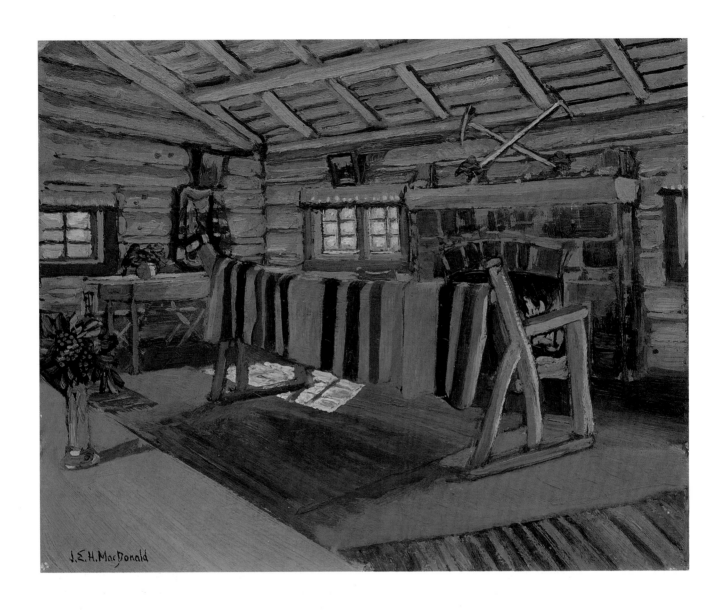

Lodge Interior, Lake O'Hara, c.1925
oil on board
McMichael Canadian Art Collection
(vantage point 14 on map)

BUT THERE WAS HUMAN INTEREST TOO, IN THAT MOUNTAIN VALLEY. IN MY STAY I SAW MANY COME AND GO, ARTISTS AND PROFESSORS AND YOUNG MILLIONAIRES. I HOPE THEY ARE REMEMBERING O'HARA AS I REMEMBER IT AND THEM. THE QUAINT LOG CABIN INTERIORS OF OUR DINING ROOM, WITH ITS BRIGHT WOOD FIRE AND THE AXE-HEWN SETTEE COVERED WITH INDIAN BLANKETS STRIPED RED AND YELLOW AND BLACK AND GREEN, IS SURELY A HAPPY MEMORY IN CAMBRIDGE LECTURE ROOMS AND NEW YORK FLATS. THEN THERE WERE THE HORSES, MICKY AND PEARL AND BILLY AND HARVEY WRIGHT, AND ALL THE EXTRA ONES WHO CAME IN SOMETIMES SINGLY OR IN A PACK TRAIN, WITH GUIDES AND RIDERS GOING PAST OUR CABIN WINDOW LIKE A WILD WEST SHOW. THIS IS A GREAT COLOUR BAND IN MY MEMORY PICTURE.

—from J. E. H. MacDonald, "A Glimpse of the West," 1924

A Point About Point Blankets

In the late 1700s, the Hudson's Bay Company (HBC) ordered blankets as trade goods from a company based in Oxfordshire, England. Each blanket was graded on a point system that was based on the blanket's worth in beaver pelts (initially, one point equalled one beaver pelt, and so forth), but gradually the system came to indicate only the blanket's size and weight. For every point, a short, narrow, black bar was woven onto one end of the blanket. As a result of this grading and trading system, these blankets became known as point blankets. White blankets with four multicoloured stripes of indigo, green, red, and yellow were introduced in the 1880s, and they became known as Hudson's Bay blankets.

As early as the 1770s, people in Quebec had begun making hooded overcoats from the HBC point blankets; such an overcoat was known as a "capot" or "capote." Quickly noticing this use of its product, the HBC began to manufacture ready-made coats, and by the nineteenth century, both men and women were wearing these overcoats for winter sports and leisure wear. Today, HBC point blanket coats are a Canadian symbol.

Each night the evening meal for guests at the Log Cabin Camp was served communal style in the camp's large cabin, now known as the Elizabeth Parker Hut. *Lodge Interior, Lake O'Hara*, from 1925, conveys a warm, welcoming atmosphere. Orange evening sunlight pours in through the window. Branches of berries, perhaps bunchberries or buffalo or elderberries, are in vases on the tables, and there are paintings on the walls. A Hudson's Bay Company blanket is neatly draped over the wood-and-hide couch in front of a burning fire, and a matching blanket coat hangs on a peg on the wall.

Nowadays, the Elizabeth Parker Hut is a bustle of activity, with climbers, families, and hikers preparing for each day's trail adventures and generally cluttering things up. Like all of the facilities in the region, the hut has been upgraded to keep up with Lake O'Hara's ever-widening popularity. Bunk beds have been strung end to end on either side of the fireplace, and tables and chairs added. Rarely is the hut as tranquil as it is in MacDonald's scene. The fireplace, the central feature in MacDonald's work and the gathering place of visitors during his time, is still a favoured spot of visitors. The chimney portion has been bricked over, and a cast iron insert, especially useful for warming tea and drying socks, has replaced the open hearth.

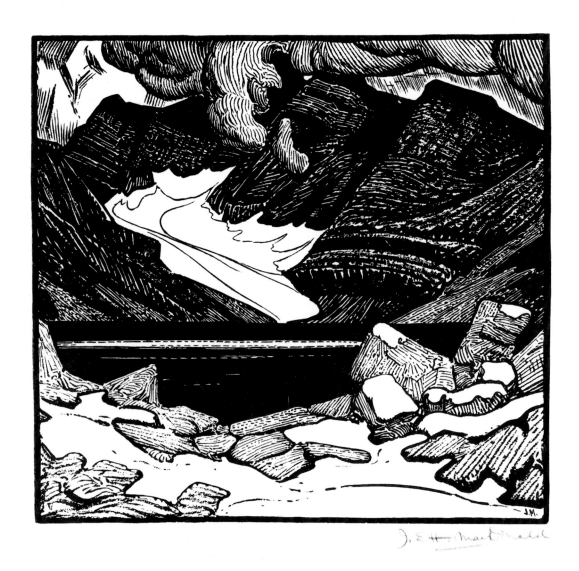

A Glacial Lake, Rocky Mountains, 1925
lithograph on paper
The Edmonton Art Gallery
(vantage point 15 on map)

THE SIGNIFICANCE OF THE EASE WITH WHICH
MACDONALD AND MANY OTHER MAJOR CANADIAN
ARTISTS MOVED BETWEEN THE WORLDS OF FINE
AND COMMERCIAL ART IS NOT GENERALLY UNDER-
STOOD. ... MACDONALD WAS AT HOME IN THE
CONTINUOUS SPECTRUM OF VISUAL PRODUCTION.

—Michael Large in *J. E. H. MacDonald: Designer*, 1996

After nineteen days, MacDonald would pack his things and retrace his route home, first by pack horse and then by train, to Toronto. The trip from Toronto to O'Hara would be made over again, seven years running. *After the first time he went to the Rockies, he never really wanted to go anywhere else. He used to say he could feel the pull of them all the way across the country.*[36] With imagery and the sights and sounds of Lake O'Hara vivid in his mind, MacDonald would return to work, pen "A Glimpse of the West," lecture his students on the mountains, and return to his studio. Using the images he gathered visually in his sketches, he would add Lake O'Hara's landmarks, such as the ridge lines of Wiwaxy Peaks and Cathedral Mountain, to his design commissions and develop ideas for larger canvases based on the mountains. In particular, the small, focused corner of Lake McArthur depicted in *Lake McArthur*, 1924, and in *Lake McArthur, Yoho Park,* 1924,[37] formed the basis for the composition of this pen-and-ink drawing, *A Glacial Lake.* The scene depicts Lake McArthur, looking south and slightly east across the lake toward Mount Biddle, with Biddle Glacier clinging to the mountain's western flank. The lake itself lies in an ancient tumble of pink and beige sucrosic dolomite, weathered by ancient rainwater, forming leach puddles and gradually percolating the rock away. The tumble is an amazing environment, the cliffs resulting from a combination of the actions of rockfall and weathering. Their severe character is perfectly captured in the stark medium of pen and ink. Later engraved and used as a magazine illustration, the work made its way into an editioned portfolio of prints by members of the Group of Seven, and it is representative of MacDonald's graphic work found in the collections of many galleries across Canada.

Rain in the Mountains, 1924–25
oil on canvas
Art Gallery of Hamilton
(vantage point 16 on map)

A PICTURE IS NOT THE REFLECTION OF A
THING SEEN, BUT A COMPOUND OF FEELINGS
AROUSED IN THE ARTIST BY THE THING SEEN
RESULTING, ACCORDING TO HIS POWER, IN A
MORE CONCENTRATED EXPRESSION THAN THE
NATURAL OBJECTS CAN GIVE.

—J. E. H. MacDonald in *Poetry and Painting*, 1929

In addition to his design works, far away from the light and air of Lake O'Hara, MacDonald would paint his first major mountain canvas, *Rain in the Mountains*. A smoothed and softened memory of that first sketching trip, this work was executed by a partnering of MacDonald the designer and MacDonald the painter. The designer has painted a forest that is all pattern, a lake that is a graphic depiction of sunlight on water. The foreground tree is an anchoring, decorative element, which could have easily been based on a real tree. The patterning of the lichens on the shoreline rocks, the stylized form of Odaray Glacier, and the bits of tree lichen on the bent trunk all contribute to the design and pattern harmony of the work. It is less wild, much more composed than the sketches. MacDonald the painter has captured the memory of the characteristic rain squalls of this area in all their driving spontaneity. On sunlit days, often with little warning, the clouds bounce from the south and west over Mount Biddle and send a sudden, sharp rain into the valley. The top-left to bottom-right corner direction of MacDonald's brushwork enhances this feeling, as the sun begins to return in the distance. In *Rain in the Mountains*, the freely responsive handling of the sketches is gone. Although it has little in common stylistically with his field sketches, it is captivating. The work has a different purpose: the sketches are conversation, the canvas is a speech. It is not raining on us, it is raining for us. It is a picture of mountain memories.

As with most of the studio canvases, there is no exact location from which to view the scene depicted in this work. It is, instead, a combination of two perspectives on the same vista: the lakeshore view, from the far southwest shore of Lake O'Hara, looking back toward Odaray; and looking the same direction, but from the Opabin Plateau 280 metres above. The interesting pattern of Odaray Glacier, a swirling smoky shape which also flows from the left side of the work to the right is a hazy form seen through the wet sky. The glacier's 1924 shape has lost the complete ring of ice that MacDonald depicts in the canvas, and this part of the picture has been the cause of some consternation. Even MacDonald's son Thoreau wanted him to repaint it to make it more readable, but MacDonald replied, "No, that's how it looked," and that is how it has stayed.

MacDonald's awareness of the glacier's presence, an indefinable feeling of cognizance for a large, ancient chunk of ice, is felt in this work. This feeling of awareness while in the vicinity of these amazing bodies of ice affects me personally more than any other aspect of mountain travel does. Although I have looked for an explanation for this feeling when I am near a glacier, I cannot seem to define it well.

Perhaps it is a combination of awe and dread, wonder at the strangeness of this frozen form, so dangerous, so primeval, so beautiful.

MacDonald, too, sensed this presence in the glaciers and mountains, the lakes and larches of Lake O'Hara. It is in his journals, it is in the strokes of his brush in the sketches. It speaks to us from his canvases and panels. MacDonald, for all his humble practicality, was an amazingly sensitive student of nature, a willing receptor for the spirituality of the woods. Lake O'Hara spoke to him in a compelling way that captured his full attention. If he had just wanted to paint mountain scenery, he could have gone to many other places, more readily accessible, such as Banff or Lake Louise, but he wanted more of what Lake O'Hara had to offer him, and so he was determined to return.

A GROWING OBSESSION – 1925

A beautiful day. Fine clear morning.
Later a few cirrus and in afternoon small
cumulus. The peaks all clear. Made sketch of
Goodsir in morning light. Mountains beautifully
clear and delicate in colour. Had lunch in
lee of big rock on Odaray Bench, the
snowflakes all round and a delightful warmth
and freshness, thought at height of <u>being</u>
and enjoyed everything completely.

—Journal Entry: Sunday, 30 August 1925

Mount Goodsir, Yoho Park, 1925
oil on canvas
Art Gallery of Ontario
(vantage point 17 on map)

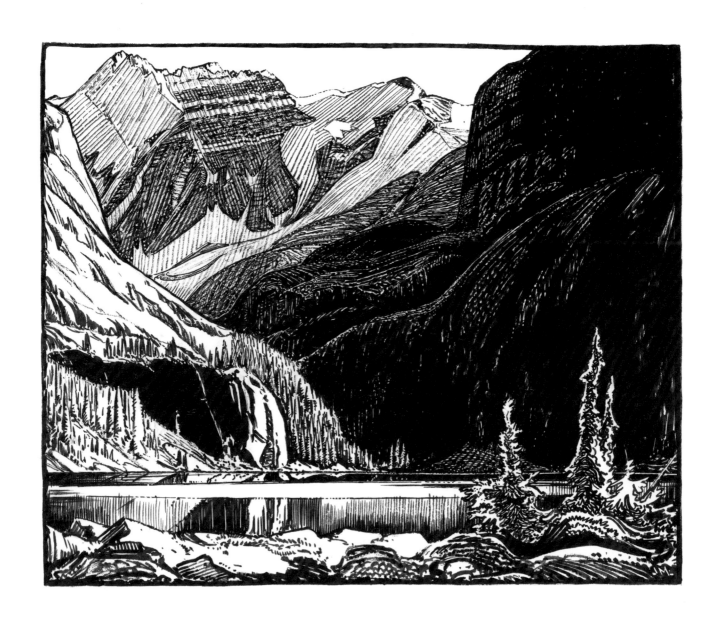

Lake O'Hara, 1925
pen and black ink with white gouache on wove paper
National Gallery of Canada
(vantage point 18 on map)

It is perhaps inevitable that the design work of J. E. H. MacDonald has always been overshadowed by his painting, but it should not be ignored. Not only was his graphic design of central importance to his career, but in other countries, where the role of graphic design in visual culture is more clearly recognized than in Canada, his stature as a designer would have long been firmly established.

—Robert Stacey in *J. E. H. MacDonald: Designer*, 1996

Upon MacDonald's return home in the autumn of 1924, his enthusiasm for Lake O'Hara spilled out into other aspects of his life. Family and friends were entertained with endless stories of the trip. Thoreau recalled his father's continuing obsession with Lake O'Hara after he returned home from each trip:

... after his journeys there his family was always prepared for a long course of mountain information. For weeks he would talk of little else but rocks, weather, marmots, rock-rabbits, bears, horses, and trees, all interspersed with the names of mountains, lakes and trails—Lefroy, Ringrose, Opaban [sic], McArthur, Otter-tail [sic]—while his listeners tried to stem the tide of mountain lore and get in a word of their own doings. [38]

In his commercial design work, MacDonald's projects began to show mountain imagery. The distinctive ridge lines of Cathedral Mountain and Wiwaxy Peaks became a recurring motif. Students at the Ontario College of Art were presented with a lecture on the trip, based on the manuscript for "A Glimpse of the West."

The 1925 exhibition organized and mounted by the Group of Seven was held at the Art Gallery of Toronto (now the Art Gallery of Ontario) in January of that year. It was their fourth show together, and the debut of MacDonald's Lake O'Hara works. He showed several works, including the canvases *Rain in the Mountains* and *Mount Goodsir, Yoho Park*, which hung alongside Rocky Mountain images by other Group artists such as Lawren Harris.

Although the artworks by Group members are now considered to be quite moderate, at the time they were first shown, the public reception to their work, in general, was anything but moderate. Their work was considered too modern by many. The Group used all this press to escalate the debate around their style and draw more attention to their art. It has been suggested that the artists included pen-and-ink drawings and prints in the 1925 show in an effort to quell the assumption that they were unskilled. [39]

MacDonald continued his exhibiting and teaching activities in Toronto throughout the spring and early summer of 1925, returning to Lake O'Hara in August. On this second trip, MacDonald knew exactly where he was going and what to expect there. He begins his travel journal shortly after the train leaves the station in Toronto and records the particulars of his trip, from travel companions to sights along the track, as he moves westward.

MacDonald had been given a pass for train travel to support his O'Hara trips by the Canadian Pacific Railway (CPR), a company well aware of the advertising potential of paintings of the Canadian Rockies. Often, painters were given passage in return for the use of their works in brochures and as advertising imagery, or canvases were specifically commissioned for hotels and railway stations.

The CPR was keenly aware of the role that attractive and enticing imagery played in luring tourists and settlers to its hotels and lodges. It was a relationship of mutual benefit: the company got a selection of imagery of the scenes along its tracks and near its accommodations, and the artists received passage to new sketching grounds. In the 1920s, John Murray Gibbon, the CPR's general tourist agent, was responsible for providing passes, and A. Y. Jackson, Fred Varley, Arthur Lismer, Lawren Harris, and J. E. H. MacDonald all took advantage of this opportunity. MacDonald was given free passage from Toronto to Lake O'Hara in 1924, 1925, and 1926, [40] and even had a private car for his first trip west in 1924. This extra luxury was not provided after that: **"No observation car on train this year. The company must have heard about that private car of mine last year. Somewhat cramping but so few people traveling that room and air are plenty indoors."** [41]

Of the works executed in the years in which these passes were provided, it seems that only MacDonald's painting *Morning, Lake O'Hara,* 1924 (p. 20), was actually used by the railway, perhaps as a result of A. Y. Jackson's complaint that MacDonald had been given three years' worth of passes and nothing he produced had ever been used. [42] It appeared in the 1928 CPR brochure "Resorts in the Canadian Pacific Rockies," entitled as *Lake O'Hara—Seen From the Bungalow Camp.* [43] More evocative than literal, this title was likely given to the work in order to enhance the appeal of going to the camp and fulfilling the CPR's agenda. Unless the title has been mistranscribed over the years, the sketch should be called *Lake O'Hara—Scene from the Bungalow Camp,* as Lake O'Hara cannot actually be seen from the alpine meadows where the Bungalow Camp was situated.

Despite the lack of a private car, MacDonald's travel continues in relative comfort

and in late August he finally reaches the mountains:

Journal Entry: 25 August 1925
Bow River west of Calgary. Tuesday afternoon, August 25. Fine afternoon. The valley green and fertile. Heavily wooded on rivers south side. Hills bare and rounded on north. The mountains lead in like architecture. At Banff, an owl who-ing in the dawn. Somebody's Big Ben ringing at 6. The millionaires friends are at station. The young son having his photo taken in a circus buckskin coat ... "Do you want it all top and bottom" says the big sister? "Oh I ain't particular about the bottom." A big fat lad about 19. The worst of things.
Mile 114. Very fine now and mountain views beyond Lake Louise. River had fine gravel and lines of water. Grey and grey green. Just below Stephen very big and snowy peaks. Trail crosses at Divide. Junction Hector. Very big back of Victoria and Lefroy. 1 mile from Stephen.
Mile 124. Trains from Wapta.

At this point, the writing ends as MacDonald obviously disembarks. The next entry we have is made at Lake O'Hara Camp. From that text, we find that MacDonald had to take a pack pony into Lake O'Hara Camp alone, again. For an unknown reason, MacDonald's first horse trip into Lake O'Hara the year before was also a solo adventure. Perhaps there were simply no other travellers or he fell behind the pack train and his absence went unnoticed. His sense of humour seems to have gotten him through it, as the events of the previous year replayed themselves. These two hilarious trips into O'Hara were as much a part of his vivid memories in the following years as were the lakes and peaks he painted while there. A humorous, delightful poem based on the two pack trips was illustrated and published by MacDonald's son Thoreau, in 1934, after J. E. H. had died. Titled *"My High Horse: A Mountain Memory,"* the poem is a tongue-in-cheek description of a non-horseman's misadventures with a typical pack horse who gets left behind by the rest of the pack train and then refuses to move, trying instead to remove his rider by using a tree. In his journal, he records a more narrative version of the trek:

Journal Entry: Wednesday afternoon, 26 August 1925
Arrived at O'Hara Camp about 5.30 leaving Wapta 1.30. Had a great time with horse. He didn't like traveling alone and I had to lead him most of way. About ½ way came across trail-makers' camp. Further on man with a 2 faced axe sympathized with me. "These bastards" he says "are wise. He ain't sick is he? Let me get on him." So he put down his axe and cut a switch while the horse watched him. Then he jumped on and "whipped him and lashed him and rode him through the mire" until I was sorry for the horse. Then he came swinging back and jumped off and said "Now you try him." I got on and tried him and with a start off from the axeman, I got away and kept him going pretty well for a mile or so when the influence weakened. The pony got worse ... But apparently he was practicing the wisdom of non-resistance and non-cooperation. Sometimes he would turn right off track and put me into an evergreen where I could not even get off him nor persuade him to move. At last I resigned myself to leading him home and was plodding up a hill with him when we came to a little tree fallen across the road. Here he stopped and as much as to say, "You're an intelligent dude from Toronto. How can you possibly expect any one to pass a barrier like this?" No persuading him to go round end. At last I got him over the higher end. Then other riders came along going to O'Hara. Sympathy and advice. When "Rabbit" saw the horses ahead that was all he needed and from there to camp he kept up with the leaders easily.

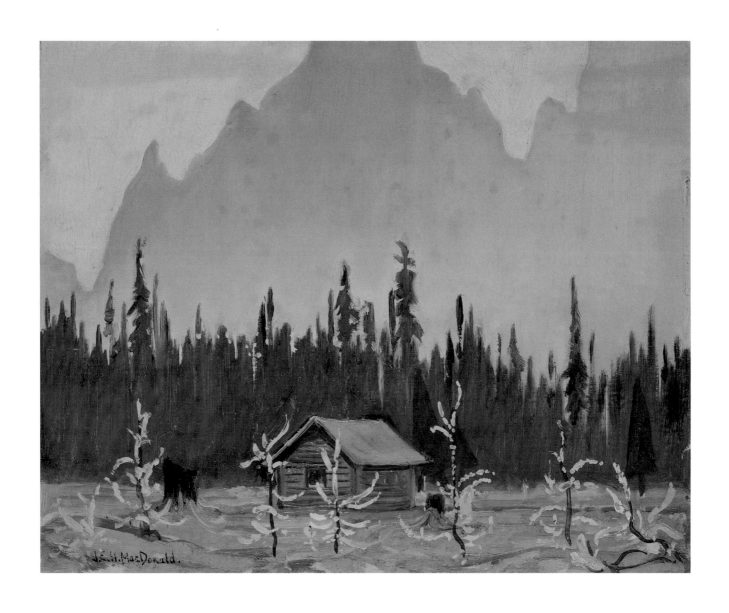

Rain, Wiwaxy Peaks, Lake O'Hara, 1924 or 1925
oil on cardboard
National Gallery of Canada
(vantage point 19 on map)

Snowing early turning to rain. Wood wet for fire. Camp life none too cheerful. Miss B. laid up ... English ladies departed and went off down trail in ordinary (English) low shoes. Tramping through the red Flanders mud thru all the downpour. They looked like a small army all walking abreast in their tightly belted dark blue waterproofs. How they'd got through the deep mud holes without going over the shoe tops I can't see. They were very reserved being a complete party in themselves, and we all regretted that they could not be got to join the family fireside. They seemed to be very fine people and I have no doubt had much to tell us all.

—Journal Entry: Thursday, 10 September 1925

Despite the trials of the trail in, the camp awaited him as it had the year before, watched over beneath the mountains in the alpine meadows. His charming scene *Rain, Wiwaxy Peaks, Lake O'Hara*, 1925, depicts one of the camp cabins below the distinctive ridge of one of Wiwaxy Peaks, an inviting shelter from the grey mist of the wet sky. The small larches in the foreground display their autumn colour, their branches flames of warmth against the purple-grey cold behind. This sketch depicts one of the outlying log cabins at Lake O'Hara Log Cabin Camp, built in the alpine meadows between 1911 and 1919, all of which were eventually moved to the lakeshore. It is not Wiwaxy Cabin or Elizabeth Parker Hut, as neither of these two remaining structures aligns properly with the silhouette of Wiwaxy Peaks from the angle that MacDonald has used to compose the scene.

The surface of this sketch has an interesting texture in that the raindrops MacDonald depicts are, in fact, raised daubs of paint, applied thickly and later painted over with the main grey pigment. This left raised dots across the surface of the work. MacDonald allowed himself room for this kind of experimentation while sketching at O'Hara, playing with compositional methods as well as with textural effects, as we see here. The end result is effective; the sketch's surface evokes both the reality of painting in the rain, that is, with droplets of water splashing and beading on the repellant surface of an oil sketch, and the reality of that particular day's weather: rainy.

First day sketching. Weather cold and mostly dull.
Some snow with bright intervals. Took lunch and went up
on Odaray Bench. Made sketch O'Hara in distance. Grand set-
ting but too cold to draw well. Fine composition higher up
with better foreground. Do later. Made sketch Goodsir
under cloud. Several good views of Goodsir patterns.

—Journal Entry: 26 or 27 August 1925

Knowing the lay of the land, MacDonald chose Odaray Bench as his first day's sketching destination. He begins to become engrossed in his work and, as often happens in a place removed from development, to lose track of the days. The sketch *Mount Goodsir from Odaray Bench Near Lake McArthur,* 1925, is a likely candidate for the work he refers to in this first-of-the-season sketching journal entry; his other trips to Odaray that season were plagued by heavy cloud. The composition he notes having seen higher up, and as having a better foreground, is perhaps the source of the canvas *Mount Goodsir, Yoho Park,* 1925, (p. 36), as the views match nicely. This larger-format canvas would have been completed in his studio in Toronto, as was *Rain in the Mountains* from 1924. It is a formal, careful canvas, clearly intended for exhibition, and as in *Rain in the Mountains,* design and pattern predominate, especially in the foreground rocks and the layered sky. In these two works, we can study the difference between sketch and canvas. In the canvas, the mountains have been smoothed and wiped clean, lacking the quick brushwork of the sketch. The forests are equally smoothed, running off the sides like rainwater. The smallish meadow in the foreground is bleached with sunlight, and the rocks are carefully outlined, one shade of green or orange defined by the next. The "idea" in the sketch is fully realized in the canvas. The foreground rocks are echoed in the cloud patterns of the masterfully handled sky. The vantage point in the larger canvas looks down on the spot where the smaller, preparatory sketch is set.

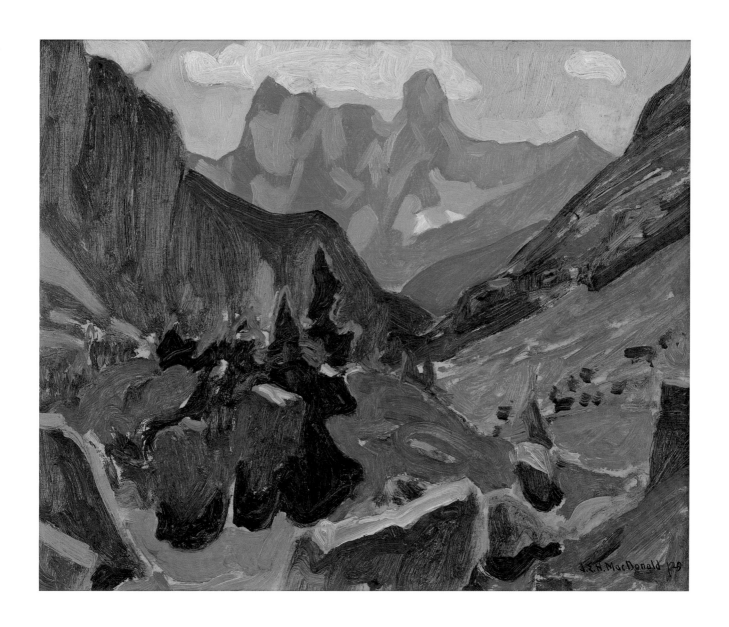

Mount Goodsir from Odaray Bench
Near Lake McArthur, 1925
oil on board
Private Collection
(vantage point 20 on map)

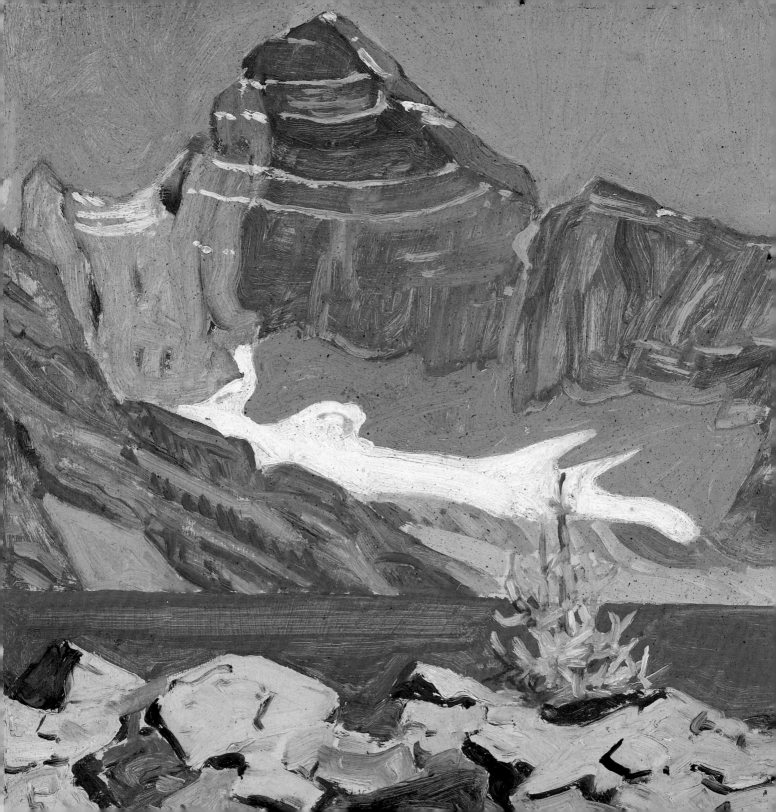

To McArthur Lake. Variable day very warm in morning with sun. Cold in afternoon. Found very rough section at McArthur chaotic and rocky. Wonderful sunset glow this evening, beginning with rosy light pink flame. Biddle on <u>fire</u> looking like furnace pot then into orange crimson with lower full of deep burning purple. Some peaks glint grey emphasizing color. Lefroy <u>eerie</u>. The passage into grey again very wonderful in the gleaming of the color.

—Journal Entry: Friday, 4 September 1925

As discussed earlier, it is often difficult to match historical images, more specifically, those more than fifty years old, to their corresponding places today because of forest growth and change. Trees block the view, forests encroach on lakeshores, shrubs fill avalanche slopes, old blow-downs and fire swaths decay and regrow. Where the landscape is mostly alpine, finding the location a painting depicts is much easier. This is the case with the sketches of Lake McArthur, as the landscape there is largely untreed, and despite the intervening years, little has changed in the compositional parameters of MacDonald's many sketches there. Here, in a remote and untreed amphitheatre, the artist would have had many vantages to choose from. For a practical painter such as MacDonald, the rocks are large enough to provide shelter, if needed, and flat enough to set up on easily, to sketch in pleasant weather. In *Lake McArthur*, 1925, he selects a view of the lake with a small larch, captured in a fleeting autumnal shade of green-becoming-yellow, in the foreground. We are looking directly across the lake toward the glacier that Mount Biddle supports. The mountain was named by Samuel Allen for Anthony Biddle, an author/publisher friend who was an extensive traveller and a member of the Royal Geographic Society. The peak rises prominently to 3,319 metres behind the lake, and the sketch is set about 60 metres back from the shore.

Lake McArthur, 1925
oil on cardboard
National Gallery of Canada
(vantage point 21 on map)

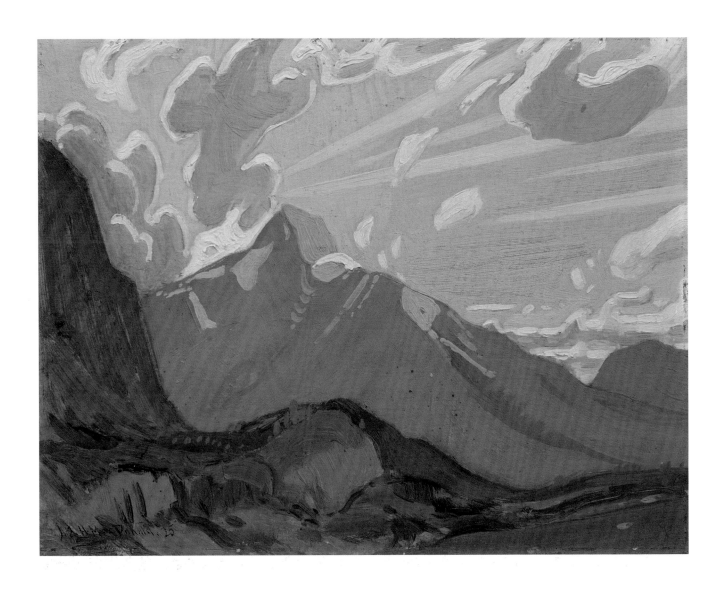

Valley From McArthur Lake, Rocky Mountains, 1925
oil on panel
McMichael Canadian Art Collection
(vantage point 22 on map)

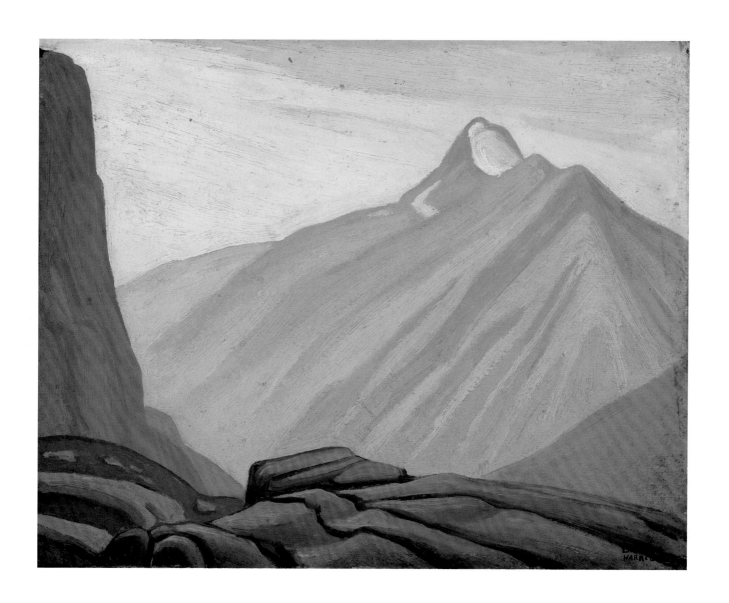

Lawren Harris
Mount Owen, undated
oil on panel
Private Collection
(vantage point 23 on map)

ART IS THE ORDERING OF THE MATERIAL

IN HARMONY WITH THE SPIRIT.

—J. E. H. MacDonald in MacDonald Papers
(lecture notes), 14 November 1930

FOR THE ARTS EPITOMIZE, INTENSIFY,

AND CLARIFY THE EXPERIENCE OF BEAUTY

FOR US AS NOTHING ELSE CAN.

—Lawren Harris in *Theosophy and Art*, 1933

FOR TWO OR THREE WEEKS, EARLY SEPTEMBER TO THE HEIGHT OF THE LARCHES' GOLD, MR. MACDONALD VISITED O'HARA. HE PAINTED LITTLE ELSE IN THE ROCKIES, ONLY SHERBROOKE LAKE ABOVE WAPTA TO THE BEST OF MY KNOWLEDGE, BUT O'HARA PROVIDED HIM WITH AS MUCH AS HE MIGHT NEED TO COMPEL HIS DYNAMIC SENSE OF COMPOSITION, THEMES OF ROCKY GRANDEUR, EXTRAVAGANT ATMOSPHERE, ELEMENTARY PRIMACY, 'TERRE SAUVAGE.'

—Jon Whyte in *Tommy and Lawrence: The Ways and the Trails of Lake O'Hara*, 1983

On one of his trips to or from Lake McArthur, MacDonald would have seen the distant peak of Mount Owen. With its smooth white snowfield shining in the distance, the peak lies to the northwest between Lake McArthur and Odaray Mountain. Although it is some distance away, it is an eye-catching peak, especially in the sun, as MacDonald has depicted it. *Valley From McArthur Lake, Rocky Mountains,* 1925, shows Mount Owen from the northwest edge of the McArthur Meadows, the open area on the edge of the Lake McArthur basin. The work is composed from the present-day trail junction, near the large cairn.

MacDonald's sketch shows the flank of Park Mountain on the left edge and a false peak of Mount Duchesnay on the right; Mount Owen is in the distant centre. In an interesting coincidence, MacDonald's fellow Group of Seven painter Lawren Harris, who would come to Lake O'Hara in 1926,[44] painted at this same spot, choosing the exact same peak as his subject and framing it in almost the exact same manner.[45] An examination and comparison of the resulting works is a compelling study of two painters approaching the same subject with completely different styles and completely different motivations. MacDonald's work is all design, Harris's is more theory. By comparing them, we can determine which features of the landscape appealed to each painter and how they are depicted in the paintings.

In his panel, MacDonald carefully notes the snow patterns and glacial shape on the mountain. Colours in the sketch match the actual colours of the scrubby plants and lichens on the exposed rocks. The rocky pattern of the foreground meadow is also accurate, and it would have appealed to his designer's eye. The sky, an interesting play of cloud and hazy green, hints at the skies that would appear in his studio canvases in subsequent years and is the primary focus of the work. Pattern and movement predominate in the picture. It is a painting about Nature.

In Harris's sketch, the focus is the space above the valley between Mount Owen and the flank of Park Mountain. The subject, therefore, is a place where nothing but air actually exists, an area of pure light and possibility. The rocky meadows have been smoothed and shaped into a more fluid, simple form, seeming to drop off into this nothingness. This is the place to stand and look out on the remote, soaring, spiritually loaded scene. The distant avalanche paths on the side of Mount Owen play counterpoint in parallel lines to the yellow and grey bands of light illuminating the sky. The flank of Park Mountain also shows on the left side of Harris's sketch, but his view is slightly turned to the right from that of MacDonald's, and Harris shows the edge of Odaray Mountain on the right. This serene work is an early example of the direction that Harris's mountainscapes would take, of his interest in theosophy, and of his personal, spiritual quest for enlightenment. In contrast to MacDonald's depiction of Nature, Harris has depicted the Ideal.

LAKE O'HARA LOG CABIN CAMP
HECTOR, B.C.

192 5

Wiwaxy Peaks, 1925
pencil on paper
Collection of Darryck & Inez Hesketh
(vantage point 24 on map)

IF YOU MUST HAVE THE GLORIES OF ROCKY
MOUNTAIN SCENERY PLUS SUCH TRAPPINGS OF
MODERN LUXURY AS MAGNIFICENT HOTELS,
ELABORATE MEALS, DANCE HALLS, GOLF COURSES,
AUTOMOBILES AND SWARMS OF VISITORS, GO TO
BANFF OR LOUISE. O'HARA'S APPEAL IS RATHER TO
THOSE WHO TAKE THEIR SCENERY STRAIGHT.

—Anonymous in *Bungalow Camps in the Canadian
Pacific Rockies*, 1927

Lake O'Hara Camp was in the business of tourism. Although the rustic backcountry facilities were billed as a simple and more adventurous alternative to the full-service, luxury hotels at Banff and Lake Louise, the camp had a certain simple charm and rustic ambience that come across clearly in MacDonald's journals. It was not without luxuries though: cooks prepared freshly caught rainbow trout, stationery was provided, mail came and went every few days. Meals were served communal style, everyone eating and talking together. Taffy was pulled in the kitchen, guides and their guests came and went. Later, the evening revolved around the hearth, where those not too tired would gather and share stories of the day's hikes and climbs, welcome new guests, and tell tales:

"American lady talked a good deal ... mostly about theatre, music etc. 'What does a Canadian look like?' Had supper with the kids. Lorna and her fancy cuffs. Her riding. Branding steers, etc. Not branded too young or brand grows as they grow and gets like a fence ad. Jack Frost and his ways. His fancy bridle with Mexican dollar ornaments ... The Englishman and his hot water bottle extra large."[46]

The pencil drawing on a piece of Lake O'Hara Camp paper is a charming memento of MacDonald's 1925 stay there. The quickly drawn silhouette of one of the Wiwaxy Peaks above a forest is very spare, nothing more than a doodle really. Its charm lies in its simplicity and the paper on which it is done. The face of the peak is softly shaded, indicating rain or misty wet weather. The forest below, also executed in a rapid fashion, is an example of MacDonald the designer at work in a manner that must have been, at this time in his career, second nature to him. The forest forms a perfect footer for the piece of paper, a border of wet and dense trees. The letter evokes the image of MacDonald the family man, writing home of his Lake O'Hara adventures. We know that mail had come into the Log Cabin Camp on 9 September 1925, as he had received a letter from his son, Thoreau, that day.[47] The crease mark across the centre of this drawing indicates that it was folded in half, perhaps for inclusion in an 11 September 1925 reply.

In late September of 1925, an exhibition of MacDonald's work opened at Hart House, the University of Toronto, in The Sketch Room. A canvas titled *Lake MacArthur* [sic] was shown and described as *a rather startling representation of an emerald mountain lake above which white snowfields are poised.*[48] It was well received, called *bold and eminently pleasing.*[49] The other works, apparently all sketches, were also lauded as *faithful representations of mountain landscape [which] ... ring true ...*[50] MacDonald gave a talk to accompany the exhibition and the next month, at a meeting of The Sketch Club, read from "A Glimpse of the West," which had by this time been published by *The Canadian Bookman*. A review of this reading appeared in the same university journal a few weeks later. It, too, was well received and MacDonald's *memoirs and intimate glimpses of nature with the background of his mountain sketches made the mountains very realistic to his audience.*[51]

FROM THE JOURNALS

MacDonald's mountain journals are a glimpse into the past. Informal and charming, insightful and poetic, they draw us a picture of life in the Bungalow Camp, documenting everything from MacDonald's sketching endeavours, to the nuances of the weather, to the comings and goings of other guests, all in much detail. They are, in and of themselves, fascinating artifacts. As is often characteristic of travel diaries, they are recorded in a haphazard fashion. MacDonald's travel budget, addresses of people he meets and determines to correspond with, notes on other topics, and reminders of things he must attend to in the future sporadically interrupt the Lake O'Hara text. Thumbnail-sized pencil drawings—sometimes ideas for larger canvases, sometimes depictions of animals and birds—illustrate the text. The books themselves are over seventy-five years old, and by virtue of being written in the mountains while painting, they are, here and there, soiled and weather beaten. They are written in ink in MacDonald's distinctive and flourishing longhand, using a personally invented shorthand that is sometimes difficult to decipher. In one diary, he wrote only on the right-hand page, then, upon reaching the end of the notebook, flipped it over and wrote on the now reversed right-hand page, going backward. All of this makes them very difficult to read, and in some places, they are simply illegible. Pages are missing, sometimes entire sections are gone, diagrams and doodles appear. The 1925 and 1930 journals are the most fluid, and the easiest to read and make sense of. A comprehensive and lengthy selection of the 1925 diary is transcribed here to give the reader a feel for life in the Bungalow Camp and for the style of MacDonald's journal writing.

Note: The diary text contains references to people who are now a part of the history of Lake O'Hara and were from MacDonald's circle. "Miss B." is Sylvia Brewster (later, Mrs. Sid Graves), who managed the camp/lodge from 1925–51. "H. D. T." refers to Henry David Thoreau. John Muir, transcendental poet and the father of wilderness protection in the United States, is also mentioned. "Ernest" is Ernest Feuz, one of the Swiss Guides; the "Hibberts" are Mr. and Mrs. Aldro Hibbard, he a prominent landscape painter from Massachusetts. Lorna is an important staff member, perhaps the cook; other guests (Liasy and Hume Wray) and staff and guides are referred to. The "little walking stones" are ptarmigan chicks. "Parnassian sprigs" refers to Grass-of-Parnassus, a distinctive alpine wildflower. "Haymakers," "rock rabbits," and "mountain hares" are pika.

Friday, 28 August 1925

Snow and hail with clearing intervals—but practically no sun. Went to O'Hara and made sketch showing Alpine Club camp at foot of Huber. In afternoon to Odaray Bench very cold but lit fire and kept comfortable. A little snow fall. Very wintry and cold windy weather. Had to find tree or rock shelter to work. Saw fine view down McArthur Valley. Rock Ptarmigan and little walking stones. I could kneel down and look right into their eyes within 8 ft. easily. Their cozy camp interesting the way they sheltered from wind behind little ledges etc., sitting just like chickens. Color protection wonderful. Grey green body mottled with black in male. Female not so delicately mottled, more splotchy.

Sunday, 30 August 1925

Sketched Lefroy and Peaks in afternoon with O'Hara and rocky foreground. Endless variety of subjects here. The little haymakers busy and more marmots out. Saw one of the haymaker's "barns" under a

projecting rock, the flowers and flower stems and grasses laid in a sheaf. Many were green and some of the flowers in downy seed. Nearby was a lot of old hay, perhaps last year's, seemingly not to be used. These little animals very attractive. There is a little rat-like sort of chipmunk. Runs with a long thin tail held high. Many birds, somewhat like sparrow, the white tail feathers showing similarly in flight. A bird singing often in mornings but have not seen it yet. Miss B. gone to Banff. Girls and Ernest and I all that remain in camp. They are making taffy in kitchen and acting as usual in taffy making. Englishmen have been here ordering hot water and cleaned boots, and getting quietly snubbed by the mountaineer Canadians. They bring their little island with them wherever they go. They had come over Abbott's [sic] Pass without a guide, and were properly set up. This was a perfect mountain day. There is such a grandeur about the landscape, and such an unusual character that one easily pictures it as the setting of a future state. No golden streets but silver peaks. Parnassian sprigs in plenty and alpine meadows for the easy going angels. The little mountain hares may be perhaps considered as the souls of farmers, or an unborn peasantry.

Monday, 31 August 1925

Another grand John Muir Day. One when John would have ranged the heights with his soul in rapture. Bigger clouds than yesterday, and now (evening) comes a little shower on the roof. Sketched at O'Hara this morning effect, delicacy the idea, the clear but delicate light tones of the mountains in shadow, the lake color absolutely unapproachable. "I don't believe nobody can do it." In afternoon made sketch of Cathedral with stream in foreground, and after supper, a small sketch of orange clouds and grey peaks. Made sketch in early morning, (7 o'clock) of Lefroy with bicolour shadow lines from peak in sky ... Lady arrived with an eccentric guide. Had thought him drunk on the trail and was mighty scairt ... She sent him back with the horse and decided to change partners. A similarly simple, sweet and attractive person. Apparently a Southerner. Full of innocent inquiries about snakes and crevasses etc., and a great ambition to climb but afraid. (Heavy scattered drops on roof now.) Lit fire this evening. Shaved and washed socks and got panels ready for morning. Two elderly English people arrived and walked up to McArthur after supper. They have just got in after stopping for directions from the mountain side. A party of five arrived over Ophabin [sic] pass. Without guides. Had walked from Valley of Ten Peaks and started 9 o'clock this morning. Ten hours steady going. The physical endurance of people is surprising here. Slight looking young girls going over these mountains like goats. (O to do likewise) And tomorrow they are off again over Abbots [sic] Pass.

Tuesday, 1 September 1925

"Jack Frost, he's full of hot air."—Ethel's description of the talkative guide and Jack Frost. Heavy rains to-day with some clear intervals. Slight change of wind in afternoon to east from west. Sketched O'Hara in morning and also in afternoon the latter Mt. Biddle and part of Hungabee and Yukeness [sic]. Water occasionally still and then color very fine especially when looked down on from a little rise. Made small sketch before breakfast and also after supper of Cathedral from different viewpoints. Toronto party here last night. Smith and Mr. and Mrs. Hume Wray and Miss Wray of Varsity. Moonlight very fine tonight. Made one feel like H. D. T. and stay up all night roaming the mountains, but was too ready for bed after the day's work.

Friday, 4 September 1925

Went to O'Hara to go along north shore. Noticed stump of tree which was laid to cross stream. Counted rings, approx. 220. Distance from centre to outside exactly height of this page. I call it <u>Queen Anne's Bridge</u>. Found a trail running up mountain and went up a way and made sketch. Coming home ran into party of sketchers, a regular art school three ladies all doing O'Hara. Found at camp that they were English, very English, long dresses, square shouldered coats. Nana with monocle etc. Have become unpopular with the indifferent mountaineers in our kitchen. ... Walked up from Wapta, had tea on arrival "shirred" eggs potatoes, etc. Came in about eight for dinner. Complaints about smell of wood in cabin etc. Wanted breakfast at seven, but refused, etc., etc., as staff would not be up. Spent evening in harmless mirth with Hibberts and Liasy round fire.

Saturday, 5 September 1925

To McArthur in snows ... on way back flushed family of ptarmigan which were sheltered from cold wind. They flew out and settled in rocks in open. Very tame. I leaned on rock within two feet of pair and watched them until they got tired of cold wind and flew back to shelter. The winter feathers beginning to show so that they look like little grey stones partly snowed up. Outer tail feathers and wing feathers show while in flight. Got home alright but realized something of baffled fooling around by loss of familiar peaks. Talked with Hibberts [sic] in evening and read some western verse. A hoe down party in kitchen, dancing so hilariously that they fell through dining room door.

Sunday, 6 September 1925

Snowed some during night. Some moments of clearing in forenoon. Made sketch at O'Hara in morning. Slowed up in working by antics of little mouse like animal working round my feet, a sort of vole or water mole. He moved freely through water not swimming apparently but darting along in shallows and in and out among rocks sniffing them all over. Very rapid in moments. At that I could get clear look at him. Seemed to have a sort of short nose, grey colour, white underneath, pink tail. Some little birds on walk as well. Light brown sandy color and slight bobbing movement of tail. Eagle overhead and also flying over McArthur direction. Made sketch near camp in afternoon. Mountains fine with snow. After supper grand color on peaks.

Monday, 7 September 1925

Frost during night. Small pond near camp with wide edging of ice. Peaks all brilliant with snow. Went up towards Goodsir view but found mountain hidden by clouds forming from morning sun. Clouds over Lefroy keeping all on far side and just rising over crest, always keeping at same level apparently by breeze blowing over from west side. Sketched near Odaray. Many marmots out. Some very tame allowing me to walk and stand within twenty feet and showing no sign of fear. Sketched near camp in afternoon. View of Hungabee and Biddle.

Pack train of bales of hay arrived in afternoon carrying among other things a box containing cat and seven kittens for war on the mice. Great doings among girls in kitchen after supper with kits crowding all over floor. Old cat caught mouse and there was a brawling like a zoo at feeding time. "Howcat to gosh!" by Lorna with all her riding and manly costume of bucks, sweater etc., had to retire to dining room and look through peep hole in door imploring Ernst to kill the mouse or take it away from cat. Wonderful clear night of stars. Milky way and all so distinct in deep blue. Jupiter seen just over shoulder of Mt. Schäffer. The Dipper with a fine tilt on. Almost uncannily clear.

Tuesday, 8 September 1925

Fine morning clearness of night continues. Went to
McArthur with Liasy a young Cleveland man. No blue
haze in McArthur valley at all. Mountains all alike in
distance. A peculiar grey mousy color. Sketched at
McArthur for composition. Wind began to blow
strong and cold. Many marmots out. Some half
grown. A rock rabbit unusually tame. Came sniffing up
to me within five feet on the trail. Very like guinea-pig
in form. Color grey rabbity with buff colored legs.
Toes of feet widely separated.

Wednesday, 9 September 1925

Heavy rain all day, but at one clearing interval English
ladies started out valiantly to McArthur. Lorna gave
them no blessing, hoped they'd stick. Much talk
around fireside books art etc. Showed Hibberts my
sketches. Well approved. Rain all night.

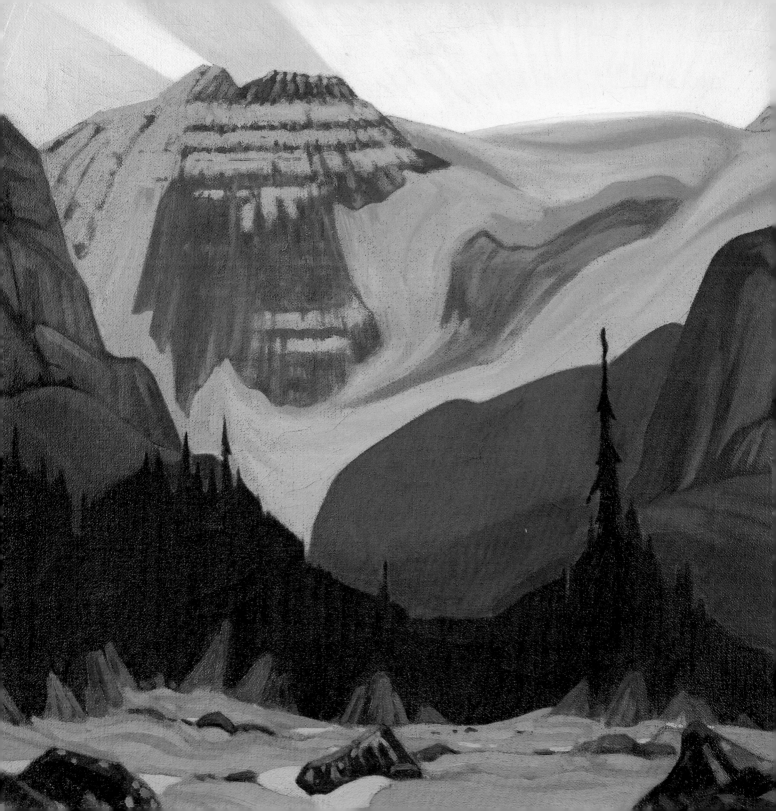

POETRY AND PAINTING – 1926

LAKE O'HARA

I would away
Away to O'Hara
By the peaks lifted
Holier than Tara
Shading the prairie
Through the cleft mountains
I would be kneeling
By her green fountains

There are the rainbows
born for all dreaming
There shouts the soul
With cataracts streaming

Lovely the morning
Lifts her tiara
Over the snow crests
Lighting O'Hara

Far do you call me
Heavenly mountains
Lead my soul wandering
By your green fountains

—Journal Entry: 19 March 1927

Early Morning, Rocky Mountains, 1926
oil on canvas
Art Gallery of Ontario
(vantage point 25 on map)

CERTAINLY THE FINE FRENZY OF THE POETIC EYE NEED NOT BLIND THE POET TO PAINTING, AND THE CONCENTRATION OF THE PAINTER ON PALETTE AND FORM NEED NOT STOP HIS EARS TO THE BEAUTY OF VERSE.

— J. E. H. MacDonald in *Poetry and Painting* lecture notes, 1929

In the months between his 1925 and 1926 Lake O'Hara trips, J. E. H. MacDonald exhibited often. His work and that of other members of the Group were included in the *First Pan-American Exhibition of Oil Paintings* in Los Angeles. He also continued with his design work and with his teaching duties at the Ontario College of Art.

International critical success followed the participation of MacDonald and his fellow members of the Group of Seven in the important *Wembley Exhibition*, part of the 1925 *British Empire Exhibition*. This success was a great boon to MacDonald and the other members of the Group. His finances improved, and he was able to move his family back to the Thornhill house. Another showing devoted to the work from Lake O'Hara was held in November at the Arts and Letters Club. His finances improved so much that he purchased another residence for the summer months in Toronto. On 23 August, with his usual signatory flourish, he signed himself into the Guest Registry at the newly built Lake O'Hara Lodge, where he was assigned to room number nine.[52] The spacious lodge, with private rooms, a dining room, and comfortable and sheltered verandahs, was a marked changed from the Log Cabin Camp. Two weeks later, on 6 September, his wife, Joan, joined him and they moved to room number four.[53]

It appears that MacDonald sketched less in 1926 than he did in other years at O'Hara. Perhaps, as his wife's presence indicates, that year's trip was taken more as a holiday than a working trip. The sketches dated 1926 are a mere handful;[54] subsequently, canvases based on these are scant. There are, however, many undated sketches, some perhaps from 1926. More likely, though, MacDonald sketched less because he was writing more. His lengthy 1926/27 journal is comprised almost entirely of poems in progress. Observations become ideas, these ideas are worked into stanzas, and the stanzas are worked into lyric verse, which MacDonald loved. Segments are worked and reworked. Sometimes a complete poem appears. The journal entries continue after the O'Hara trip is over and he has returned to Toronto. There, he continues to work through the same poetic mountain themes, playing with words and ideas. The journal goes into 1927, with the last dated entry being July of that year.

In October of 1929, MacDonald gave a lecture to his fellow Arts and Letters Club members on the topic of "Poetry and Painting." Much of his philosophy and practical approach to art is made apparent through it: *Painting is the successful communication to others, through the medium of form and colour, of a worthy or idealized experience in the world of form and colour. Poetry, we might define, as the successful communication through spoken or written words, intensively or rhythmically arranged, of a passionate experience.*[55] MacDonald believed that poetry and painting were two shared aspects of expression, feeling that *... so closely are the arts related that the medium of one becomes the metaphor of the other ...*[56] and that, together with music, these three forms of expression were the ultimate artistic feat of humanity. He sought, in his own work, to use aspects of each muse to enrich the other: poetry's brevity enhanced a sketch, painting's requirement of selective observation enhanced poetry. Poetic painting and painterly poetry were the goal. He felt these to be arts that went hand in hand: *My impression of the Muses is that they were a united family. They were the daughters of God and Memory. They lived in mountain sunshine and had no jealousies of each other's work. ... I fancy Painting as a sturdier damsel than Poetry, Painting has its material intrusions. Perhaps Poetry's fine senses are offended by the smell. She prefers to sit with her harp by the lilac bush while her*

practical sister is painting the kitchen chairs on the lawn, though she also has an eye for the birds and clouds and sun changes as she works.[57]

MacDonald found Lake O'Hara as conducive to writing poetry as it was to painting. His first entry in the 1926 journal is made looking out across the water at Lake O'Hara, where he pens a painterly description of Mount Victoria at sunset. Almost illegible, the phrases "Victoria at Sunset, Sky, delicate purple and later blue grey" with "the value of the bush darker than mountains beyond, but Victoria lighter in tone than O'Hara ..."[58] are written in stanzas, words are crossed out, and other suggestions for words, mostly illegible, line the margins. It is unclear whether the text is the description of a potential sketch or canvas, or a poem in its infancy of ideas and words. The boundary between the two is often vague.

These insightful poems from 1926 are most often concerned with aspects of nature: cloud patterns, raindrops, sunlight, thunder, the golden colour of larches and wheat. There are poems about the animals of O'Hara: dippers, marmots, and pikas. There is little of the play-by-play description of his hiking and sketching that we have from other years. Entries begin with phrases such as "Thursday, September 9th, 1926. At McArthur, all in snow"[59] and then a poem begins. Some of the entries in this journal were reworked and included in a book of verse published by Thoreau MacDonald after his father's death. Titled *West By East and Other Poems by J. E. H. MacDonald* and published by Ryerson Press, it was illustrated and designed by Thoreau MacDonald in 1933.

It is evident that, in 1926, MacDonald has achieved a greater degree of serenity in the mountains, is less overwhelmed by their stature and physical magnificence, is less concerned about his hiking time to Lake Oesa, no longer compares his efforts with those of the other lodge guests. The influence of guides and packers and climbers has dwindled, the "inner man" is under control, in fact, quite in his element. He sees the mountains during this trip as less a compositional problem to be tackled and more a source of philosophical nutriment. The poet has taken over.

This mountain side bears
The heart of the earth
Beating in aeons
From its far birth
Pulse of the strata
Throb of the rock
Twisted in raiment
Effort a shock

—Journal Entry: 1926

The mountains are the heart of earth
It beats in accord
Looking at the mountains we see
the hidden heart of earth
We see her thoughts. We feel her
pulse beating to a slow aeon of change.

—Journal Entry: 1926

61

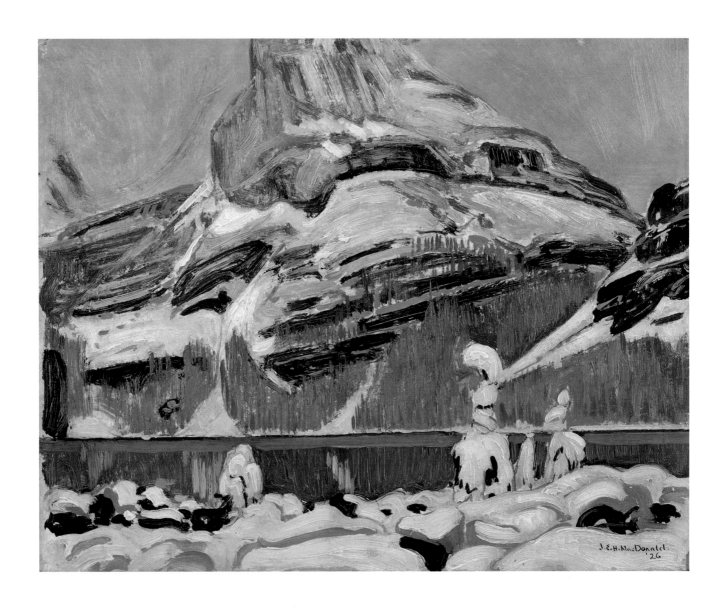

Snow, Lake O'Hara, 1926
oil on board
McMichael Canadian Art Collection
(vantage point 26 on map)

LOCATED NEAR TIMBERLINE, THIS LARGE, ASTONISH-

INGLY BLUE LAKE FRAMED BY MOUNTAIN AND

GLACIER IS THE CLIMAX OF A MEMORABLE HIKE.

—Don Beers in *The Wonder of Yoho*, 1989

Snow, Lake O'Hara, 1926, depicts a day of fresh autumn snow looking out toward Yukness Mountain. The waters of Lake O'Hara are utterly still, painted in a deep, glassy black, a sharp contrast to the brighter, snow-covered near shore. The wintry sky has blocked Mount Lefroy from view; the day is motionless and wet. MacDonald has focused our attention on the lake and near shore by cutting off the top of Yukness Mountain, running it off the top edge of the panel. This sheer and dominating peak, named using the Stoney word for sharpened, has been reduced to pattern in the sketch.

Early Morning, Rocky Mountains, 1926, was painted in the winter months after the 1925 trip and exhibited a number of times in the following years. Looking across Lake O'Hara from the shoreline in front of the present-day warden's cabin, the scene is a soft swirl of mountain and snow, rock and forest. Mount Lefroy and her glaciers have been smoothed and pressed flat; the rays of light coming from the top left corner of the canvas emphasize the peak. The rough rock on the distant shore has also been polished smooth, one rock face falling cleanly against the next. The height of the forest has been greatly exaggerated, but is roughly true in place-ment. The surface of Lake O'Hara is stirred and choppy, with water slapping up against the protruding rocks.

Morning, Lake O'Hara, 1926 (cover image, vantage point 1 on map), is a sunlit depiction of a perfect mountain dawn. The brilliant light has already reached us on the near shore, breaking over the edge of Glacier Peak in the east (centre top of the canvas) and beginning to lighten the colour of the lake waters below. The air is clear and free from haze; the purple blue of the mountain's face is echoed in the shadows on the glaciers. The canvas is a wonderful contrast of delicacy and strength: the bold design patterns of the tree boughs, the shape of the distant forest, and the neat division of the space within the picture all play against the softened colour tones, the long autumn shad-ows dancing on the forest floor, and the bright thread of white on the uppermost portions of the glacier. The needles of the pines nearest us are in shadow, those on the opposite side are in brilliant morning sun. Composition furthers the contrast: the mountains roll and dip, the lake is a flat, linear sheet. With its stained-glass appeal and inviting mood, the work is one of MacDonald's finest mountain canvases.

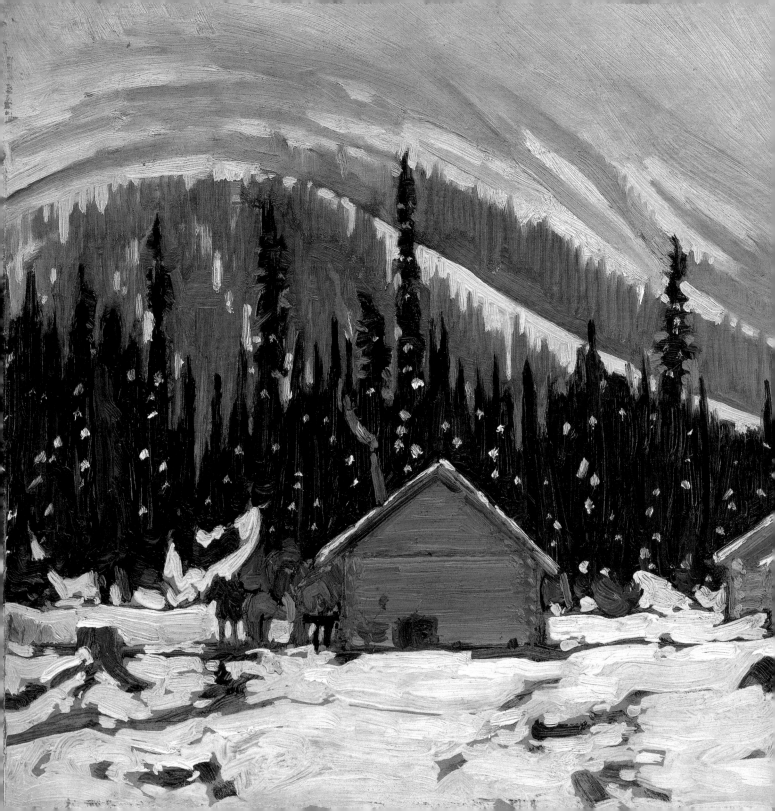

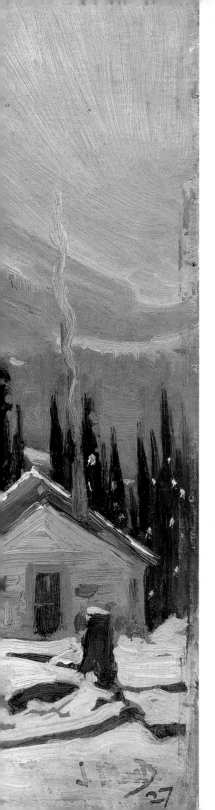

SKETCHING: THE FIRST OUTDOOR SPORT – 1927

THE FUNCTION OF PAINTING IS TO RECORD, TO RECALL,

AND TO INSTRUCT—AN IDEAL WORK COMBINES ALL THESE

QUALITIES, BUT GOOD SKETCHING MAY HAVE ONLY ONE.

IF YOUR SKETCH IS A GOOD RECORD ONLY, IT IS WORTHWHILE.

IF IT IS A GOOD RECORD OF SUCH A NATURE THAT IT HAS A

POWER WITHIN IT OF WIDE ASSOCIATION FOR MANY PEOPLE,

SO MUCH THE BETTER, IF IN ADDITION TO THIS IT CAN

INSTRUCT THROUGH GREATNESS OF THEME OR TREATMENT

IT HAS COMPLETED THE SPELLING OF THE WORD ART:

ASSOCIATION, RECORD, TRUTH.

— J. E. H. MacDonald in *MacDonald Papers*, undated

Snow, Lake O'Hara, 1927
Alternately titled *Snow, Lake O'Hara Camp*
oil on board
McMichael Canadian Art Collection
(vantage point 27 on map)

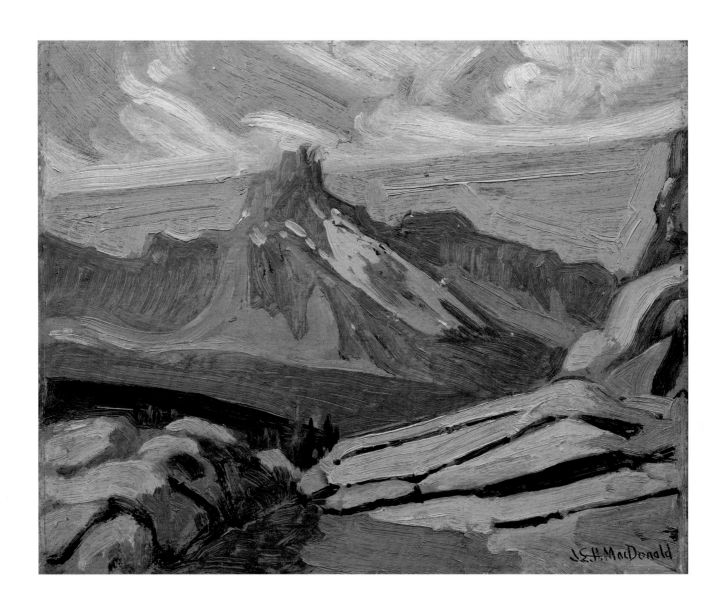

Cathedral Mountain, 1927
painting on board
McMichael Canadian Art Collection
(vantage point 28 on map)

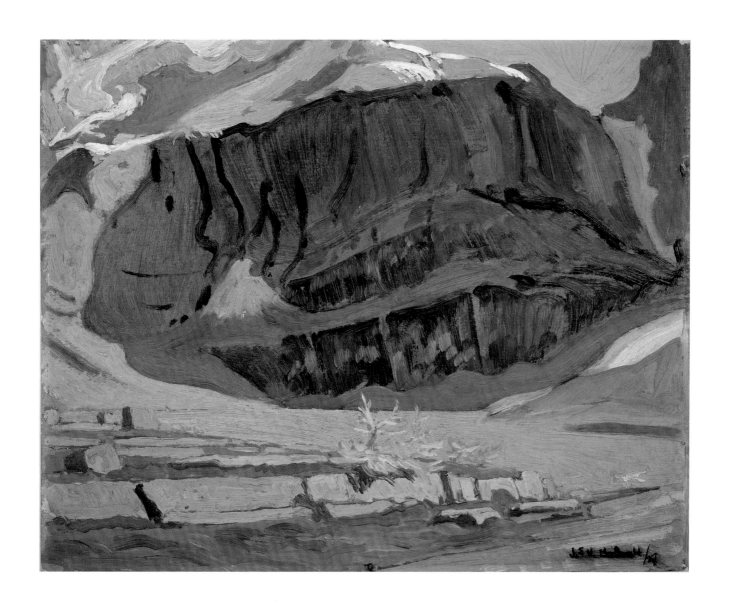

Lake Oesa, 1927
oil on canvas
Whyte Museum of the Canadian Rockies
(vantage point 29 on map)

THE FINE ART OF DESIGN

MacDonald had several opportunities to revisit the theme of the mountains in his design work in the months between his 1926 and 1927 Lake O'Hara visits. Referencing photographs, he contributed seven pen-and-ink drawings of beauty spots in Jasper National Park and at Mount Robson to a brochure produced by the Canadian National Railway (CNR).[60] These drawings depict Mount Kerkeslin, Jacques Lake, Shovel Pass, the Astoria River, Mount Tekarra, Pyramid Mountain, and Medicine Lake. He also designed the end papers for *Lord of the Silver Dragon*, by Laura Salverson (Toronto: McClelland and Stewart, 1927), using a peak that clearly has Cathedral Mountain as its source. Some particularly notable design projects were completed that winter. He illuminated and hand-lettered a souvenir book created by members of the Arts and Letters Club and given to Vincent Massey upon his appointment as Canadian High Commissioner to the United States. He designed the cover of the CNR's Diamond Jubilee dining-car menu; he had designed the borders for its commemorative publication earlier that year. He also won a Royal Canadian Mint competition with two designs, based on eastern scenes, for five- and twenty-five-cent coins. Regrettably, the coins were not struck. A charming Christmas card was issued later that year (not illustrated), depicting an enticing, snow-covered log cabin backed by the simple, yet distinct lines of the Wiwaxy Peaks. The welcoming plume of smoke and delightful snowflake patterns are enchanting. The card was issued as part of the Rous & Mann publishing company's beautifully printed Canadian Artist Card Series, 1922–1932.[61]

In the spring of 1927, MacDonald was appointed head of the Department of Graphic and Commercial Art at the Ontario College of Art, a significant addition to his already demanding responsibilities. Once again, between design commissions, teaching and lecturing, exhibiting, family responsibilities, and continuing his duties at the Arts and Letters Club, that year few mountain canvases were produced.

Despite his new duties, MacDonald was still able to take his Lake O'Hara trip that fall, and on 26 August he settled into cabin number one along the shore of Lake O'Hara. Banff painter Peter Whyte also visited O'Hara that fall, arriving on 10 September. MacDonald and Whyte would develop a sketching friendship, climbing the valleys together to paint and sharing an interest in detail over panorama, pattern and form over commanding peak.

MORE THAN MOST ARTISTS, MACDONALD WAS A MAN OF VARIED TALENTS; AND MORE THAN MOST MEN, HE WAS THE PERENNIAL STUDENT.

—William Colgate in *Canadian Art: Its Origin and Development,* 1943

When sketching *Cathedral Mountain,* 1927, MacDonald would have been up on the Opabin Plateau, looking across Lake O'Hara, which lies almost 250 metres below. This was one of his haunts, where he painted, explored, composed poetry, shared tea, and wrote in his journals. MacDonald explored a great deal in this verdant hanging valley; the short but steep hike up from the lakeshore put him in a region of ample contrast and variety. Regardless of the day's weather and light, he found endless subjects to sketch here. Detailed, close-in views of rocks, such as *Lichen Covered Shale Slabs* from 1930, to wide-open views back toward Cathedral Mountain and over Lake O'Hara to Odaray Mountain could be found within a short hike on the plateau and are repeated themes in his Lake O'Hara sketches. From this elevation, the view is expansive. Cathedral Mountain is less towering, the base appears much more spread out, and the peak is shortened, less soaring, as we see in the sketch. The rocky foreground, with a small larch showing, is a reminder that MacDonald sat down, most often in the shelter of rocks, to work.

THE GREY QUARTZITE LAY IN SLABS BEFORE US, LEVEL AS A FLOOR AND POLISHED BY ANCIENT ICE. FROM THE GROOVES AND CRACKS OF THIS ANCIENT PAVEMENT GREW LONG GRASS, AS IN THE STREETS OF SOME DESERTED CITY. AS WE STEPPED UPON ITS SURFACE OUR HOT FACES WERE COOLED BY A WHIFF FROM THE ICE-FIELDS, AND BEFORE US, THE GREY PAVEMENT GENTLY SLOPING TO MEET IT, LAY A PLACID LAKE, A DARK BLUE CIRCLE OF ABOUT A HALF A MILE IN DIAMETER.

—Samuel Allen in *The Alpine Journal,* 1886

Lake Oesa, 1927, is painted from the rocky shoreline of Lake Oesa. The distance of the work is all cliff, mostly in shadow. In the foreground, the yellow larches provide a sense of depth, and the shadows behind the small rock erratics imply bright sunlight above, readable in the bright white snow atop the bluffs.

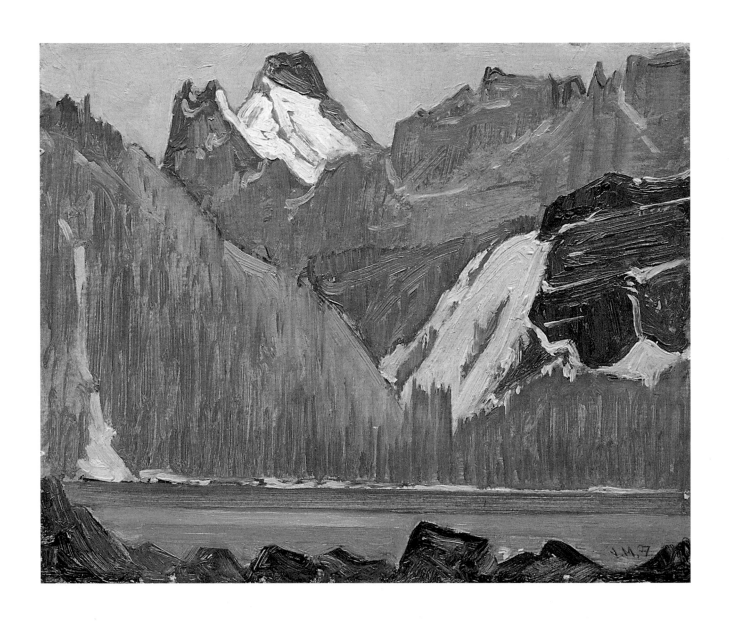

Lake O'Hara, 1927
oil on cardboard
Vancouver Art Gallery
(vantage point 30 on map)

MY BIAS IS THAT THERE IS SOMETHING INHERENT
IN PEOPLE THAT MAKES THEM FEEL BETTER AND
MORE CENTERED IN THE MOUNTAINS THAN IN
OTHER PLACES. THERE ARE DEFINITELY MOUNTAIN
PEOPLE AND OCEAN PEOPLE, AND BOTH THOSE
ENVIRONMENTS PROVOKE AN APPRECIATION OF
NATURAL FORCES AT WORK AND AN ENERGY MORE
IMPORTANT THAN HUMAN POWER, AND A SENSE OF
OUR PROPER PLACE IN THE WORLD. I'VE COME TO
UNDERSTAND THAT THERE'S AN INTERACTION
BETWEEN PEOPLE AND ENVIRONMENTS THAT
CHANGES US, AND I SUPPOSE IT ALSO CHANGES
THE ENVIRONMENT. WHICH IS THE ACTOR AND
WHICH IS THE REACTOR IS NOT ALWAYS CLEAR.

—Peter Hackett in *The Power of Place*, 1993

The composition that MacDonald has used in the sketch *Lake O'Hara*, 1927, is one of the more astonishing and remarkable vistas at Lake O'Hara. In MacDonald's painting, we are looking out across a turquoise band of Lake O'Hara's water toward the Opabin Plateau from the Adeline Link Circuit, about one quarter of the way around the lake heading southeast. Here, the looming shapes of Mounts Schäffer and Biddle, distant over the water and high above you, seem to move and shift against one another like a changing stage-set backdrop. In the painting, the lower edge of Yukness Mountain is on the left, the promontory of Opabin Plateau, darker and on the right, and above, the combined ridges of Mount Schäffer and the uppermost peak of Mount Biddle appear stacked upon one another. These two mountains, Schäffer and Biddle, often blend together in a way that makes them appear to be one peak. Although composed of entirely different rock and quite different in shape, they have weathered to a similar appearance. When lit by the sun, the colours become even more uniform and the peaks meld and appear to blend together into one seamless form. Yet they are, in fact, two separate and distinct peaks, their blended faces, shown here, at right angles to one another. MacDonald has depicted such a moment. Interestingly, the early season's snow hangs on the south side of the steep valley between Opabin Plateau and the edge of Yukness Mountain, whereas the day's sun has melted the snow on the near face of the Plateau, leaving the rock stained and darkly wet. The composition is a striking play of geometry that he would sketch again and that numerous other artists would be attracted to and capture in dramatic and bold stage-setting-like compositions of light and shadow.

GREY DAYS, RAINY WEATHER – 1928

To me it seems a tragedy that he

had to spend so much of his time teaching,

a fine influence though he has been

amoung [sic] the younger generation.

If there had been opportunities offered

for his fine flights of imagination, Macdonald,

the painter, the poet, and the master craftsman,

might have left us a still greater heritage

than he has done.

—A. Y. Jackson in *The Canadian Forum*, 1933

The Front of Winter, 1928
oil on canvas
Montreal Museum of Fine Arts
(vantage point 31 on map)

HIS WEEKS IN THE ROCKIES WERE FOR THE LAST
FIVE YEARS OF MR. MACDONALD'S SKETCHING LIFE
THE ONLY PERIODS IN WHICH HE COULD BE AT ONE
WITH A STAGGERINGLY BEAUTIFUL LANDSCAPE. HIS
ENTHUSIASM FOR O'HARA AND HIS EXPRESSION OF IT
BOTH IN HIS PAINTINGS AND IN HIS CONVERSATION
WITH OTHER ARTISTS AND INTELLECTUALS IN
THE LODGE MUST HAVE STIRRED IN THEM DEEPER
APPRECIATIONS OF THE MEANINGS OF LANDSCAPE.

—Jon Whyte in *Tommy and Lawrence: The Ways and the Trails
of Lake O'Hara*, 1983

After the 1927 trip to Lake O'Hara, MacDonald returned to
Toronto, where he was elected chairman of the Picture
Committee of the Arts and Letters Club and began numerous
design commissions, including books, building decorations, and
stage designs for theatre, all the while continuing as head of the
graphic and commercial art department at the Ontario College of
Art. When George Reid retired as principal there, the student
body threatened to go on strike if MacDonald was not elected
principal. He was, although in an interim "acting" role. He was
obviously well liked as a teacher, despite his quiet and modest
temperament, and his quick wit, often used to his advantage,
and eloquent poet's mastery of words made him an inspiring
speaker: *He could criticize a design or a colour problem deftly and
well, but he never, like several eminent contemporaries, worked on the
student's drawings and canvases. ... He could tell if a student had
worked seriously on his problem, and was outraged (inwardly, for he
had great self-control), if he had not. ... A serious student, however,
could feel the strong arm of eager interest and cooperation. He spoke
well, briefly and to the point, and moved to the next.*[62]

The Group of Seven held
its sixth show in February of
1928, and MacDonald's work
appeared in a number of
exhibitions in Canada and
abroad. In July, he attended a
meeting of the Ministry of
Lands and Forests with sev-
eral other artists to discuss
ways to preserve the forests
of northern Ontario. He was
elected to the executive com-
mittee of the Ontario Society
of Artists, and he travelled to
Boston and New York.

The 1928 Lake O'Hara
Guest Registry reads like a
who's who of Canadian
Rocky Mountain history.
Names such as Mrs. Mary
(Vaux) Walcott, James
Brewster, George Vaux, and
Henry James Vaux fill the
lines. Lawren and son
Howard Harris (16 July) are
to be joined by the rest of the
Harris family: Mrs. Lawren
Harris and Lawren P. Harris
(18 July).[63] On 30 July,
painter and author Frederick
Niven signs in. Fred and Bess
Housser arrive 6 August;
Arthur Lismer, together with
Mrs. Lismer and Marjorie
Lismer, on 20 August.
MacDonald was the last of
the artists to paint there that
year, arriving 1 September.
During his stay, Tommy and
Adeline Link would visit
O'Hara for the first time, and
a young Georgia Engelhard

would arrive with her par-
ents. MacDonald found him-
self in excellent company,
with stimulating conversation
and interesting people all
around. He impressed the
Links with his work, and sold
them a sketch. **"Mr. Link
wanted to buy a sketch, I
agreed with him, sketches
preferred. Hungabee Lake,
Larches, Goodsirs."**[64] They
became backcountry com-
rades; Link would become a
patron of sorts, buying works
by a number of artists who
worked in the Rockies, sup-
porting their efforts and facil-
itating their sketching
through his trail building.
Peter Whyte was also there,
at the time a student at the
Museum School in Boston,
and he and MacDonald dis-
cussed the various aspects of
student life there, MacDonald
being interested in the Boston
program as his responsibili-
ties at the college increased.
*... Mr. J. E. H. MacDonald [is]...
so sincere and honest about
things, and has a keen sense of
humour. He has just been made
head of the Toronto College of
Art and he seems quite tickled
about it. We have some good old
talks and he wants to know as
much as possible about our
school so that he can use some
of the ideas and make a few
changes.*[65]

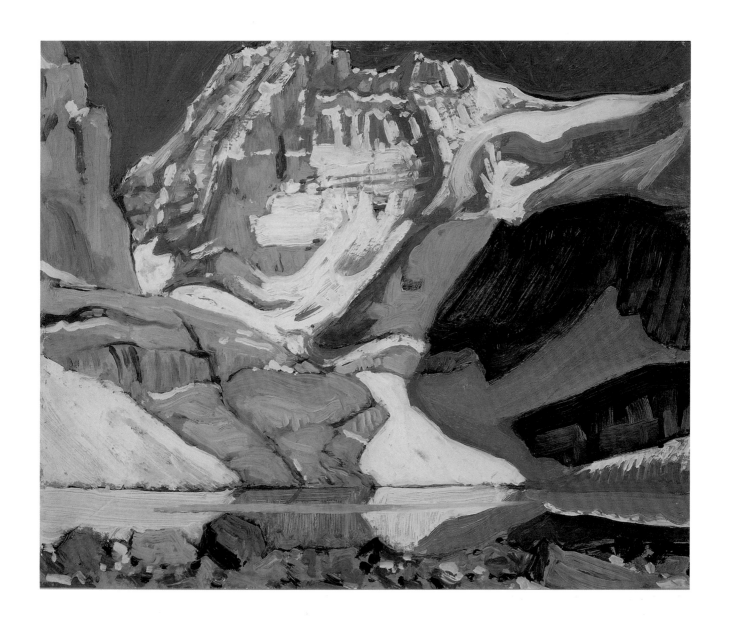

Lake Oesa and Mount Lefroy, c.1928
oil on board
Tom Thomson Memorial Art Gallery
(vantage point 32 on map)

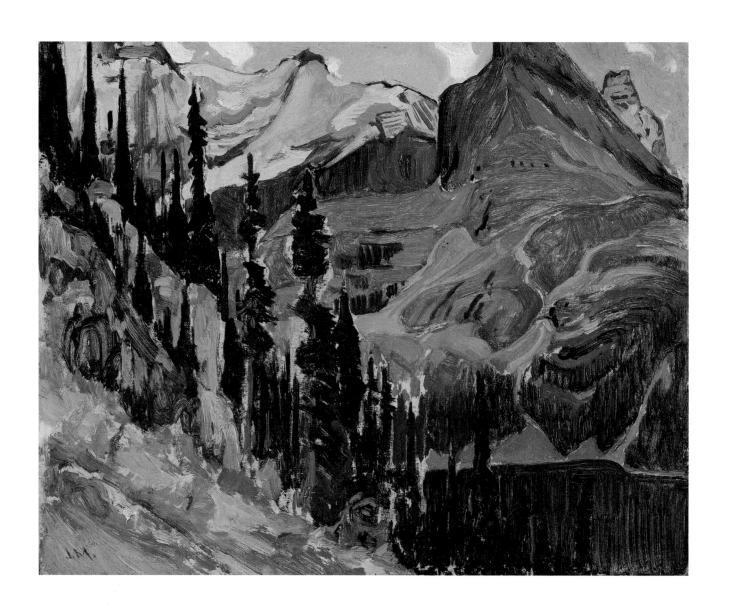

Lake O'Hara, 1928
oil on panel
McMichael Canadian Art Collection
(vantage point 33 on map)

TO TRULY SEE WONDER IN ANY PLACE, ONE HAS TO EXPERIENCE IT THROUGH THE SEASONS, THROUGH YEARS OF SUBTLE LEARNING THAT COMES FROM CUMULATIVE OBSERVATION. ONE HAS TO BATHE IN THE COUNTRY, IN ITS SPRING CREEKS, IN ITS SUMMER LAKES, IN ITS AUTUMN LARCHES, AND IN THE HOWLING WINDS OF ITS BITTER WINTERS.

—R. W. Sandford in *Yoho: A History and Celebration of Yoho National Park*, 1993

MacDonald's biggest challenge in the 1928 season seemed to be the weather. If it was not snowing, it was raining or hailing. Sunny spots, as far as his journals tell us, were few and, almost without fail, short. He devised ways of sketching, finding shelter in the lee of large rocks, staying off exposed slopes and below high and open passes, and as that fall's sketches make clear, he, in fact, delighted in the wild weather. The varied skies, the storm effects, the way in which light changed and reflected in clouds became his focus. He worked as often as he could, giving up only when his hands became too cold or the wind too relentless.

MacDonald's interest in larches would also begin to develop that year, likely due to spending considerable time in the protection of the forest. With mountain silhouettes hidden by cloud, and valleys filled with mist and rain, he instead concentrated on the pattern, colour, and form of near-found views. MacDonald paints the weather picture in words:

Journal Entry: Thursday, 13 September
I am writing this at top of McArthur trail near Larch Lake. Have a fire under an overhanging rock and am scribbling in a cloud of smoke and wood ashes tossed around in the changeable wind. Cold and unpleasant away from fire, now and then a little snow or rain and wind in every direction. Difficult to find a good composition of larch and rock with a sheltered place to work at same time. Morning's sketch a bad failure. This nook is ideal for a fire, and rock overhangs enough to keep out all rain, and it has a deep cellar like recess at back to store the firewood. Have warmed up by gathering a big supply and I shall have to come back next year to use it. I can understand H. D. T.'s journalizing, though I have not his thoughts. I feel like a bear or an old pack horse recuperating, nothing highly spiritual but a bodily satisfaction. Perhaps that is being in "toon with the Infinite." ... Now there is a lull and O'Hara falls can be heard a couple of miles away. Snow is showing on Hungabee as the clouds lift. The climbers would be glad of the fire.

The climbers are Georgia Engelhard and Swiss Guide Ernest Feuz, who are attempting to climb Mount Hungabee. MacDonald mentions looking for them in vain through field glasses and not finding them due to a veil of cloud: "The climbers did not succeed as the mist came low on the mountain and made it dangerous to go on. They returned about 10 o'clock. Miss Georgia pretty disappointed I should judge."[66]

In keeping with the poor weather is the 1928 canvas *The Front of Winter*. This work relates to the 1925 sketch *Valley From McArthur Lake, Rocky Mountains* (p. 48) in its composition, and it also recalls the work of Lawren Harris, who, by 1928, had smoothed the mountains into slick, geometric forms. Harris had expanded his visits to other regions of Yoho National Park and would begin to paint a remarkable series of works based on Monts des Poilus in the Whaleback in 1929. If ever it could be said that Harris influenced MacDonald, it is in this work. *The Front of Winter* is extremely undetailed for MacDonald: the smoothed foreground, the wet and melting snow, the very limited and sombre palette, even toned and flat. The scene looks southwest over the McArthur Pass valley. Mount Owen, on the very left edge of the canvas, frames the vista together with the flank of Odaray Mountain. The work is all movement, liquid sky and liquid snow, and is very flat with no depth of space.

RECALLING WHAT O'HARA MEANT TO
J. E. H. MACDONALD, WE MUST CONSIDER
WHAT HE MEANT TO O'HARA. LAWREN HARRIS
BY 1930 WAS RELINQUISHING LANDSCAPES
AND STARTING THE ABSTRACTIONS THAT EMBODIED
HIS THEOSOPHICAL PHILOSOPHY. ...
MR. MACDONALD, OLDER AND MORE CONSERVATIVE,
PURSUED DESIGN AND COMPOSITIONS, COLOUR AND
PATTERN. O'HARA WAS A PROVOCATIVE SUBJECT
FOR THOSE ELEMENTS IN HIS PAINTING.

—Jon Whyte in *Tommy and Lawrence: The Ways and the Trails of Lake O'Hara*, 1983

The next day continues much the same:

Journal Entry: Friday, 14 September
Thought I would pay my annual visit to Oesa. Weather cloudy and threatening. Some snow and sleet during night. N.E. wind, and gusty. Cold wet day with five gleams of sun. Clouds at Oesa very desolate. Saw the nail tracks of our Ernst and Georgia on the trail, going up Abbot's [sic] Pass to stay the night at the hut, intending to climb various mountains the next day. Bitter cold wind. Oesa felt like the ages before man was. Couldn't work so wandered about on moraine on side opposite pass and got view of ascent which I had never done. Went down and lit fire behind a tumble of rocks and had lunch. Then rambled down valley getting near view points of various features. Many of them. The larches brilliant and cheerful. Cached some raisins in my rock for next year. After lunch the cold wind moderated and was able to make sketch of larches. ... Very dramatic clouds came along, dark blue sky over Odaray with vivid contrasts of light, and soon it was veiled in by downward streams of snow ... by the time I reached the boat, snow and hail were falling on the lake and I rowed home through it hugging the shore to keep out of the wind.[67]

MacDonald loved all this bad weather. He delights in the staccato tapping of light rain on his roof in the middle of the night. He lies awake in his cabin, listening to the quickening notes as the shower escalates into a downpour and records his delight at it in his journal the next day. Ever resourceful, he finds ways to sketch in relative comfort and never expresses frustration with the weather. His reaction is consistently one of easygoing affability. He depicts, in pen and ink, in his journal a "fire rock" at Lake O'Hara. Using a natural hollow under a large rock, he built a fire that was out of the rain and vented through a natural opening in the rocks above, a ready-made fireplace. This outdoor hearth kept him warm, and he made plans to return to it again. So went the days of 1928, and ironically, the day he leaves seems to provide the clearest weather:

Journal Entry: Saturday, 15 September
Very clear morning and snow brilliant on peaks, but clouds forming quickly. Went to old camp and made a sketch of Hungabee in snow and bright coloured morning clouds. A perfect silence at the old spot when the wind fell, the brilliant clouds moving slowly among the peaks ... A perfect day, and then a little dropping of hail, hinting at more to come. So I left with the birds (though not so lightly). Glad to come and glad to go and went off down the trail ...[68]

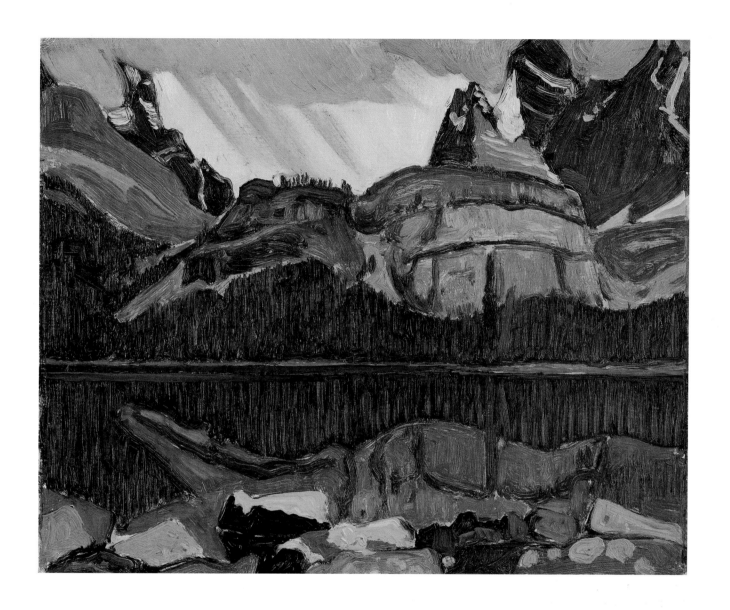

Lake O'Hara, Rainy Weather, undated
painting on board
McMichael Canadian Art Collection
(vantage point 34 on map)

THE LOVELY LYALL'S LARCH – 1929

… AND THERE ARE THE TREES, THE SPRUCE AND

THE BALSAM AND THE PLUMY LYALL'S LARCH. THIS LAST

ESPECIALLY A BEAUTIFUL COLOUR NOTE IN MY MEMORY,

AS IT BEGAN TO GET THE GOLD OF AUTUMN ON IT

BEFORE I CAME AWAY, AND THAT, WITH THE DELICATE

PURPLE GREY OF THE BRANCHES MINGLING WITH IT

MADE A DREAM TREE OF PARADISE.

—from J. E. H. MacDonald, "A Glimpse of the West," 1924

Larches and Mount Schäffer, 1929
oil on board
Vancouver Art Gallery
(vantage point 35 on map)

LARCH AND WHEAT

But yesterday the sleety wind
Hissed in the mountains larch
And now the yellow prairie spreads
The sheaves in endless march
I dream of Earth at timberline
Or plain in sun or wind
Showing in golden plume of grain
The pleasure of her mind

Sept. 17. 28, J. E. H. MacD. [69]

I have a particular affection for larch trees. All Rocky Mountain sentimentality aside, I find them the most visually attractive specimen in the forest. Skiing in the Mount Assiniboine region in February of 2002, after a tremendous blizzard dumped nearly a metre of snow, I was struck by their beauty in a profound way. Heading up to Wonder Pass in hip-deep powder with ancient larches all about me, I was continually distracted from the task of climbing, on skins, up the trail. My group soon left me behind, tired of my exhortations to "Look at those trees!" It was incredibly cold, -35°C the night before, and the larch limbs were piled with snow on top, covered with hoarfrost underneath. The day was cloudless, the snow sparkled, my breath froze in my hair and eyelashes. It was perfectly silent and still all around me; occasional laughter as someone fell through an air hole in the powder was all that broke the silence. I kept stopping, compelled to look at these black trees, with their remaining needles, now almost orange, dried and withered against the woolly black branches, glittering under a coating of frost against the white of the snow. Occasionally, the sun would warm the snow enough to melt it off a branch, and here and there, a handful would fall silently to the drifts below. It was, for me, a moment of astonishingly pure and simple beauty, wherein I was completely bewitched by my surroundings, and of utter visual joy, where all I could do was look, until my frozen body urged me to get moving again and warm up a little.

I am not alone in my adoration of larches. In the fall, as the hiking season draws to a close, the state of the larches is the main subject of hikers' conversations. In mountain coffee shops and outdoor stores, conversations regarding their daily state can be overheard, as though the tree is a member of the extended family, the old aunt whose health and countenance are remarked on by those fortunate to visit her.

Larches and Mount Schäffer is a delightful sketch in mauvey blue and yellow, depicting a favourite view of MacDonald's that looks at the northeast face of Mount Schäffer from the meadows on Opabin Plateau. The face of Mount Schäffer, flatly lit in the autumn light, is painted with bold brush strokes in tones of beige and purple blue. The larches have begun their annual transformation from apple-green to gold. Stark against their scraggly black trunks, the feather-soft needles are, in places, still a summer green, in places, an early golden yellow, and, in a few places, reaching the saffron yellow that makes them so vivid in contrast to the pervading green of fir, pine, and spruce. *Larches and Mount Schäffer* is dated 5 September 1929, a fairly early date for the larches to have turned.

Tamarack, Lake O'Hara, 1929
oil on card
McMichael Canadian Art Collection
(suggested vantage point 36 on map)

Morning Light, Rocky Mountains, 1931
oil on cardboard
Vancouver Art Gallery
(vantage point 37 on map)

Morning Light, Rocky Mountains, 1931, depicts another of MacDonald's favourite haunts, the outstanding views from the slopes of Odaray Mountain below the glacier, southwest to the Goodsirs and southeast to the colossal amphitheatre surrounding Lake O'Hara. Higher up on the Grandview trail, past the Odaray Plateau and up into the glacier's moraine, you can see all the lakes in the O'Hara region. These were the favourite places of Tommy and Adeline Link, the builders of the trail to Odaray Prospect in the early 1940s. Beginning in the summer of 1942, they constructed the trail around the lakeshore of Lake O'Hara. Adeline died just after the trail was completed in 1943; the trail is named the Adeline Link Circuit in her memory. Grief-stricken, Tommy threw himself into further trail-building efforts to ease his loss, constructing many of today's trails during those years.

Trails were originally called "ways" and, in 1946, Tommy completed his plans for the "way" to Odaray Prospect in just three days. Link was an artist in his own right, but without brush or pen; his art making consisted of his signature trails. Link's trails are remarkable pathways, and the Odaray Prospect Trail is his masterpiece. *It is ... one of his finest achievements in landscape*, said Jon Whyte of the trail. *As it emerges to the diffused light among the larches, it provides better and better views of both the bold glory of Odaray in its gloomy wedge against the sky, the swath of glacier traversing it, and the delicate traceries of waterfalls shimmering against the blackness. Then while the charged grandeur of mountain forms is holding all perception, a sudden breath-taking glimpse of the first Morning Glory Lakes from the vertiginous heights one has so casually attained provokes a contrasting stillness. Tommy might have taken the trail by wide switchbacks across the moors to the edge of the fellfields, but instead he directs it assuredly and deftly up. The landscape becomes a felt thing of drama and revelation. And he avoids switchbacks which he hated.*[70]

The central feature in the *Morning Light, Rocky Mountains* sketch is the protruding north face of Mount Schäffer, a triangular, striped mound of purple and brown set against a turbulent cloud-filled sky. The small larch in the foreground is still sporting summer green, while the heather and scrub of the mountainside is a characteristic yellow-brown. Hiking up the open lower slopes of Odaray Mountain, you travel first through dense forest, then open forest dotted with numerous meadows and divided by stands of larch and fir, to more open meadow, more larch. A number of Link's trails in this vicinity are permanently closed, as are a number of meadows he named to commemorate artists: Walter Phillips, John Singer Sargent, Lawren and Bess Harris, Peter and Catharine Whyte, and, of course, J. E. H. MacDonald.

The trail to the site of this sketch climbs steadily through this beautiful region, leaving the subalpine zone and moving into an open slope of alpine rock tumble and scree. The region is extremely exposed; the wind can be relentless and there is no shelter from it. Cold air wafts off the glacier above you. The area of scree is deceptively large, and as the footing is unsteady, it is not easy terrain. The slower pace you need to cross the scree allows you time to look at the rocks beneath your feet. Bands of tan rock, weathered and oxidized, contrast to the newly fallen grey, less weathered and still retaining its freshly exposed surface.

The 1931 date on this sketch is perplexing. MacDonald did not visit Lake O'Hara that year, and he would be unlikely to execute a sketch in the studio. More likely, the date has been misapplied somewhere in the painting's provenance.

The larches are immense but cannot very well be sketched. Such a sharp falling water sound the wind makes in them ... The air is filled with little flying larch needles.

—Journal Entry: Thursday, 13 September 1928

Although the site for the sketch *Larch Trees* is somewhat difficult to place, the ridge line of the mountain in the background is very like that of Wiwaxy Peaks, a feature that became a regular motif in MacDonald's design work and sketches of O'Hara. The alpine meadow, however, where the ridge-line silhouette matches that in the sketch, is currently devoid of a stand of larch such as the one he depicted, as far as I can find. Additionally, the meadow is just slightly below the preferred elevation of the larch; the first thick stands are found a bit higher on the trails to the McArthur and Odaray areas. This does not entirely rule out the meadow as a location, as the trail-closure areas are near enough to approximate the vista in *Larch Trees*, and the scene could be up the meadow in that direction. As well, during the period when camping was allowed—and took place anywhere—the meadow was decimated. Campers like campfires, and as larch is a very flammable wood, such a stand may have been felled to feed their fires. Without a distinct and identifying feature, such as a peak or a body of water, the work could be almost any-where in O'Hara's numerous larch belts—for instance, the shores of the many lakes up on the Opabin Plateau, look-ing toward Victoria from the slopes of Odaray, or along the trails to Lake McArthur.

In MacDonald's day, the alpine meadows and the area between them and McArthur Pass were known as Contentment Meadow. This region became a signif-icant place in MacDonald's relationship with O'Hara. After the lodge was con-structed and his days began and ended on the lakeshore instead of at the meadow, he still returned to the old camp, sketching the remain-ing cabins, the woodpile and woodcutters, the val-leys nearby. He called it "the old spot" or "the old camp" and referred to it often in his journals.

Larch Trees, c.1929
oil on cardboard
Hart House Collection
(vantage point 38 on map)

THE ARTIST DEVELOPS OUR EYES' PERCEPTIVENESS.
HE TRAINS THEM TO TRANSMIT TO OUR BRAINS
NOT ONLY LITERAL DESCRIPTIONS BUT POETIC
IMAGES OF THE SURROUNDING WORLD. THROUGH
MACDONALD'S EYES, CANADA LEARNED TO
APPRECIATE THE MAJESTY, THE SPLENDOR,
THE MAGNIFICENCE OF HER LANDSCAPE.

—Josephine Hambleton in the *Ottawa Evening Citizen,* 1947

With the help of the specific place name given in the sketch title, the little oil *Larch and Lake, Mary's Meadow, Opabin Pass* proved easy to place. On the Opabin Plateau in Mary's Meadow, this image is a view looking west across Hungabee Lake toward the east flank and scree on the slopes of Mount Schäffer. The "viewfinder method" was used to match the two features—the distant treeline on the far shore of Hungabee Lake lined up with the uppermost ridge line of Mount Schäffer. But there is no likely larch tree in the right place. Even allowing for

an additional seventy-four years of growth, which is a short amount of time in the life of a larch,[71] there is no likely tree. Trees, of course, grow and die in the mountains, storms blow them down, avalanches break off their tops, animals uproot them, water flowing and changing its course erodes their root holds and they topple over. Artists, too, add and remove trees from their sketches to suit the composition, and perhaps MacDonald did this. However, I have found so many of the details in his sketches to be exact depictions that I hesitate to

make this assumption. The lone fir on the north shore of Lake O'Hara in front of cabin number three is depicted in another sketch by MacDonald.[72] This tree was healthy and growing in 1996, but now it has been topped, perhaps by winter winds, and has begun to suffer. A landmark tree, it may not be there much longer, and in another decade or so, we might assume that it, too, had just been added to the sketch.

MacDonald's interest in the colour patterning of the larch reasserts itself in many of his sketches. Larches became the bright colour note that could

be added, and following the grand design of Nature herself, the yellow of the larch is the perfect contrast to the green forests, blue sky and water, white glaciers and snow. Here, the tangled limbs of the trees, in varying states of turning, are freely painted against the sombre green of the conifers behind them. The black trunks of the trees, together with the brighter branches, and the knowledge that the turning of the larches in the Rockies is such a fleeting moment, combine to give this sketch tremulous and transitory life.

Larch and Lake, Mary's Meadow, Opabin Pass, 1929
oil on board
McMichael Canadian Art Collection
(vantage point 39 on map)

ALL HIS LIFE MACDONALD STROVE TO EXPRESS

IN PAINT THE MOODS HE SENSED IN NATURE AND

FELT WERE THE ESSENCE OF LIFE.

—Nancy Robertson in *J. E. H. MacDonald, R. C. A.,* 1965

At Lake O'Hara, hikers in good condition and with good gear (especially footwear) should not miss the spectacular hike up to Wiwaxy Gap. Having not hiked there himself, MacDonald instead depicts a view of the gap from a distant location across the valley at Lake Oesa. If you are up for it, you can hike right into the centre of the scene in MacDonald's sketch. In a short distance of 2.4 kilometres, you climb 500 metres straight up. This is one of the most panoramic places at O'Hara, with Lake Oesa and the three smaller lakes nearby clearly visible across the valley. You can also see northwest to many summits in the Yoho Valley. Be warned, though, this trail is extremely steep—a "total burn" in hikers' slang—has many exposed ledges, and offers no shelter. Consider that and also consider that Wiwaxy means windy; there is nowhere to hide when the weather turns foul. MacDonald's vantage point, the northwest shore of Lake Oesa, is much more welcoming and easier to reach. Looking across the high valley as he was, the distant mountains of the Wiwaxy Peaks and the nearer form of Mount Huber rise away on either side of Wiwaxy Gap. Huber is named for the Swiss alpinist Emil Huber, famous for the first ascent of Mount Sir Donald in the Columbia Mountains.

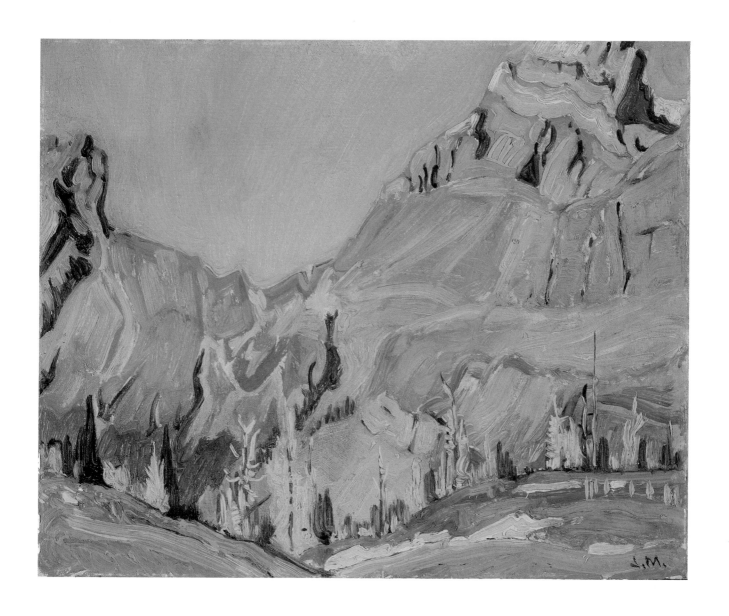

Mountain and Larches, Rocky Mountains, undated
oil on cardboard
National Gallery of Canada
(vantage point 40 on map)

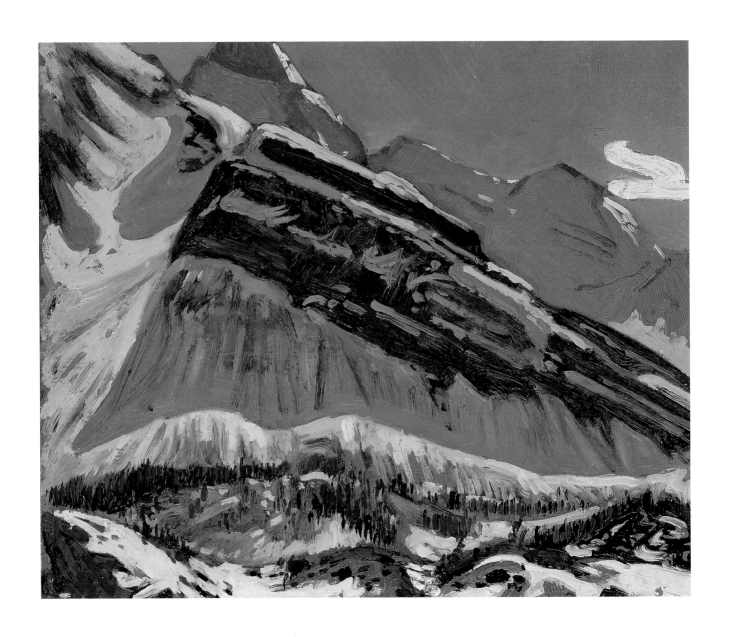

September Snow on Mount Schäffer, 1929
oil on cardboard
National Gallery of Canada
(vantage point 41 on map)

HE HAD A GIFT FOR UNDERSTANDING AND
SUMMARIZING THE LANDSCAPE, FOR
EXPRESSING GRAPHICALLY THE CHARACTER
OF GRANITE OR LIMESTONE, SPRUCE AND PINE,
POPLAR OR HARDWOODS, MUSKEG OR FARM
FIELDS, ALL THE WELL LOVED VARIATIONS
OF CANADIAN LAND AND SEASONS.

—Thoreau MacDonald in *J. E. H. MacDonald, 1873–1932*, 1957

September Snow on Mount Schäffer is set from another of MacDonald's favourite O'Hara haunts—the lower slopes of Odaray Mountain. This area was easily accessible from the site of the old camp in the alpine meadows, and by 1929, MacDonald knew it well. When you look south from the Odaray Highline Trail near The Goodsirs lookout, the triangular north end of Mount Schäffer dominates your field of vision. The hanging valley that holds Lake McArthur is hidden behind Schäffer's looming bulk. The uppermost part of Mount Biddle, which shows as the darker mauve peak in the background, runs off the top of the sketch. Thorington and Gardner Peaks fall away behind. The spirit of this sketch is found in the area of dazzling sunlight, which is given MacDonald's full attention. The dark shadows foil the darker lines of Schäffer's strata, heightening the brilliance of the sunlit white snow. Glints of sunlight underline this as they catch on the very thin edge of cornice that is showing over the tops of Thorington and Gardner Peaks.

In the fall of 1928, MacDonald was officially elected principal of the Ontario College of Art, a post he had been filling for some months already. He had consulted with Peter Whyte about the job that summer, confiding that he was uncertain if accepting the post was wise, and wondering if the workload would be more than he could manage.[73] MacDonald would talk of this subject again with Whyte and Tommy Link. Link would recall the conversation in a taped interview many years later: *... he [MacDonald] consulted with the Whytes about whether or not to accept the post as head ... would it be too much—he really wanted to be an artist.*[74] In particular, he feared for the time he would not have to devote to painting, admitting to Whyte that being an artist, not a teacher or, more truthfully, an administrator as the job would prove, was his desired priority.[75] He feared for the loss of creative time, which he knew would be sacrificed if he accepted the job. His conscientious personality must have recognized there would not be enough time for both. Yet he was under *strong pressure*[76] to accept the post of principal, with other staff members threatening to resign if he did not, and so he accepted the position in October of that year.

His efforts to continue with the mountain themes, in the format of larger canvases, were curtailed by his waning health: *He would bring [the sketches] home, set up a space in the garage, and begin translating them on to a big canvas. But he was tired and weak and the job was beyond him.*[77] Despite accepting the job at the College, he continued with his freelance design work, completing some significant commissions including two architectural design projects, and made regular contributions to *The Canadian Forum*. He was also elected to the Hanging Committee of the Ontario Society of Artists. Time for painting lessened, as he expected: *My father is trying to paint these days but has little time,*[78] recalled Thoreau MacDonald. One important canvas from that year is *Lichened Rocks, Mountain Majesty*.

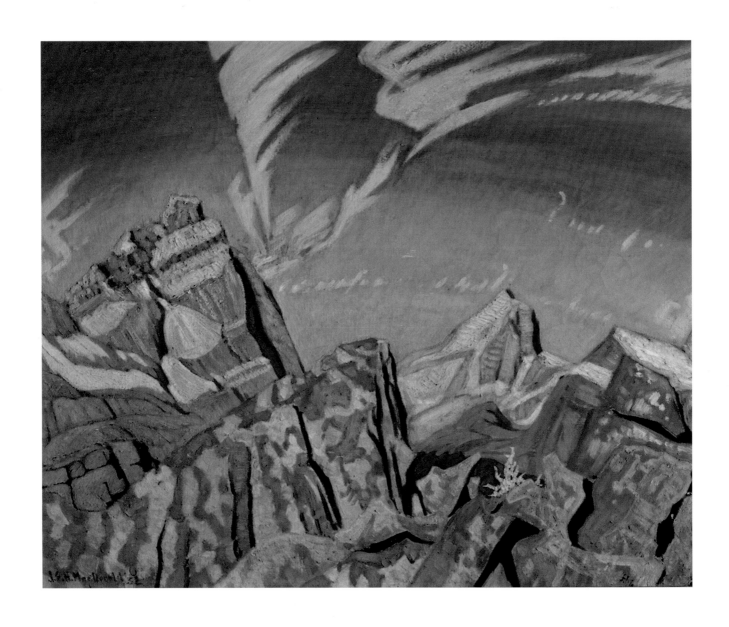

Lichened Rocks, Mountain Majesty, 1928
oil on canvas
University College Art Collection, University of Toronto Art Centre
(vantage point 42 on map)

I MAKE IT MY BUSINESS TO EXTRACT FROM NATURE
WHATEVER NUTRIMENT SHE CAN FURNISH ME,
THOUGH AT THE RISK OF ENDLESS ITERATION.
I MILK THE EARTH AND SKY.

—Henry David Thoreau, 1853, cited in
Wilderness Visionaries, 1994

Unusual compared to MacDonald's other Lake O'Hara canvases, *Lichened Rocks, Mountain Majesty* depicts a tight, close-in view of the characteristic rock tumbles found in many places at Lake O'Hara. On the Opabin Plateau, at Lake McArthur, along the Lake Oesa trails, around Lefroy Lake, and beneath Odaray Glacier, massive heaps of rock, with many house-sized obstacles, lie in the valley like shipwrecks. In *Lichened Rocks, Mountain Majesty*, most of the subject is foreground; we are in one of these massive debris piles. MacDonald has conveyed to us, through this composition, the feeling of looking up. For hikers, the work is quite evocative of the physical sensation of cresting a trail-less pass, where the scrambler has found the way, hand over foot, through the rockfall. The work is anticipatory—we are just about to see the vista that awaits us over the rocks MacDonald has painted. The sensation of climbing in a rock slide is furthered by the angular movements of the clouds in the sky and the direction of the brush strokes that have shaped them, very visible in the work and all leading our eyes into the space over the rise. The map and crust lichens, two types of amazingly colourful, tough, and long-lived plants, grow tightly over the rock surface that they pattern with shades of yellow, blue, orange, and green. A few branches of a seared larch tantalize us to climb up and over the rocks and down into the golden larches of the valley beyond.

Lichened Rocks, Mountain Majesty depicts a spot somewhere in the glacial debris near the Odaray Grandview. Not an exact rendition of the features of the distant mountains, rather, the scene is a composite of the silhouettes of Cathedral and Odaray Mountains. The peak on the left is the uppermost portion of an Odaray-like mountain; the tower on the right is based roughly on the shape of Cathedral Mountain and placed, in the canvas, quite near where it should be in the real scene.

When I first looked closely at this painting, I did not like it. It is an unusual work for MacDonald, and too close, too unreadable for me. Then, in the summer of 2002, I took my seven-year-old son hiking to Lake O'Hara. The first morning, we made our way up the trail to Lake Oesa, stopping in the vicinity of Yukness Lake for lunch. As he poked about in the rock tumble, delightedly watching a pika for the first time, and following the struggles of a pair of hikers high above us on the Yukness Ledges, I lay forward on one of the large slabs of rock that border the lake. Lying down, nose to the rock, looking at Odaray and Cathedral over the lichen patterns, I was reminded of the canvas. The feeling in it was much like the moment I was experiencing, of being right down on the ground, but at a high elevation, looking out over a deep valley to distant mountains. The patterns of the lichen filled my field of vision, the dry, earthy smell of the rocks filled my senses. These moments, of utter relaxation and enjoyment, are the memories that MacDonald took home from O'Hara, and the "valuable experiences" he tried to capture the essence of in his canvases. MacDonald had upwards of three weeks at O'Hara; I have rarely had more than three days at a time. The slower pace forced on me by my seven-year-old had allowed me to take in O'Hara in a much more leisurely manner. I had time to get nose-to-nose with the lichen, to lie in the grass and do nothing. Later, I had the opportunity to look closely at the work in a gallery setting, and this time I was drawn immediately back to that salient moment in the sunshine with my oldest child, face down on a lichened rock, surrounded by mountain majesty.

THE OPABIN SHALE-SPLITTERS – 1930

To peter and catharine whyte with congratulations

(better late than never,) and with the hope that life

will always be as pleasant for them both

as for pete in the sketch, from their humble

fellow member in the opabin shale-splitters.

—J. E. H. MacDonald verso inscription, *Cathedral Mountain from Opabin Pass*, 1930

Cathedral Mountain from Opabin Pass, 1929
oil on board
Whyte Museum of the Canadian Rockies
(vantage point 43 on map)

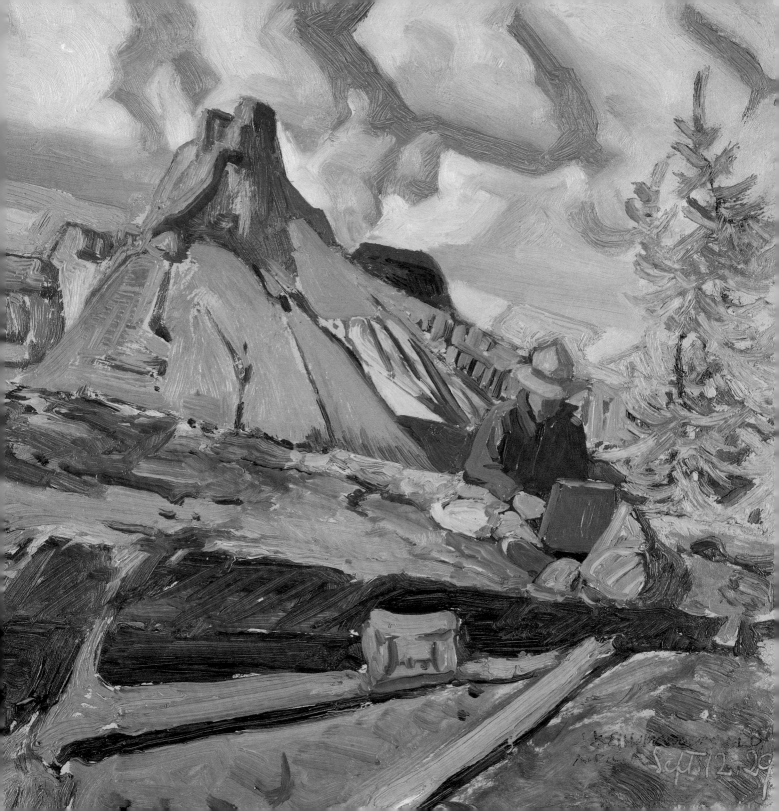

KNOW ALSO THY COUNTRY, KNOW ITS CHARACTERS, ITS WEALTH OF BEAUTY IN RIVER AND MOUNTAIN, THE EFFECT OF ITS SEASONS, ITS ROCKY AND BARREN PLACES, ITS FERTILE VALLEYS. BE HOME-CONSCIOUS, WORSHIP THE POTENTIAL SOIL.

—Bess Housser in *The Canadian Bookman*, 1925

J. E. H. MacDonald probably met Peter Whyte for the first time at Lake O'Hara in 1925. It is difficult to pin this date down with absolute certainty. The 1925 journal is in two parts; the latter part (dates after 10 September. ... 1925), wherein meeting Peter Whyte would certainly have been mentioned, is lost. The 1926 journal consists mostly of poetry. Letters between the two are known from 1929 and 1930 only. Whyte is understood to have gone into Lake O'Hara at the direction of Brewster Transport, for whom he drove a bus in the summers from 1925 to 1929. They wanted him to become familiar with the district and be able to guide others there.[79] In 1960, Tommy Link began writing a history of all the artists who had worked in the Rockies. He wrote to Peter and Catharine Whyte, asking them to recall all they can, assign dates, and answer a number of questions, which they did to the best of their recollections. This correspondence gives us a number of clues about the date that Peter Whyte and MacDonald met. The letter also contains a number of errors, however, and so is not entirely reliable as a factual source for dates. Despite this, it does give us the following: in one passage, Catharine refers to another artist, Aldro T. Hibbard of Massachusetts, stating that *... they [Whyte and Hibbard] were at Lake O'Hara until it closed that year. It was at the old camp and Mr. MacDonald was there. ...*[80] We know that MacDonald only stayed at the old camp for two years—1924 and 1925—and that the year MacDonald met Hibbard (he misspells his name as Hibbert) was likely the same year he met Whyte. Hibbard is mentioned numerous times in the first part of the 1925 journal; in fact, MacDonald and Hibbard sketched together at Lake McArthur that year. We also know, however, that in 1925 Whyte *didn't paint, only took a few photographs,*[81] so it might not have been apparent that Whyte was a painter. He could have been one of the unnamed guides who did not stay at the Bungalow Camp and who are only mentioned by MacDonald in a passing manner. A self-sufficient outfitter, Whyte may not have even stopped at Lake O'Hara Camp, leaving MacDonald unaware of his presence in the region. Regardless of when they met, by 1928 they were sketching friends, sharing a love of lard-pail-brewed tea and painting in the same regions at O'Hara: *There is an artist here from Toronto,* Peter writes to Catharine (then his fiancée) in 1928, *Mr. J. E. H. MacDonald, and we always seem to come here at the same time, about the second week of September. He is a lovable old Scotchman with red hair, a remarkably fine painter. We get along fine together and tramp and paint together all day ... Yesterday and the day before, Mr. MacDonald and myself walked up towards Opabin Pass a few miles, taking our lunches along, and spent the days sketching and observing. The high valleys have such nice carpets of moss and grass that after eating lunch we sprawl out on the ground and rest until we know we shouldn't waste any more time but back to the sketchbox again.*[82]

Whyte was one of Banff's first native-born painters. The son of merchants Dave and Annie White, he grew up skiing, ski jumping, hiking, and packing in many ranges of the Rockies. The mountains were his backyard, and his intimate knowledge of them made him the companion of choice for visiting artists, an informal guide of sorts. His own interest in painting led to his taking a year of training at the Otis Art Institute in Los Angeles (1924–25). In 1925, very likely at the suggestion of Aldro Hibbard, he attended the School of the Museum of Fine Arts in Boston (1925–29), where Hibbard himself had been a student. It was there that he met and fell in love with fellow student Catharine Robb. They were married abroad in 1930, changed the spelling of White to Whyte, and, in time, would settle and build a studio home in Banff. Their home would become the hub of artistic activity in Banff for many years, and, using Banff as a base, they would hike

and paint together all over the Alberta and British Columbia Rockies. Peter brought Catharine to Lake O'Hara in 1930, where he introduced her to MacDonald on Sunday, 31 August, when **"Peter Whyte arrived with his bride, a quiet little downeaster, they had been sketching in Yoho."**[83] The next day they rowed to the O'Hara falls, now known as the Seven Sisters Falls. MacDonald had been painting near there the day before, attempting, unsuccessfully he felt, to capture the lighting on the day's fresh snow: **"snow reflections were beautiful, but transient effects and other difficulties were beyond me."**[84] He had cached his painting kit in the rocks **"to save bringing up again,"**[85] and upon retrieving it, while the Whytes explored, he made two additional sketches, which he felt to be **"a little better."**[86] Later, on the row back across the lake, they talked of the difficulties of painting the ever-changing light, ephemeral colour, and fleeting atmospheric effects of the mountains.

Sketching that year in the Rockies was plagued by smoke from numerous forest fires in the Pacific Northwest. Huge swaths of forest burned and contributed their blue-grey smoke haze to the colour of the skies. In addition, the great drought of the 1930s was on its way, and increasingly dry conditions on the prairies added dust to the air. MacDonald refers to this several times in the 1930 journal, wherein he found it both a hindrance and an asset to his sketching: **"McArthur Lake delicate in the smoke haze."**[87] or **"Beautiful morning, slight cloud and west wind which blew quite freshly later, bringing in a lot of smoke from the west, making the mountains all silver haze."**[88] This smoke would manifest itself in his sketches—many from 1930 have the decidedly blue and grey tinge of wood smoke in the air. It is obvious from his journals that he painted what he saw at O'Hara, refusing to change things in his works to suit the desires of others: glaciers remained the shape they appeared, skies were the colours he saw them, and these colours were rarely sky-blue. The grey skies and darker palette of his Lake O'Hara sketches are often remarked upon for their notable divergence from his other scenes. Simply put— he painted what he saw.

In the three-quarters of a century since the Group of Seven had the full attention of Canada's art going public, time has smoothed the lines, our eyes are have made sense of the colour and pattern, and we have grown accustomed to their works. Images that enraged critics are now symbols of quintessential "Canadian-ness"; we know these images from grade school and now find them to be completely uncontroversial.

It is also important to recall that, in the 1920s and 1930s, travel was not something every individual could undertake easily. Now we are familiar with landscapes from around the world; we are more visually educated in the variety of topographies of other parts of Canada and the world. These considerations of place are a critical component in any discussion of landscape that attempts to be whole. Certainly, a painting can be appreciated in and of itself, but this is only one of many steps towards full appreciation. A further critical series of steps should be taken with one's hiking boots on.

The particular nature of mountains, their presence, their massiveness, and their innate hazards and delights dictate that mountainscape painting is as much about the experience of being in the Canadian Rockies as it is about the trees, peaks, sun- shine, and glaciers that the artist depicts. A painting can be appreciated without any knowledge of the nuances of the subject. However, for deeper understanding, you must consider the place. Just as knowing something of the life of the individual depicted in a portrait is crucial to critical discourse on that portrait, knowing something of the place is crucial to critical discourse on landscape depicting that place.

To head of lake again alone, and up Oesa trail again. Went higher up on Wiwaxy and made sketch of Biddle and Schaffer in mist effect. Eagle soaring again, a curious chicken like chirp as he flies. Climbed higher for lunch and ate it above gravel slopes in a goat pasture. Many signs of goats about but saw no animals. ... Smoky mtns. again in afternoon and a singing bird new to me ... A hurried formless little song but sweet and wild. Later it cleared a little and made a third one of Lefroy and Ringrose ... a fine day.

—Journal Entry: Tuesday, 2 September 1930

MacDonald returns to the lodge by a trail he describes as a "well established goat path," stopping to watch trout jump near the falls in Lake O'Hara. Lake O'Hara always seems to have numerous fish jumping in it, but they are small and skittish, tending to stay near the shoreline as the water is so heavily silted. *Lake O'Hara's fishing has never been able to match its beauty,*[89] a current guidebook tells us, listing the size of cutthroat trout found there at 20–25 centimetres (8–10 inches), with some over 40 centimetres (almost 16 inches). In MacDonald's day, the fishing seems to have been better: "Many fish caught in lake by a Mr. and Mrs. Wilson, the Links assisting. We can all see that O'Hara will soon be spoiled by fishermen. The fish are a good size, most of them going over twelve inches, many 16 or 18. But of course the best one got away."[90]

Peter Whyte and MacDonald hike to Lake McArthur the next day, 3 September, while Catharine stays at the O'Hara lakeshore to sketch. Thwarting the day's fine, warm weather and its possibilities for good sketching, they discover the view to be lost in a haze of smoke, so they wander the meadows, examining the wildflowers, including some sort of thistle-like plant. MacDonald describes this specimen in his usual observant and humorous way as "a rough small thistle in places, gone to seed and most offensive looking little plant, even a mountain goat would say grace before eating."[91]They try to identify the birdsongs they hear and watch for mountain goats, of which MacDonald notes many signs. He attempts to sketch despite the haze, climbing "higher up to get a different view, and in afternoon higher again."[92] But as he notes in his journal, while looking down at Peter Whyte below him, the haze was very thick: Pete a long way down. Could hardly be seen even when on a snow patch.[93] MacDonald's climbing that day confirms his good physical health: there are no established trails above, the shoreline is all scree. Together, they return to the lodge and find that the Links have arrived.

Occasionally, a group of people encounter one another with shared ideals in a setting conducive to clear thought and purpose. This was the case in 1930 when MacDonald, the Links, and the Whytes met at O'Hara: MacDonald, Group of Seven orator and poet/painter, newly appointed head at the Ontario College of Art; Peter Whyte, local guide/painter, avid art student; Catharine Whyte, educated art student, who left her life of wealth and finery in Boston among the notables of New England business and society to embrace mountain life and her new community of Banff; the Links, avid photographers, Tommy the botanist and Adeline the teacher, both head over heels in love with Lake O'Hara and embarking on a life's dedication to building the trails we walk today. Catharine was an extremely dedicated letter writer. Through her correspondence with her mother, and the text of MacDonald's journals, we can easily piece together their days in 1930. The resulting story is a chronicle of a remarkable group of people who encountered each other in an exceptional place that each cherished. Often the only guests at the lodge for extended periods of time, they found themselves happily together with only the pursuit of their combined interests to shape the day.

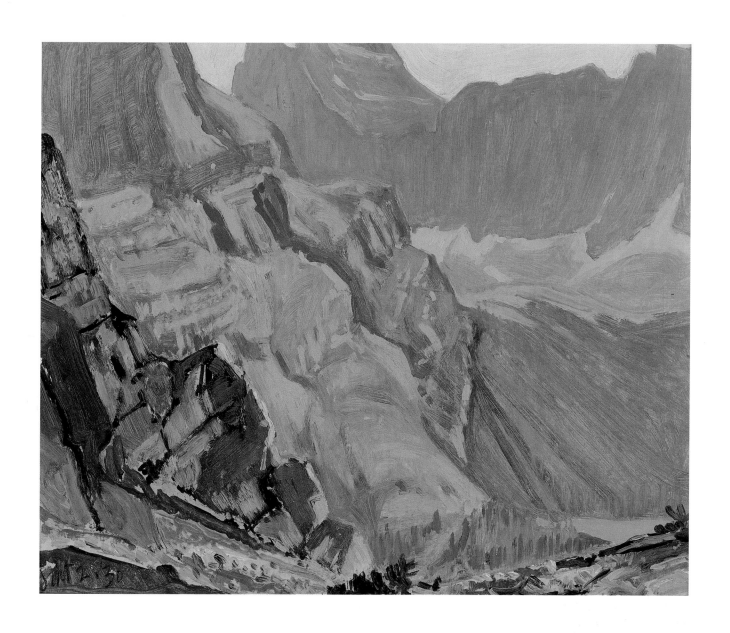

Mountain Goat Land, Lake O'Hara and Opabin Pass From
the Flank of Wiwaxy, 2 September 1930
oil on panel
Private Collection
(vantage point 44 on map)

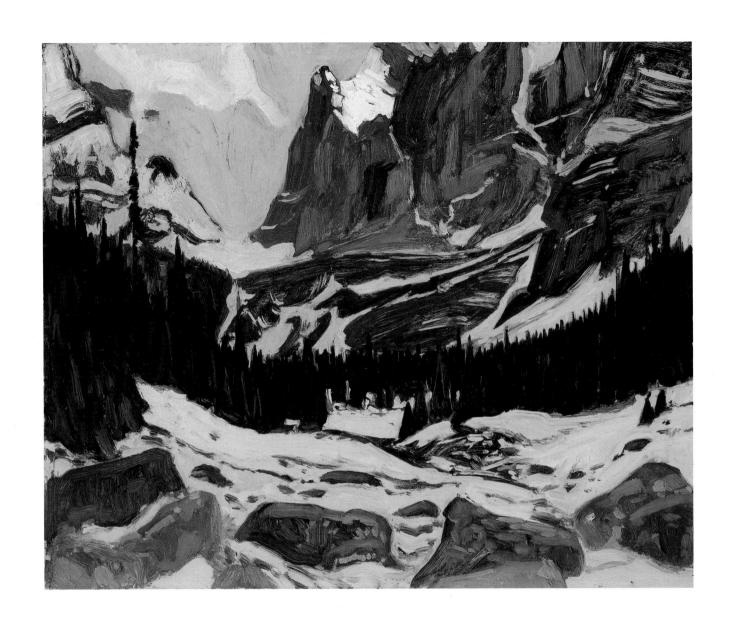

Snow in the Mountains, c.1930
oil on paperboard
Art Gallery of Ontario
(vantage point 45 on map)

A very clear morning, blue sky and no cloud. We all went to Opabin and had a fine time among the rocks and valleys.

—Journal Entry: Wednesday, 10 September 1930

That year the group formalized their camaraderie one afternoon on the Opabin Moors. In a ceremony during which MacDonald spoke some *sacred, secret words,*[94] now unknown to us, he declared the Links, the Whytes, and himself to be "the Opabin Shale-Splitters": *At Mr. MacDonald's favourite location, near where the sedimentary rocks are heaved up and frost cracked, and the dark slopes of Mount Schäffer are a foil to the bright needles of the larch, ... Mr. MacDonald made them all members of the "Opabin Shale-Splitters," the five of them, and then each of them raised a slab of shale and splintered it by heaving it against an outcrop.*[95] With a poet, artists, photographers, botanists, scientists, and mountain lovers, the Opabin Shale-Splitters' membership was an eclectic mix. A Christmas card that MacDonald sends to Peter and Catharine Whyte, dated 20 December 1930, warmly recalls the afternoon that the group was made official: *The little rock shrine dedicated to Art, Love, and Adventures, is doubtless deep under snow by now, but Mary's Meadow will always be flowering for us.* He sends the Christmas card to the Whytes in memory of *our famous Opabin Rabbit's Club.*

Snow in the Mountains looks up toward Opabin Pass from this area, where the Shale-Splitters first convened.

THE SHALESPLITTERS

Afternoons on Opabin Plateau
tea in tin cups
surreptitiously hidden
under rocks,
Adeline and Tommy,
Mr. MacDonald.
the artist, J. E. H.,
at easel,
umbrella protecting
his canvas,
now so valuable.
Catharine and Peter
young painters
and heirs to
American fortune,
good humoured
philanthropist
bohemians.

What did they speak of that day
Tommy captured on Kodak, their
happiness evident, filters through
the frame, across time?

They are no different from we
who tarry now in the
glades of Opabin.
our sharings, laughter,
tones of the heart,
magic of light.

The Shalesplitters,
artists, naturalists
at home in O'Hara's wilderness.

On the planes at which
all things
happen at once,
they rest there still.

Their laughter
bubbles in brooks,
spirits play in the breeze,
their conversations
echo from peaks,
unfinished words
tumbling off the tongue
in white cascade—

their colours painted
every season.

—Carol Ann Sokoloff, 1993

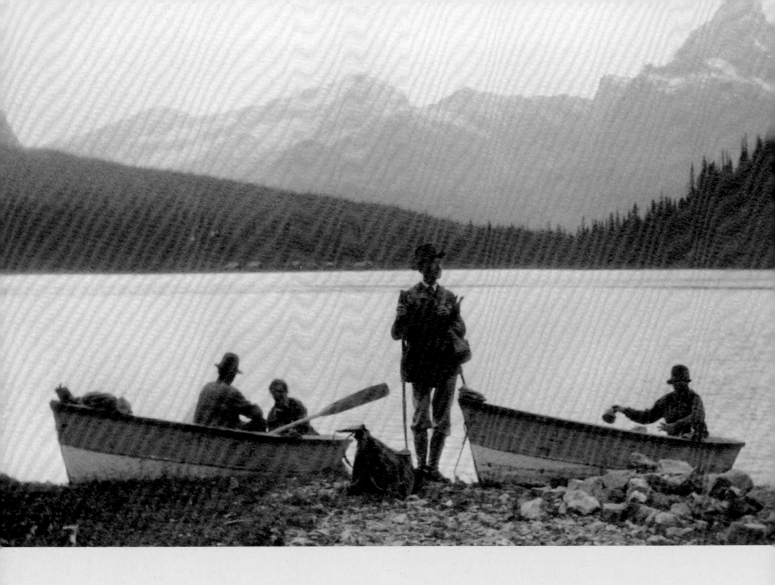

Getting Ready to Return to the Lodge after a Day of
Sketching at Opabin Creek, 1930
George K. K. (Tommy) Link photograph
Whyte Museum of the Canadian Rockies

YESTERDAY A FINE DAY UP AT OESA. IT WAS RATHER CLOUDY IN THE MORNING BUT, NOTHING DAUNTED, WE SET OUT WITH OUR LUNCH AND SLICKERS, MR. MACDONALD, MR. AND MRS. LINK, PETE AND I. WE ROWED ACROSS THE LAKE AND CLIMBED OVER AN HOUR. OESA IS THE LOVELIEST SHADE OF GREEN, THE SHADE CHANGING CONSTANTLY AS GUSTS OF WIND SWEEP ACROSS IT. WE THREE ARTISTS MADE A SKETCH BEFORE LUNCH, THEN ATE A TREMENDOUS MEAL OF SANDWICHES AND TEA MADE IN A LARD PAIL OVER A FIRE. AFTER LUNCH WE SKETCHED AGAIN BUT IT GREW DARKER AND CLOUDIER ALL THE TIME. MR. MACDONALD WAS STILL SKETCHING SO WE MADE SOME MORE TEA, AND GOT WARM AROUND THE FIRE. IT BEGAN TO THUNDER AND SOON STARTED RAINING, SO WE PUT ON SLICKERS AND STARTED DOWN, THE CLOUDS AROUND US AND THUNDERING A GOOD DEAL.

—Catharine Whyte to Edith Robb, 7 September 1930

Journal Entry: Saturday, 6 September 1930

To Oesa, the Links, the Whytes and I, a cooler day. A mad crew in the boat rowing wildly, two in the centre seat. ... soon the thunder began and heavy rain, we all left in a heavy marching order through the down pour. Rain had ceased when we reached the lake and our crew stirred up the lake again.

I HAD NO DIFFICULTY REACHING THE SUMMIT OF
OPABIN COL BY 10 O'CLOCK, 9,000 FEET ABOVE
THE SEAS. BEFORE ME I SAW A BROAD VALLEY
DESTITUTE OF VEGETATION AND WALLED ON EITHER
SIDE BY LOFTY, PRECIPITOUS CLIFFS, THE GLACIERS
AT THE FEET OF WHICH RESEMBLED THE DASHING
WAVES OF A STORMY SEA.

—Samuel E. S. Allen in *The Alpine Journal,* 1896

The year 1930 is particularly interesting in this study of
MacDonald's Lake O'Hara works. The sketches have devel-
oped into more finished compositions, the journal from that
year is fluid and easy to decipher. Occasionally, a match
between the day's writing and the day's sketch can be made.
One such case is *Lichen Covered Shale Slabs.* The inscription
on the back reads: *Hungabee from Shale Slopes, Opabin Pass,
Sept 8. 1930.* Set quite near to the location where the Shale-
Splitters brewed their tea, the sketch depicts the huge slabs
of shale below Mount Hungabee on Opabin Plateau. We
know from the journals that it had been **"a beautiful clear,
cool fresh mountain day of the perfect type."**[96] It had also
been a day of good sketching and alpine adventure, when,
for the first time in many days, the heavy smoke in the air
from nearby forest fires had cleared and a hard frost the night
before had added its wintry accent to the scenery.
MacDonald, the Whytes, and the Links had climbed up the
creek bed trail to Opabin Plateau, now the East Opabin Trail:
**"To Opabin entirely by creek trail, much easier, with fine views
of Cathedral Mountain and lake as we went up with the
stream falling downward through the gorge, which framed the
mountains."**[97] Of this sketch, MacDonald says only: **"Sketched
Hungabee and foreground rocks but had trouble as afternoon
shadows and forming clouds changed colour."**[98] MacDonald
tells us very little other than the description of the sketch,
which indicates that he was pleased with it. When he is

unhappy with what he has
executed, he describes why,
consistently and in lengthy
detail, in his journals. When
field sketches have captured
the effect or idea or moment
he wants, we have only a
brief description of where
and what he sketched. Often,
the only hints of his taking
pleasure in the outcome of
his daily efforts are found in
the closing of each journal
entry: **"A perfectly fine day."**[99]
Until 17 September, the
Opabin Shale-Splitters spent
each day together, hiking,
sketching, photographing—
Whyte working in a very
small format *three by four inch
sketches, four per panel*[100] and
MacDonald painting larger
*one in the morning one in the
afternoon.*[101] They talked of
new scientific theories and
discussed the concept of
knowing one's soul: **"interest-
ing but difficult to follow,
easier to intuition, as it seems
obvious the soul cannot
know itself, the knower only
is. He is not revealed. He
cannot be weighed, mea-
sured, or seen."**[102] They
laughed and explored, Link
sprained his ankle, they
were soaked by rain, and
bathed in sunshine. In the
evenings, they listened to
the gramophone, were
entertained by Peter's imper-
sonations of Charlie Chaplin,

and MacDonald recited
My High Horse.
MacDonald's sense of the
possibilities for decorative
design went with him to
O'Hara. He had worked in
Toronto on a number of sig-
nificant interior decorative
commissions in the 1920s,
and he had also designed
symbolic standards and
backdrops for a number of
plays and pageants and the
decorations of St. Anne's
Church in Toronto. Together
with Tom Thomson and
Arthur Lismer, in 1915,
MacDonald had painted
murals for the interior walls
of Dr. James MacCallum's
small cottage at Go Home
Bay. When faced with the
stark white, newly plastered
interior wallboards of Lake
O'Hara Lodge, all neatly
divided with flat wooden
beams, MacDonald suggested
that he and Peter Whyte
paint them. In a truly disap-
pointing decision, the CPR
wouldn't give permission.[103]
Together with the
MacCallum cottage, these
two interiors would have
given us a sample of the
artist's work inside a wilder-
ness cabin of singular signifi-
cance for him at the
beginning and at the end of
his painting career, in west-
ern and in eastern Canada.

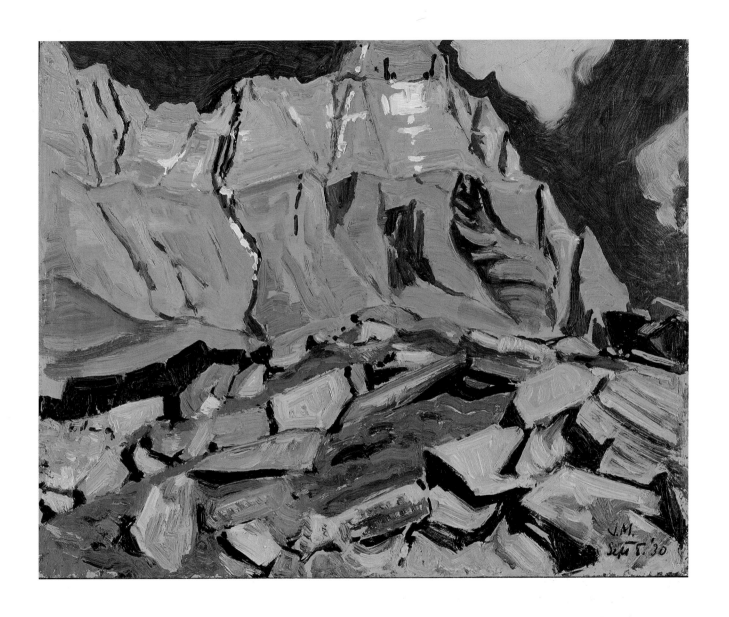

Lichen Covered Shale Slabs, 1930
painting on panel
McMichael Canadian Art Collection
(vantage point 46 on map)

Another fine warm day, hazy and little cloud. To Odaray Bench, saw many fungi on the way up and some flowers explained by Link. Sketched near glacier at north end of bench, the little falls from glacier a pleasant musical but tantalizing on account of hot sun.

—Journal Entry: Friday, 5 September 1930

The massive form of Odaray Glacier, with its distinctive swirl, is visible from many places at Lake O'Hara. Its strange form dominates the composition in the 1924 canvas *Rain in the Mountains* (p. 34), and its looming presence dominates the atmosphere as you approach it on the trail. Hiking up to the Odaray Grandview, you can get very close to the glacier, as close as MacDonald would have been in order to make the sketch *Mount Odaray*. Here, you are in true alpine country. Odaray, meaning stone mountain, is indeed that, for very little other than low-growing plants and lichens is found up in the vicinity of MacDonald's sketch. The glacial debris is ever changing and shifting and moving with each season's runoff, freeze, and thaw. The scrubby trees he depicts are the last tough specimens that guard the border between the sub-alpine and alpine zones. The lichens, which he notes in his journal entry dated the same date as the sketch, form the main vegetation here, as varied and multi-hued as they are in other alpine locations at O'Hara. MacDonald captured the vertical grooves in the rock face of Odaray below the glacier where continual meltwaters, torrential in the heat of summer, lessening in the cooler autumn, erode their way down the mountainside.

Oddly, there are no sketches known from this vista looking south. MacDonald notes the view from this vantage point high above Lake O'Hara: "Beautiful outlook over valley as we lunched among the heather,"[104] and we know he had been up there before. Additionally, from the sketches known to have been executed but now lost (just to art historians—they are somewhere), there are no titles indicating a view south from Odaray Bench. This is odd, as the trail looks out over one of the most expansive and breathtaking views at O'Hara. Perhaps that is the answer to the question: the view is simply too expansive. It is quite obvious from the Lake O'Hara sketches that MacDonald was far more interested in the intimate details than he was in the vast panoramas: "I sketched effect of coloured rocks and snow on Odaray. If enlarging, try for brighter snow and more luminosity in shadows although very dark." and "After lunch could not pull anything together, bad colour to work on, too much light etc. etc. O' the difficulties of mountain art for the little glories."[105] He goes on in his journal to note some ideas for future subjects, all of which might seem unimportant compared to the grand vistas all around him. "Many subjects for next year, especially at camp, wood pile, lake etc."[106] MacDonald was able to take these minor scenes and depict them with a sensitivity and freshness that makes them equal to the towering peaks competing for his attention.

Mount Odaray, 5 September 1930
oil on cardboard
National Gallery of Canada
(vantage point 47 on map)

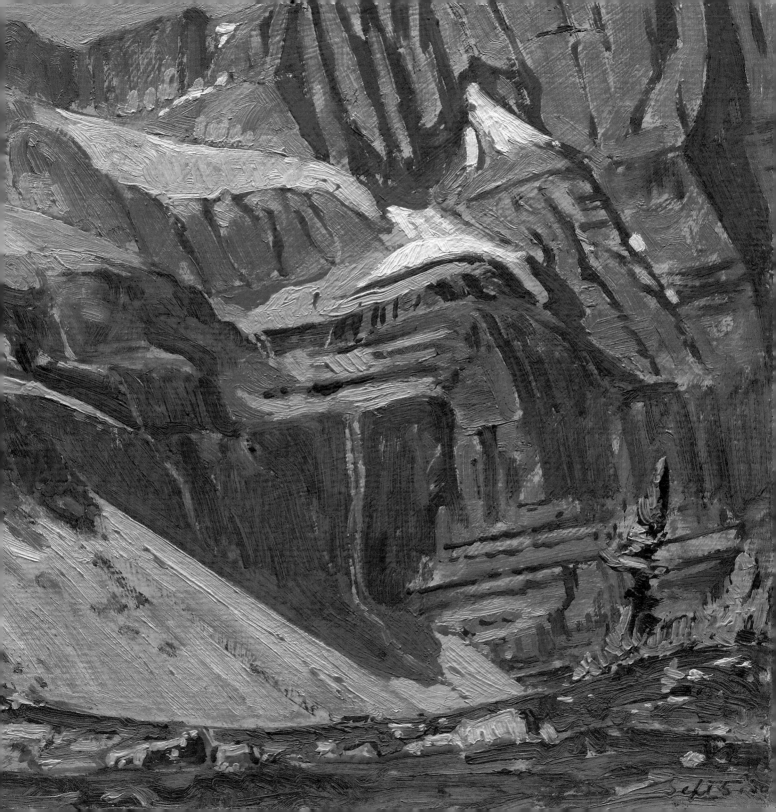

Wind and rain and sleet during the night. Milder this morning, but much rain ... Clouds low, everyone loafing. ... In afternoon, made a sketch of cabin, very cozy and homelike ... Continued rain and sleet ... Cathedral very grim in the west at sunset time.

—Journal Entry: Sunday, 14 September 1930

My personal affection for Lake O'Hara should be quite apparent at this point in the text. The meadows of Opabin Plateau, the shores of Lake McArthur, the slopes of Odaray are my most-favoured places to spend time. However, I consider one of O'Hara's most charming spots to be the small verandahs of the old log cabins that line the northwest shore of the lake. From them, there is nothing but the occasional passing hiker between you and the grandest view. Out your door in the morning, you greet the day's weather unobstructed and head-on. The water is just a few steps away. Spare and yet cozy, historically evocative and alive with the stories of those who have stayed in them, the cabins are a step back in time. No telephone rings, no kitchen sounds can be heard. MacDonald's sketch of one such cabin interior, with neatly made beds and the open window, is a fitting image to end his 1930 stay at Lake O'Hara. On 17 September he would have packed after breakfast and started for Wapta Lake, sending his belongings down by horse with Sidney Brewster and Tommy Link, who rode down with the pack train. MacDonald preferred to walk, with Adeline Link and Peter Whyte as trail companions. Upon reaching Wapta Lake, Peter Whyte gathered them into his car, collected their luggage, and drove them east to Lake Louise on the highway, which had been completed in 1926.

MacDonald and the Links stayed at Lake Louise that night, and late in the evening, they went out walking along the lakeshore, comparing the vista with that of venerable Lake O'Hara. They found it lacking: "The great Lake Louise view very dark and dull in approaching storm, and the glacier grim as the snow clouds shut it out. We voted for O'Hara."[107] They walked out along the lake again the next morning, when the light was better, but still MacDonald found the scene unappealing for sketching: " ... the lighting too strong and contrasted. Morning colours without the purple delicacy of O'Hara."[108] As a result, there are no (known) sketches by MacDonald that depict Lake Louise.

Returning by train to Toronto, MacDonald wrote to the Whytes on 27 September, still entranced by his visit and resenting, somewhat, his return to the duties of the college: *The mountains are a dream now, I haven't quite awakened from it and I hope you are still enjoying the full beauty of it. ... But what have these things to do with office and routine and curriculum and courses and other remnants of the Fall of Man.*[109] With this letter, he promises to send Peter and Catharine, as a wedding gift, the painting he had made that summer of Peter sketching at Opabin, deprecating his work by stating that *it probably has more to do with affection than art ...*[110] It is, in fact, one of his most charming sketches. Peter Whyte sits painting contentedly in the sunshine, his hat pulled low to shade his eyes, engrossed in his work and seemingly unaware that MacDonald is sketching him.

Upon his return to Toronto, MacDonald is represented internationally in the American Federation of the Arts *Exhibition of Paintings by Contemporary Canadian Artists*, wherein his works travelled to Iowa, Tennessee, New Jersey, and Massachusetts. He delivers a number of lectures and continues his work at the Arts and Letters Club. The Whytes visit him in Toronto in February of 1931; he takes them to his studio and introduces them to Lawren Harris. Harris would later accept an invitation to their studio home in Banff and be consulted by Catharine for advice on both her and Peter's careers as artists.[111] Correspondence flows back and forth between the artists over the winter, and plans are made for the following summer's O'Hara trip.

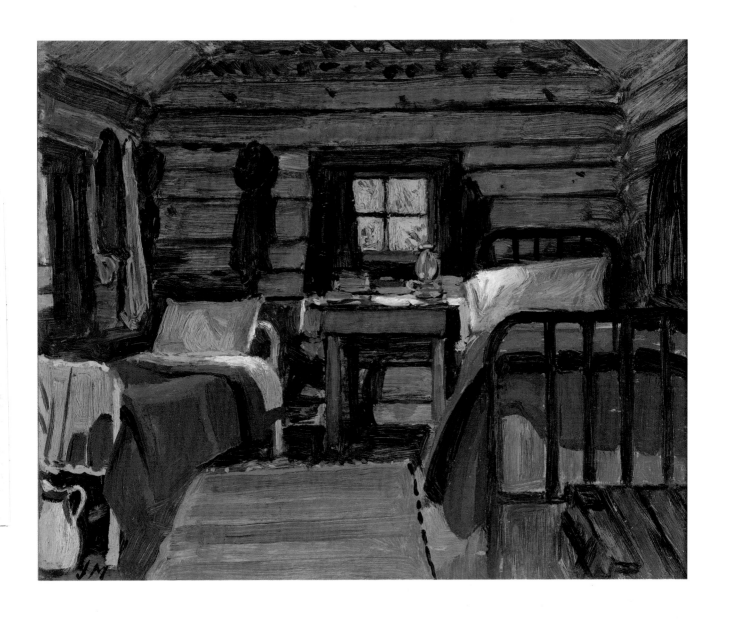

Mountain Cabin, Lake O'Hara, 1930
oil on board
Collection of Walter B. Tilden
(vantage point 48 on map)

Waiting for the Train

Absent minded pack-man counting his horses. "I got 16
but there's one missing and that's my saddle horse." "What's
that you're riding?" says his mate, "looks to me like it."
"Sure, you're right, damn you," says the pack-man.

—Journal Entry: 16 September 1928

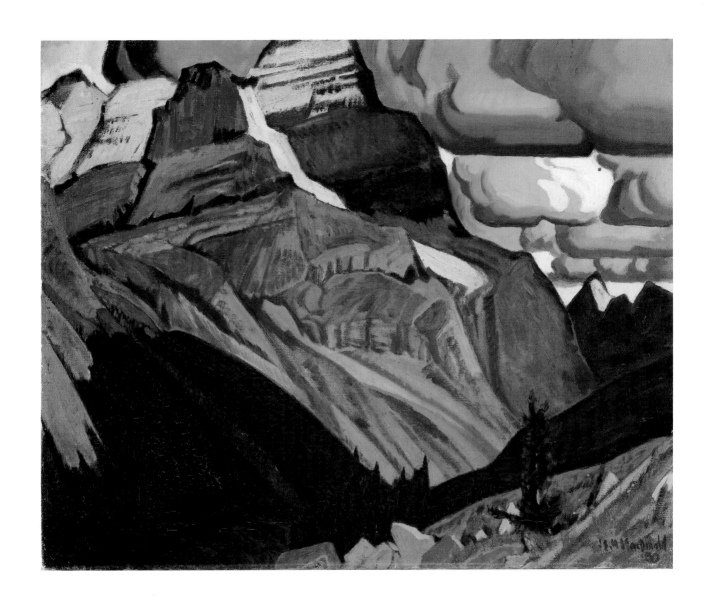

Dark Autumn, Rocky Mountains, 1930
oil on canvas
National Gallery of Canada

NATURE IS NOT ONLY A SOURCE OF IMMEDIATE
PHYSICAL BEAUTY, BUT ALSO A TREASURE TROVE OF
SYMBOLS AND VALUES ON WHICH WE ALL RELY.
WHETHER FRAMED BY TENT FLAPS OR HANGING ON
A MUSEUM WALL, ITS MANIFESTATIONS STAND FOR
LIFE ITSELF, AS WELL AS GROWTH, CHANGE,
CONTINUITY, PURITY, FREEDOM, MYSTERY, AND
THE TRANSCENDENT.

—Stephen Kaplan in *The Power of Place*, 1993

On each of MacDonald's Lake O'Hara trips, he would have
connected with the train at Hector Station, at the southeast
end of Wapta Lake. Aside from the one year we know he went
to Lake Louise with Peter Whyte by car, MacDonald would
have been in the vicinity of Hector Station about a dozen
times in preparation for his pack-train trips into Lake O'Hara.
The station was situated just above the infamous Spiral
Tunnels, which had been completed in 1909. These tunnels,
a remarkable feat of engineering and a spectacular sight to see
when a train heads through them, changed the grade of the
track through the steep Kicking Horse Canyon from 4.5 per-
cent (at its worst) to a manageable 2.2 percent. Still, the sec-
tion required numerous railway service men to keep the line
open and running smoothly. The additional congestion of
passenger traffic travelling on to Field, British Columbia,
about 9 kilometres away, and further points down the track,
and those coming and going from the adjacent grand hotels
and backcountry lodges made this steep and dangerous section
of the track a busy place.
MacDonald must have had
time on his hands while
there, waiting for his belong-
ings to be loaded on the pack
train or due to one of the
many other uncertainties of
travel. He is known to have
stayed overnight at Wapta in
1928, on 17 September, a
cold, crisp fall night when
**"standing water [was] frozen
thick in the bathroom closets,
ground all white and lake
steaming cold during the
night."**[112] Eight sketches are
known from this vicinity: two
at Sherbrooke Lake (see *A
Hiker's Guide to Art of the
Canadian Rockies*, p. 86, for
*Clearing Weather, Sherbrooke
Lake, Above Wapta Lake*,
c.1928 or 1929, second
sketch not illustrated); two
looking southwest down the
valley of the Kicking Horse
River (*Ottertail Valley*, 1930,
and *Dark Autumn, Rocky
Mountains*, 1930); two look-
ing northeast toward the Slate
Range (*Near the Divide, CPR,
Rocky Mountains*, 1928, and
*Distant Mountain From Divide
Near Hector, B.C.*, 1928); one
at Ross Lake (Collection of
the London Regional Art and
Historical Museums, not
illustrated); and *Poplars and
Mountain Slopes*, 1929.

If you stop on the small
pullout on the present-day
Trans-Canada Highway at the
very west end of Wapta Lake,
you can look southwest far
down the valley of the
Kicking Horse River toward
the distant Van Horne Range,
southwest of Wapta Lake.
This vista is the subject of the
Ottertail Valley sketch. The
work does not actually look
out over the Ottertail Valley,
as the valley veers sharply
south of this vista, past the
flank of Mount Stephen,
which is the large bulk in the
left quadrant of the sketch.
Mount King is the distant
purple, triangular peak,
with Mount Burgess in front.
The deadfall in the fore-
ground of the sketch is
common in this region,
known for its wild winds
and winter "Yoho Blows."

*Dark Autumn, Rocky
Mountains* is framed from a
point high on the slopes
above the road, but can also
be approximated well from
this pullout. Mount King
appears again, even more dis-
tant in this sketch and, this
time, capped with snow on
one side. Mount Stephen is
the central focus, looming
over the shoulder of
Cathedral Mountain. The
clouds in this canvas are
magnificent, rolling a storm
into the region and casting
the steep valley into deep
shadow; this canvas is bad
weather about to happen.

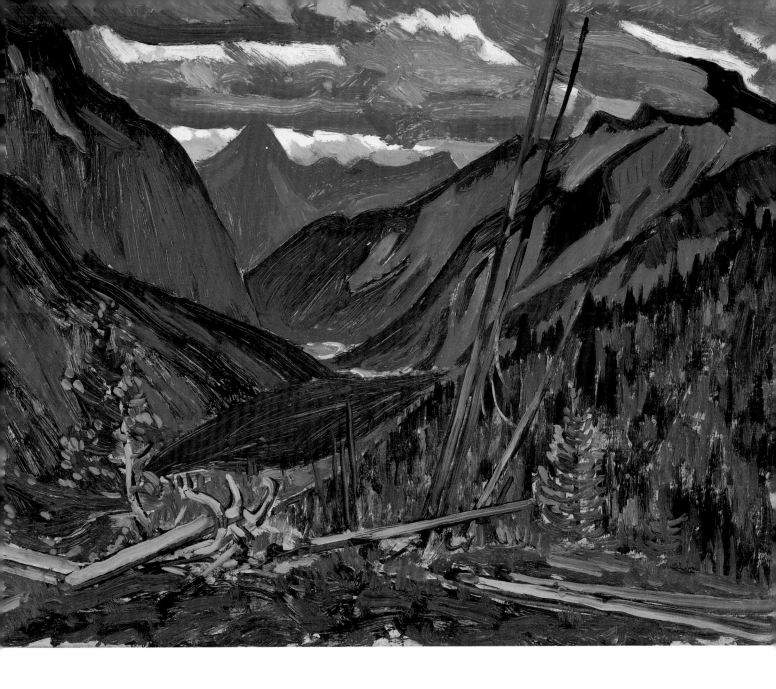

Ottertail Valley, 1930
oil on cardboard
National Gallery of Canada

Every new development in the arts has had a handful

of adherents merely, and hosts of opponents.

This is ever the test. If it has sufficient vitality,

inner life to withstand the repugnance and recrimination

of the conservatives, it persists, and the temporary

fuss and animosity subside. ... Great art is never kept alive

by the masses of men, but by the perceiving,

by those who are sufficiently affected to bother about it.

—Lawren Harris in "Modern Art and its Aesthetic Reactions, An Appreciation," 1927

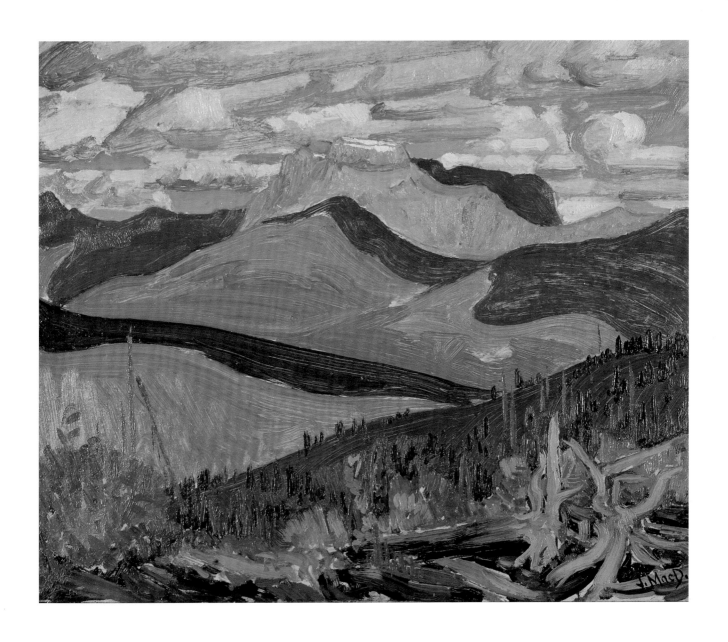

Near the Divide, CPR, Rocky Mountains, 1928
oil on multiply paperboard
Collection of The Nickle Arts Museum

MACDONALD WAS A POETIC SEER, IN WORDS AS WELL AS IN PAINT. HIS MASTERY OF THE FUNCTION OF DESIGN, RATHER THAN OF MERE SURFACE IMITATION OF APPEARANCES, MADE HIM A SUPREME CANADIAN ARTIST. HE SANG IN TUNE WITH THE VOICE OF NATURE, IN ECSTATIC RHYTHMS OF FORM AND COLOUR. HIS EXPRESSIVE USE OF THE ELOQUENT LANGUAGE OF LINE, TONE, AND COLOUR SYMBOLIZES, AS IN MUSIC, THE FUTILITY OF WORDS. AS TIME GOES ON HE WILL BE KNOWN AS AN "OLD MASTER" OF THE NEW SPIRIT OF CANADIAN ART.

—Arthur Lismer in *Canadian Comment,* 1933

Near the Divide, CPR, Rocky Mountains and *Distant Mountain From Divide Near Hector, B.C.,* both depict Mount Richardson, the large peak just north of the present-day location of the Lake Louise ski hill. At 3,086 metres, the peak is named for doctor and naturalist Sir John Richardson, who survived two of Franklin's arctic expeditions. Richardson also accompanied John Rea on the famous search for Franklin in 1848–49. MacDonald must have roamed the hills on the south shore of Wapta Lake to capture this vista, which depicts a scene that is, in fact, quite distant over the Bow River Valley some 15 kilometres away. *Distant Mountain From Divide Near Hector, B.C.,* is a more developed version of *Near the Divide, CPR, Rocky Mountains.* In both sketches, MacDonald has given as much attention to the windfall of silver tree trunks and the open rocky slopes in the foreground as he has to the distant panorama of mountains. *Distant Mountain From Divide Near Hector, B.C.,* is a finely handled scene, the lively, bright yellow and green brushwork of the shrubs in the foreground and the white snow on Mount Richardson contrast with the smoother strokes in the blues of the middle ground. More attention has been paid to the sky in *Near the Divide, CPR, Rocky Mountains.* The thick bank of white clouds throws the broad Bow River Valley into purple shadow. In *Distant Mountain From Divide Near Hector, B.C.,* the support of the work plays a role in capturing the qualities of the surface of the rock face in the middle ground of the panel. A great deal of the wood shows through the thinly executed sketch, creating a feeling of consistent atmosphere and air quality. The stubby, dark green pines indicate forest regrowth on the hill on the right edge of the work.

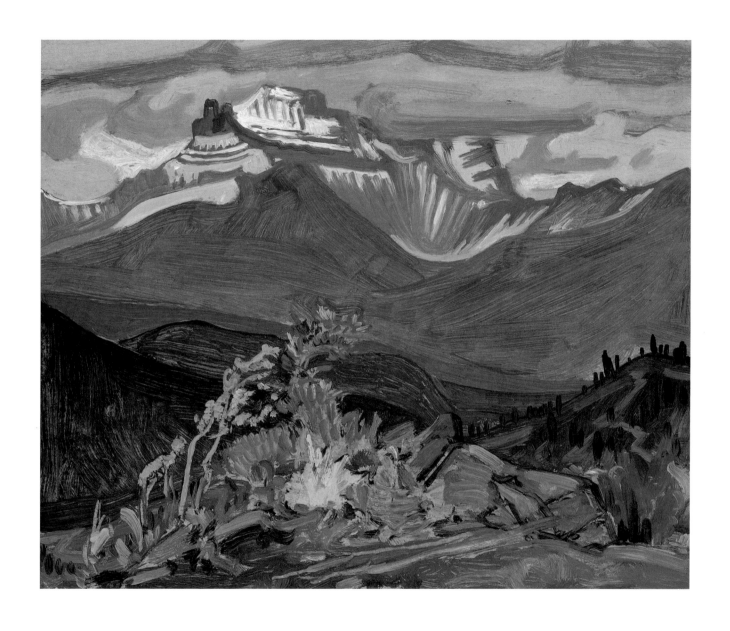

Distant Mountain From Divide Near Hector, B.C., 1928
oil on panel
Private Collection

Poplars and Mountain Slopes, 1929
oil on board
Private Collection

ON HIS HOLIDAYS IN THOSE LAST YEARS OF HIS LIFE, HE WENT MAINLY TO THE ROCKY MOUNTAINS. THEIR DISTANT SOLITUDES SEEMED TO SATISFY THAT CONTINUAL HUNGER WHICH HE POSSESSED FOR MEDITATION AMIDST THE UNSPOILED SCENES OF NATURE.

—Donald W. Buchanan in *J. E. H. MacDonald, Painter of the Forest*, 1946

One of the fun parts of matching art to vista is the detective work that goes into the search. Each painting has clues; each artist leaves a trail. But not infrequently, I come across a sketch I feel I will never find, such as *Poplars and Mountain Slopes*. Sometimes I find them by diligent searching, sometimes I never find them, and occasionally I just get lucky. When the painting's owner is interested in the search, locating the scene is more rewarding, as illustrated by this series of e-mail correspondences: ... *you may recall our conversation (where) I indicated that I have a panel by MacDonald entitled "Poplars and Mountain Slopes." Its provenance includes the notation "may be in the Lake O'Hara district." Having hiked at O'Hara for the last 18 consecutive years, I believe this was looking up to the Odaray Plateau ...*

Several hikes over several years proved inconclusive. There was simply nothing distinctive enough in the sketch to locate its corresponding venue. The only placeable feature MacDonald painted was the grey and white, sharply curved bedding planes on the distant mountain in the upper right corner of the sketch. I corresponded regularly with the owner; between us, we visited Lake O'Hara five times yet found no match. Then one day, while resting after a short hike, I looked up to gaze across the valley, and there it was, right in front of me. Here is my note to the collector:

Totally by chance, I found the location of your little painting. Two weeks ago today—while resting with my husband and kids after a very hot hike into Sherbrooke Lake, I looked up towards Lake O'Hara and there it was—your picture. It depicts the bottom most edge of the northern flank of Cathedral Mountain, across the valley from the northwest shore of Wapta Lake just about where I was sitting. What luck! I imagine it was painted while waiting for the train or for the horses to be ready for the trip up Cataract Creek. The bedding planes match exactly—the forest is of course very overgrown since but all in all it is the same.

His reply came a few days later:

I am so grateful that you discovered the venue for my JEHMcD. It would have taken me a lifetime. I am actually going to be able to get out there to investigate quite soon. This time, I will look especially forward to the trip in/out. I'll be in touch thereafter.

And a few weeks later:

With the benefit of experience, to have said that it might have taken me a lifetime to find the venue for the JEH sketch was an understatement. It would have taken me two lifetimes, at a minimum. There is no doubt that you have correctly identified the venue. JEH, as you suggest, would have sketched it on his way in or out of Lake O'Hara in late afternoon, given the light in the painting. I truly was thrilled to see the site. The painting now has much more personal meaning for me. I still marvel at your "accidental" discovery.

Poplars and Mountain Slopes shows the northwest slopes of Narao Peak, with its curvilinear bedding planes defined clearly by early autumn snowfall. The subject here is mostly the forest and its contrast with the open, subalpine slope beyond, painted slate grey. The white slopes of Narao above and the very edge of Mount Victoria, also white, contrast nicely with the deeper tones of the middle ground and the bright tapestry of the forest. The fall reds of Indian paintbrush are captured exactly and repeated here and there in the colouring of the bedding planes high on Narao. At the Wapta Lake Picnic Area, you can situate yourself so that the busy highway is out of view and frame the scene exactly.

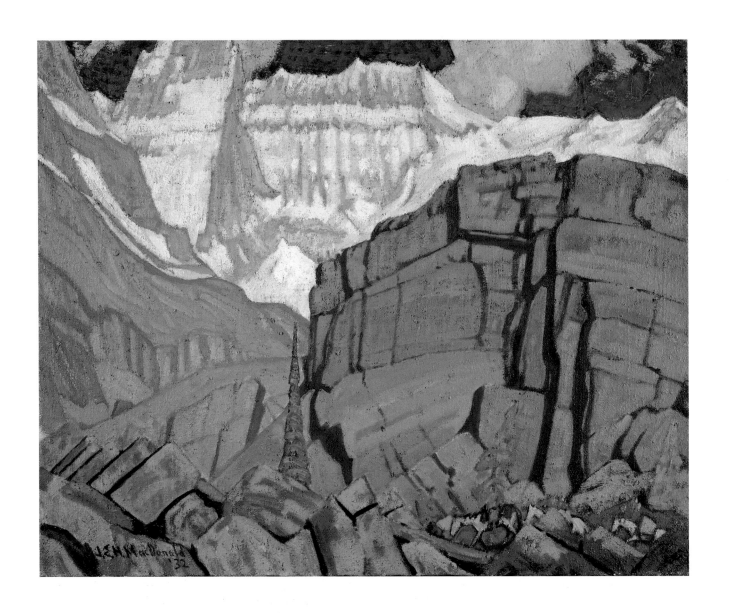

Mount Lefroy, 1932
oil on canvas
National Gallery of Canada
(vantage point 49 on map)

I PERSONALLY FEEL VERY MUCH A PART OF THE
MOUNTAIN LANDSCAPE, AND MOST OF THOSE
GROUP OF SEVEN PAINTINGS HAVE NO ONE IN THEM.
WHERE ARE THE CLIMBERS, THE HIKERS?

—Chic Scott to the author, in conversation, 2002

PEOPLE IN THE PAINTING

One afternoon toward the end of preparing this manuscript, I was fortunate to have a conversation with climber and author Chic Scott. We talked of books, and the summer's adventures, and of paintings. Chic made a comment that he felt less connection with the Group of Seven's mountain works in general because of their lack of human presence: there are so few people, and even less evidence of their presence in the mountains. There are none in the work of Lawren Harris or Arthur Lismer, the two other members of the Group who worked the most in the Rockies. Their associates, followers, and contemporaries also leave humans and all things associated with civilization out of their scenes, with a few exceptions. Walter Phillips paints the occasional skier, Charles Comfort paints a single pack train, Peter Whyte paints ski trails and cabin rooflines here and there, but for the most part, an unpopulated, empty scene predominates. This has been the case with Canadian landscape painting in the Rockies from its beginnings in the late 1800s to the present day.

MacDonald is an occasional exception to this: his snow-covered cabins tell us that humans are there, and mountain goats look out of the paintings at us, acknowledging our relationship with them by their returned gaze. But even MacDonald is a minor exception to the unpopulated scenes of vast wilderness. His works with a human element in them are few in the overall body of his mountain work. There is Peter Whyte sitting in the rocks, painting a sketch. In *Mount Lefroy*, the vast white face of the mountain fills the sky, multicolour rock slabs occupy the middle ground, and below the massive rock formation on the right, a small pack train, almost unnoticed at first glance, winds up the trail. A red-coated packer is just visible before guiding the lead horse down a dip in the path. Perhaps carrying supplies to Abbot Hut, the horses are heavily laden, distant from us as we look at the scene, aware yet unconcerned with our presence. The search for solitude, both personally for MacDonald and visually in Rocky Mountain landscape painting, is a continued quest.

I had a little cabin

With cedar walls and floors

With mountains in the window

And spruces at the door

—J. E. H. MacDonald
Journal Entry: March 1927

In the last years of his life, MacDonald's time for painting was limited. Despite greater success in his life and work, and a return to the Thornhill address, the "old illness of '17," still unspecific in diagnosis, recurred in the 1930s.[113] Again, the exact nature of this illness is uncertain, but his health was failing so rapidly that even painting was becoming too much for him. The obligations of his office job took all of his strength. *Of late years, his position as Principal of The Ontario College of Art has occupied his time to such an extent as greatly to interfere with his work as a painter.*[114] Sadly, this is the time when the mountain canvases become the most eloquent, the most interesting. *Mountain Solitude (Lake Oesa)* (p. 3), from 1932, is certainly among the finest he ever produced. The quiet clarity of the scene, and our forced personal involvement in it, makes this a masterpiece of mountainscape. His use of falling snowflakes, which, by their large size, shorten the space between viewer and painting, brings us very close into the picture plane. It is as if we are standing in the snow as it falls, participating in the scene. We are there. As his relationship with the Rockies ripened, so did the resulting canvases, despite their limited number.

Not being able to return to his beloved Lake O'Hara exacerbated his illness. From the 1930 journal entries, it is obvious that MacDonald intended to return to O'Hara in 1931—he had stashed supplies in his favourite places, made plans for compositions, sent Peter Whyte a stock of painting canvas. But as his health began to fail he was forced to change his plans: *Finally the doctor told him the mountain altitudes and the climbing were too much and he gave them up. He was very disheartened.*[115] He wrote to Peter Whyte to tell him he might not be able to make the intended Shale-Splitters reunion:

Box 201
Thornhill, Ontario
June 23, 1931

Dear Pete:
I hope you have a masterpiece all a going by now and that you are blessing the quality of the canvas. It was the best I could get at the time, but I understood them to say that they expected new stock in later on, of good quality and low price. I hope the "Shale Splitters" will be able to have their annual reunion, and of course I want to be there. At present the outlook is poor as I am laid up with something, due apparently to too much Art School. But here's hoping. Kindest Regards to the good wife and salutations to the mountains.
Yours Very Truly
J. E. H. MacDonald[116]

MacDonald was well enough to take two sketching trips that summer—one to Georgian Bay, the other to Sturgeon Bay—and to complete a number of canvases in the studio. He would suffer a stroke in November, just prior to his election to the Royal Canadian Academy of Art. Overwork is often cited as the cause. J. W. Beatty was appointed acting principal at the college, and MacDonald was given a year's leave. His various duties were taken over by a number of other individuals, and in December 1931, the Group of Seven would formally dissolve. MacDonald contributed to the eighth and last Group of Seven show, which took place that month, and closed a landmark chapter in the art history of Canada.

The winter of 1931 and spring of 1932 brought some renewal in MacDonald's health; he was able to complete a few design commissions, and with his wife, Joan, he visited Barbados for three months. There, he sketched extensively and kept a diary in the spirit of his Lake O'Hara journals, full of the sights and sounds of daily life in the place he was visiting. The following spring, he completed a number of significant mountain canvases: *Mount Lefroy* (p. 122); *Goat Range, Rocky Mountains* (not illustrated); *Mountain Solitude (Lake Oesa)* (p. 3); and *Lake McArthur* (not illustrated). These final canvases, discussed previously in the text, are combinations of a variety of elements from a number of sketches that MacDonald would have had in his studio at the time.

Mountain Solitude (Lake Oesa) is one of the finest of his design-based compositions, idyllic memories of a fondly recalled place that he was, no doubt, missing. Lake O'Hara was still a place of inspiration, rehabilitation, and joy. The mountains, however distant, were a grounding force in the last year of MacDonald's life. He had another stroke at work on 22 November and died a few days later, on 26 November 1932. He was fifty-nine.

MacDonald's gift for capturing the essence of the Canadian land and coming to know it in an intimate and personal way was unique. Rarely does a painter have his combination of sensitivity to subject, painterly skill, designer's talent, focused eye, and poetic voice.

In 1945, Tommy Link landscaped and built a terraced rock garden of regionally native plants in front of Lake O'Hara Lodge as a homage to J. E. H. MacDonald. Sadly, the garden fell into disrepair and was overtaken and trodden upon in the decades following, and did not survive. Its significance, however, should not go unnoted. Tommy Link was an astutely perceptive man. After the death of his wife, Adeline, with whom he had shared O'Hara for fifteen years, Link threw himself with the fervour of grief into trail building and planting the garden he envisioned at Lake O'Hara. "The J. E. H. MacDonald Terrace and Garden," as he named it, was an apt and especially appropriate memorial. Link knew of MacDonald's fascination with the plants at O'Hara, of his interest in *the paradoxes of landscape...or finding gardens in the deepest wild ...*[117] Link knew, as well, perhaps because of his own life's experiences, of MacDonald's struggles with his emotional health, and he sensed MacDonald found solace at Lake O'Hara, a comfort he himself shared. In short, he knew how important Lake O'Hara was to MacDonald: *Tommy, I believe, recognized the inchoate, scarcely utterable juxtaposition of sanity and madness that pivoted on Mr. MacDonald's keen consciousness, and endeavored to recreate it in the garden on the MacDonald terrace ... Tommy, I believe, knew precisely what he was paying homage to when he dedicated his garden to Mr. MacDonald.*[118]

It is a significant oversight that MacDonald's name is not formally associated with any of the trails, meadows, or lakes of the Lake O'Hara region today. His impact on the region, through association with the characters of O'Hara's founding years, and his delightful record of the lakes, valleys, vistas, and meadows that make O'Hara unique, is greater than any other painter who has worked there before or since. His journalized tales of O'Hara's early days are a singular historical record. He is very much a part of Lake O'Hara. Catharine Whyte would tell her mother in 1932 after MacDonald's death: *I can hardly believe I was only there one summer when he was there; he made such a strong impression on me. He was so much a part of O'Hara, I felt I'd been there several years with him.*[119]

MacDonald, with an incisive understanding of the dangers that Lake O'Hara's beauty disguised, realized O'Hara's splendor could easily lead to ruin. He felt that this was already the case, even in 1930, with nearby Lake Louise. He closes his 1930 journal with a cutting remark voicing this fear, referring to a fictitious "Mr. Mammon," a metaphor using the word "mammon," which means wealth personified and worshipped. "They" refers to the CPR. MacDonald states: "The future of Lake O'Hara is doomed. It cannot be left undisturbed. We can only hope that they will not marry her so shamelessly to young Mr. Mammon as they did Louise to his elder brother." Fortunately, others became aware that Lake O'Hara could easily be loved to death, and it is now one of the most closely controlled places in the Canadian Rockies. A balance between access and preservation has, for the most part, been met. Beginning long before MacDonald's day, and continuing today, many people feel a particular personal relationship to Lake O'Hara, which adds both difficulties and assistance to this challenge.

The Lake O'Hara art of J. E. H. MacDonald expresses this astounding region of the Canadian Rockies in all of its many moods, and in both its grand and its quiet moments. MacDonald took in everything O'Hara gave to him and responded to it in a passionate and insightful way. He looked at all that he saw at Lake O'Hara with open-eyed, childlike delight, and he contemplated it with sage wisdom. His footsteps lead down the very best paths Lake O'Hara offers—trails to a charmed land. His sketches and his journal writings provide a beautifully framed window to the past and a welcoming doorway to delight in the present through the heart and mind of a gifted Canadian poet/painter.

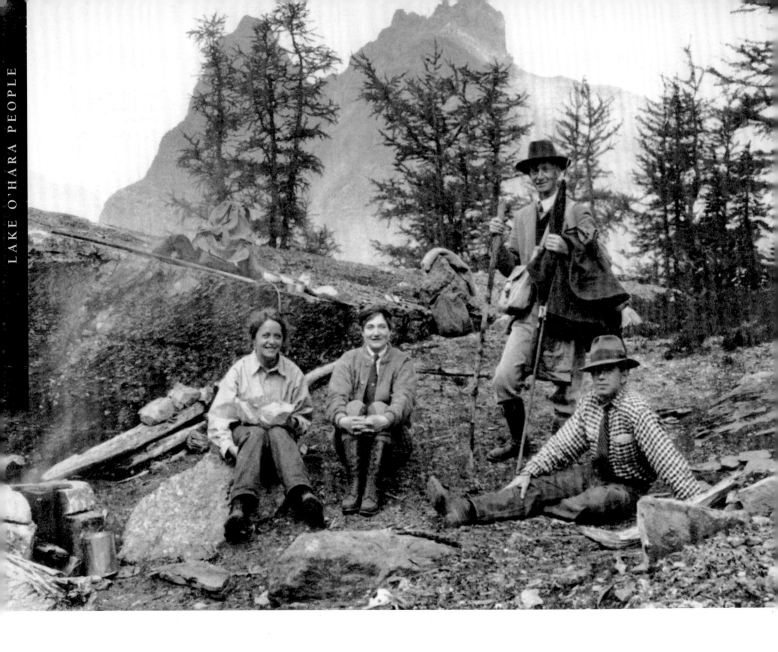

Peter and Catharine Whyte, Adeline Link and
J. E. H. MacDonald on Opabin Plateau, 1930
George K. K. (Tommy) Link Photograph
Archives of the Whyte Museum of the Canadian Rockies

Abbot, Phillip Stanley
1867 (unknown) – 1896 (Canada, Yoho National Park)
Fell and was killed ascending Mt. Lefroy in 1896. First recorded climbing fatality in the Canadian Rockies. The nearby pass and the climbers' hut atop it are named for him.

Allen, Samuel E. S.
1874 (Philadelphia) – 1945 (unknown)
Yale graduate, mountaineer, philologist. Named many of the features at Lake O'Hara, using Stoney names. Visited the Rockies in 1891, 1893–95. Explored alone, and without maps, the territory from Paradise Valley to Opabin Pass and back, including the Wasatch, the Wenkchemna, and the Opabin Pass, in a single day. Made first ascent of Abbot Pass.

Brewster, Forrest Oliver (Pat)
1896 (Banff) – 1982 (Banff)
Trail guide, outfitter, businessman. Established first permanent camp at Lake O'Hara for the CPR. Ran Brewster Transport company after 1926.

Brewster, Sylvia (Graves), also called Sidney, Sid, or Syd
d. 1953
Managed Lake O'Hara Lodge from 1925–1951.

Grassi, Lawrence (Lorenzo)
1890 (Falmenta, Italy) – 1980 (Canmore, Alberta)
Miner, mountaineer, trail builder, guide, park warden (1956–60). Worked for the CPR (1916–45) and later for Canmore Mines. His distinctive trail-building style can be seen at Lake O'Hara in Yoho National Park, at Skoki in Banff National Park, and near his home in Canmore at Grassi Lakes, now named for him. Unofficial custodian of the Elizabeth Parker Hut prior to being appointed warden at Lake O'Hara.

Hector, Sir James
1834 (Edinburgh) – 1907 (New Zealand)
Doctor, explorer, geologist for the Palliser Expedition. Victim of infamous incident at Kicking Horse Pass, where his horse kicked him unconscious and he awakened only moments before he was to be buried by his fellow explorers. Hector Station, the connecting point for travellers heading to and from Lake O'Hara by horse, is named for him.

Hibbard, Aldro T.
1886 (Falmouth, Massachusetts) – 1972 (Rockport, Massachusetts)
American painter and baseball player. Attended the School of the Museum of Fine Arts in Boston. Founded the Rockport Art Association (later, the Hibbard School of Painting). Well known for his winter landscapes. Met Peter Whyte and J. E. H. MacDonald at Lake O'Hara about 1925. Encouraged Whyte to attend the Museum school in Boston.

Link, Adeline DeSale
unknown (Omaha) – 1943 (Chicago)
Wife of Tommy Link. Chemistry professor and college adviser. The Adeline Link Memorial Circuit Trail, or the Lakeshore Trail, was built to commemorate her love of Lake O'Hara.

Link, Dr. George Konrad Karl (Tommy)
1888 (unknown) – 1979 (Arizona)
Botany professor (retired Professor Emeritus of Plant Pathology, University of Chicago), trail builder, amateur historian, and geologist. Regular visitor to Lake O'Hara (fifty consecutive summers, 1928–77). Founded Lake O'Hara Trails Club and built many of the first trails there, with Lawrence Grassi.

McArthur, James Joseph
1856 (unknown) – 1925 (Quebec?)
Topographical surveyor. Surveyed the 49th parallel in the Rockies, 1887. Mapped and named Lakes O'Hara and McArthur. Served on the Alaska Boundary Commission and International Boundary Commission.

O'Hara, Lieutenant-Colonel Robert
1853 (unknown) – 1926 (unknown)
Namesake of the region. First saw Lake O'Hara in 1887; camped there numerous times. Directed J. J. McArthur to the Lake O'Hara region.

Sargent, John Singer
1856 (Florence, Italy) – 1925 (London, England)
American portrait painter. Achieved great fame in his lifetime in the United States and Europe, lesser known in Canada. Painted in Yoho National Park in summer 1916 at the invitation of Brewster Transport. Sargent's Point, near Lake O'Hara warden's cabin, is named for him.

Whyte, Catharine Robb
1906 (Concord, Massachusetts) – 1979 (Banff)
Married to Peter Whyte. Artist, cultural worker, benefactor, outdoor enthusiast, photographer. Member of the Order of Canada (1978). Founded the Whyte Museum of the Canadian Rockies in Banff in honour of Peter upon his death. Painted with MacDonald at O'Hara in 1930. Funded the building of Skoki Lodge, managed it 1932–34. Painted in many locations in the Rockies, including Banff and Lake Louise and Assiniboine, Lake O'Hara, Skoki, and Bow Lake.

Whyte, Jon
1941 (Banff) – 1992 (Banff)
Historian and writer; nephew of Peter and Catharine Whyte. First director of the Whyte Museum of the Canadian Rockies in Banff.

Whyte, Peter
1905 (Banff) – 1966 (Banff)
Husband of Catharine Robb Whyte. Artist, photographer, outdoor enthusiast, traveller, ski enthusiast, philanthropist. Instrumental in the development of skiing in the Canadian Rockies. With Catharine, built Skoki Lodge; managed it 1932–34. Official Canadian War Artist, served with the Calgary Highlanders. Sketched with MacDonald at O'Hara c.1925–30. Whyte Museum of the Canadian Rockies in Banff is named for the Peter Whyte Foundation, upon which its collections, with those of Catharine Whyte, are based.

LAWREN STEWART HARRIS
(1885–1970)

Mount Owen, undated
oil on panel
29.7 x 37.5 cm
Private Collection

**JAMES EDWARD HERVEY
MACDONALD** (1873–1932)

Cathedral Mountain, 1927
oil on board
21.4 x 26.6 cm
1966.15.8
McMichael Canadian Art Collection,
Kleinburg

Cathedral Mountain from Opabin Pass,
1929
oil on board
20.8 x 26.0 cm
MaJ.01.01
Whyte Museum of the Canadian
Rockies, Banff

Clouds over Lake O'Hara, 1930
oil on canvas
106.0 x 134.5 cm
1975.075
Collection Musée d'art de Joliette, Joliette
Dépôt permanent des Clercs de
Saint-Viateur de Joliette

Dark Autumn, Rocky Mountains, 1930
oil on canvas
53.7 x 66.3 cm
4875
National Gallery of Canada, Ottawa
Purchased 1948

*Distant Mountain From Divide Near
Hector, B.C.*, 1928
oil on panel
21.6 x 26.7 cm
Private Collection, Montreal
Courtesy of Galerie Walter Klinkhoff

*Early Morning, Lake O'Hara and
Mount Lefroy*, 1929
oil on board
21.5 x 26.6 cm
Private Collection, Montreal
Courtesy of Galerie Walter Klinkhoff

Early Morning, Rocky Mountains, 1926
oil on canvas
76.2 x 89.2 cm
L76.1
Art Gallery of Ontario, Toronto
Gift of Mrs. Jules Loeb, 1977,
donated by the Ontario
Heritage Foundation, 1988

The Front of Winter, 1928
oil on canvas
87.0 x 115.2 cm
1960.1229
Montreal Museum of Fine Arts,
Montreal
Gift of Dr. and Mrs. Max Stern, 1960

A Glacial Lake, Rocky Mountains, 1925
lithograph on paper
edition # 47/100
15.3 x 16.5 cm
93.24
The Edmonton Art Gallery
Collection, Edmonton
Purchased with funds from the Dr.
Max Stern Endowment Fund

Lake and Mountains, 1924
oil on cardboard
21.5 x 26.6 cm
4850
National Gallery of Canada, Ottawa
Purchased 1947

Lake McArthur, 1924
oil on board
21.3 x 26.3 cm
Private Collection

Lake McArthur, 1925
oil on cardboard
21.2 x 26.4 cm
4530
National Gallery of Canada, Ottawa
Purchased 1936

Lake McArthur, Lake O'Hara Camp,
1924
oil on panel
21.6 x 26.7 cm
1968.25.18
McMichael Canadian Art Collection,
Kleinburg

Lake Oesa, 1927
oil on canvas
26.0 x 20.6 cm
MaJ.01.02 or MaJ.01.03
Collection of the Whyte Museum of
the Canadian Rockies, Banff
Gift of George K. K. Link

Lake Oesa and Mount Lefroy, c.1928
oil on board
21.6 x 26.7 cm
999.001.15
Tom Thomson Memorial Art Gallery,
Owen Sound
Gift of the estate of David Jennings
Young

Lake O'Hara, 1925
pen and black ink with white
gouache on wove paper
28.5 x 34.7 cm
3170
National Gallery of Canada, Ottawa
Purchased 1925

Lake O'Hara, 1927
oil on cardboard
21.5 x 26.6 cm
36.3
Vancouver Art Gallery, Vancouver

Lake O'Hara, 1928
oil on panel
21.4 x 26.7 cm
1972.5.5
McMichael Canadian Art Collection,
Kleinburg

Lake O'Hara, Cloudy Weather, c.1926
oil on panel
21.1 x 26.0 cm
73.183
Art Gallery of Greater Victoria, Victoria

Lake O'Hara, Rainy Weather, undated
oil on board
21.5 x 36.9 cm
1966.16.37
McMichael Canadian Art Collection,
Kleinburg
Gift of the Founders, Robert and
Signe McMichael

*Larch and Lake, Mary's Meadow,
Opabin Pass*, 1929
oil on board
21.5 x 26.6 cm
1966.15.16
McMichael Canadian Art Collection,
Kleinburg

Larch Trees, c.1929
oil on cardboard
27.5 x 23.5 cm
Hart House Permanent Collection,
University of Toronto, Toronto

Larches and Mount Schäffer, 1929
oil on board
21.5 x 26.5 cm
36.4
Vancouver Art Gallery, Vancouver

Lichen Covered Shale Slabs, 1930
painting on panel
21.4 x 26.6 cm
1969.7.3
McMichael Canadian Art Collection,
Kleinburg

Lichened Rocks, Mountain Majesty, 1928
oil on canvas
53.8 x 66.7 cm
University College Art Collection,
University of Toronto Art Centre, Toronto
Purchased 1933

Lodge Interior, Lake O'Hara, c.1925
oil on board
21.4 x 26.6 cm
1966.16.36
McMichael Canadian Art Collection,
Kleinburg
Gift of the Founders, Robert and
Signe McMichael, 1966

Morning, Cathedral Mountain,
1924–26
in *On Account of Defries*, presentation
album
watercolour and coloured inks on
wove paper
21.0 x 18.1 cm
17921
National Gallery of Canada, Ottawa

Morning, Lake O'Hara, 1924
oil on canvas
21.6 x 26.7 cm
Private Collection, Calgary

Morning, Lake O'Hara, 1926
Alternately titled *Early Morning,
Rocky Mountains*
oil on canvas
76.8 x 89.4 cm
Collection of The Sobey Art
Foundation, Nova Scotia

Morning Lake O'Hara, c.1926
oil on panel
21.3 x 26.3 cm
Private Collection, Calgary

Morning Light, Rocky Mountains, 1931
oil on cardboard
21.5 x 26.6 cm
36.2
Vancouver Art Gallery, Vancouver

*Mount Goodsir from Odaray Bench
Near Lake McArthur*, 1925
oil on board
21.6 x 26.6 cm
Private Collection

Mount Goodsir, Yoho Park, 1925
oil on canvas
107.3 x 122.3 cm
79.228
Art Gallery of Ontario, Toronto
Gift of Dr. and Mrs. Max Stern,
Dominion Gallery, Montreal, 1979

Mount Lefroy, 1932
oil on canvas
53.7 x 67.1 cm
15495
National Gallery of Canada, Ottawa
Massey Collection of Canadian
Paintings,
Vincent Massey Bequest, 1968

Mount Odaray, 1930
oil on cardboard
21.6 x 26.7 cm
4851
National Gallery of Canada, Ottawa
Purchased 1947

*Mountain and Larches, Rocky
Mountains*, undated
oil on cardboard
21.4 x 27.3 cm
15501
National Gallery of Canada, Ottawa
Massey Collection of Canadian
Paintings,
Vincent Massey Bequest, 1968

Mountain Cabin, Lake O'Hara, 1930
oil on board
21.6 x 26.7 cm
Collection of Walter B. Tilden

*Mountain Goat Land, Lake O'Hara and
Opabin Pass From the Flank of
Wiwaxy*, 1930
oil on panel
21.6 x 26.7 cm
Private Collection
Courtesy of Galerie Walter Klinkhoff,
Montreal

Mountain Solitude (Lake Oesa), 1932
oil on canvas
50.4 x 66.7 cm
95/160
Art Gallery of Ontario, Toronto
Gift of Stephen and Sylvia Morley, in
memory of Priscilla Alden Bond
Morley, 1995

*Near the Divide, CPR, Rocky
Mountains*, 1928
oil on multiply paperboard
21.4 x 26.6 cm
Collection of The Nickle Arts
Museum, Calgary

Ottertail Valley, 1930
oil on cardboard
21.4 x 26.7 cm
4856
National Gallery of Canada, Ottawa
Purchased 1947

Poplars and Mountain Slopes, 1929
oil on board
21.6 x 26.0 cm
Private Collection, Edmonton

Rain in the Mountains, 1924–25
oil on canvas
123.5 x 153.4 cm
55.87.J
Collection of the Art Gallery of
Hamilton, Hamilton
Bequest of H. L. Rinn, 1955

Rain, Lake O'Hara Camp, 1924
oil on board
21.6 x 26.7 cm
Collection of Walter B. Tilden

Rain, Wiwaxy Peaks, Lake O'Hara,
1924 or 1925
oil on cardboard
21.4 x 26.5 cm
16699
National Gallery of Canada, Ottawa
Gift of Mel Dobrin, Montreal, 1970

September Snow on Mount Schäffer,
1929
oil on cardboard
21.4 x 26.5 cm
4852
National Gallery of Canada, Ottawa
Purchased 1947

Snow in the Mountains, c.1930
oil on paperboard
21.6 x 26.7 cm
2104
Art Gallery of Ontario, Toronto
Purchased 1933

Snow, Lake O'Hara, 1926
oil on board
21.6 x 26.7 cm
1968.25.13
McMichael Canadian Art Collection,
Kleinburg

Snow, Lake O'Hara, 1927
Alternately titled *Snow, Lake O'Hara
Camp*
oil on board
21.5 x 26.6 cm
1966.15.10
McMichael Canadian Art Collection,
Kleinburg

Tamarack, Lake O'Hara, 1929
oil on card
21.3 x 26.5 cm
1969.14.2
McMichael Canadian Art Collection,
Kleinburg

*Valley From McArthur Lake, Rocky
Mountains*, 1925
oil on panel
17.8 x 22.8 cm
1969.19
McMichael Canadian Art Collection,
Kleinburg
Gift of Dr. and Mrs. J. Murray Spiers,
1969

Wiwaxy Peaks, 1925
pencil on paper
28.0 x 21.5 cm
Collection of Darryck & Inez
Hesketh, Burlington

JOHN SINGER SARGENT
(1856–1925)

Lake O'Hara, 1916
watercolour and graphite on white
wove paper
40.0 x 52.0 cm
1969.185
Fogg Art Museum, Harvard
University Campus, Cambridge
Gift of Edward W. Forbes

BOOKS, EXHIBITION CATALOGUES AND LEAFLETS, NEWSPAPERS AND PERIODICALS

Ambrosi, Joey.
Fly Fishing in the Canadian Rockies. Calgary: Rocky Mountain Books, 1987.

Anonymous.
"Art critic reviews 'Group of Seven.'" *The Calgary Herald,* 16 January 1929.

—. "Exhibition Canada's Group of Seven." *The Calgary Herald,* 8 December 1928.

—. "Group of Seven returns to city." *The Calgary Herald,* 6 December 1928, 11–12.

—. *Jasper National Park.* Ottawa: The Canadian National Railways, 1927.

—. *J. E. H. MacDonald, Memorial Exhibition.* Montreal: Dominion Gallery, 1947.

—. "MacDonald memorial collection includes many fine canvases." *The Calgary Herald,* 12 July 1933.

—. *A Portfolio of Prints by Members of the Group of Seven.* Toronto: Rous & Mann Press Ltd., 1925.

—. "Would send every easterner west to discover beauty." *The Varsity,* Vol. XLV, No. 10 (13 October 1925).

Anonymous (C. P. S.).
"The Sketch Room." *The Varsity,* Vol. 45, No. 1 (30 September 1925).

Ayre, Robert.
"The Magic is Still There." *Montreal Star,* 12 February 1966.

Barnes, Christine.
Great Lodges of the Canadian Rockies. Oregon: W. W. West Inc., 1999.

Beers, Don.
Lake O'Hara Trails. Calgary: Rocky Mountain Books, 1996.

—. *The Wonder of Yoho.* Calgary: Highline Publishing, 1989, rev. ed., 1991.

Buchanan, Donald W.
The Growth of Canadian Painting. Toronto: William Collins Sons and Co., Ltd., 1950.

—. "J. E. H. MacDonald, Painter of the Forest." *Canadian Geographic Journal,* Vol. XXXIII, No. 3 (September 1946): 149.

Christensen, Lisa.
A Hiker's Guide to Art of the Canadian Rockies. Calgary: Fifth House Ltd., 1999.

—. *A Hiker's Guide to the Rocky Mountain Art of Lawren Harris.* Calgary: Fifth House Ltd., 2000.

Colgate, William.
Canadian Art, Its Origin and Development. Toronto: The Ryerson Press, 1943.

Coo, Bill.
Scenic Rail Guide to Western Canada. Toronto: Greey de Pencier Books, 1985.

Cook, Ramsay.
"Landscape Painting and National Sentiment in Canada." *Historical Reflections,* Vol. 1, No. 2 (Winter 1974): 263–283.

Cronin, Fergus, Franklin Arbuckle, and Jack Carr.
The Group of Seven. Why Not Eight or Nine or Ten? Toronto: The Arts and Letters Club, nd.

Davidson, Margaret F. R.
"A New Approach to the Group of Seven." *Journal of Canadian Studies,* Vol. IV, No. 4 (November 1969): 9–16.

Dick, Stewart.
"Canadian Landscape Painters of To-day." *Apollo: A Journal of the Arts,* Vol. XV, No. 90 (June 1932): 279–282.

Duval, Paul.
The Tangled Garden. Scarborough: Cerebrus/Prentice-Hall, 1978.

Esten, John.
John Singer Sargent: Painting Out-of-doors. New York: Universe Publishing, 2000.

Ford, Phyllis M.
O'Hara: The Ford Years, 1954–1975. Calgary: Phyllis M. Ford, 1998.

Gadd, Ben.
Handbook of the Canadian Rockies. 2d ed. Jasper: Corax Press, 1995.

Gallagher, Winnifred.
The Power of Place: How Our Surroundings Shape Our Thoughts, Emotions, and Actions. New York: HarperCollins Publishers, Inc., HarperPerennial, 1993.

Gest, Lillian.
History of Lake O'Hara in the Canadian Rockies at Hector, British Columbia. Philadelphia: privately printed, 1961.

Haberl, Keith.
Alpine Huts: A Guide to the Climbing Facilities of the Alpine Club of Canada. Canmore: The Alpine Club of Canada, 1997.

Hambleton, Josephine.
"Artist of Canada's Wilderness." *Ottawa Evening Citizen,* 26 November 1947.

Hart, E. J.
Trains, Peaks and Tourists: The Golden Age of Canadian Travel. Banff: E J H Literary Enterprises Ltd., 2000.

Hill, Charles C.
The Group of Seven: Art for a Nation. Ottawa: The National Gallery of Canada, McClelland and Stewart, 1995.

Hoover, Dorothy.
J. W. Beatty. Toronto: The Ryerson Press, 1948.

Housser, Bess.
"Ideas of a Painter: In the Realm of Art." *The Canadian Bookman* (April 1925).

—. "Impressions of the Group of Seven: In the Realm of Art." *The Canadian Bookman* (February 1925).

Housser, F. B.
"Thoughts on a Trip West." *The Canadian Theosophist,* Vol. IX, No. 8 (October 1928): 225.

Hunter, E. R.
J. E. H. MacDonald: A Biography and Catalogue of his Work. Toronto: The Ryerson Press, 1940.

—. "J. E. H. MacDonald." *Educational Record,* Vol. LXXX, 3 (July-September 1954): 157–162.

—. *Masterpieces of Twentieth-Century Canadian Painting.* Florida: The Norton Gallery and School of Art, 1984.

Jackson, A. Y.
"J. E. H. MacDonald." *The Canadian Forum* (January 1933): 136–138.

Jackson, Christopher E.
With Lens and Brush: Images of the Western Canadian Landscape: 1845–1890. Calgary: Glenbow-Alberta Institute, 1989.

Jessup, Lynda.
"Canadian Artists, Railways, The State, and 'The Business of Becoming a Nation.'" Ph.D. thesis, Department of Art History, University of Toronto, 1992.

Jones, Donald.
"MacDonald's 'Tangled Garden' still surrounds Thornhill house." *Toronto Star,* 17 January 1981.

Lismer, Arthur.
"The Man Who Saw Canada." *Canadian Comment* (February 1933).

—. "Memorial show proves greatness of late J. E. H. MacDonald." *Saturday Night,* 21 January 1933.

Longstreth, T. Morris.
"Art in Canada." *The Studio* (July 1934), np.

MacDonald, J. E. H.
The Barbados Journal. Introduction by John Sabean. Kapuskasing: Penumbra Press, 1932.

—. "A Glimpse of the West." *The Canadian Bookman,* Vol. VI, No. 11 (November 1924): 229–231.

—. *My High Horse: A Mountain Memory.* Ontario: Woodchuck Press, 1934.

—. Scandinavian Art. *Northward Journal* 18/19 (1980), 9–35.

—. *West by East and Other Poems by J. E. H. MacDonald.* Toronto: Ryerson Press, 1933.

MacDonald, Thoreau.
The Group of Seven. Toronto: The Ryerson Press, 1944.

—. *J. E. H. MacDonald, 1873–1932.* Hamilton: The Art Gallery of Hamilton, 1957.

Marjoribanks, Robert.
"Talent from the Tangled Garden: J.E.H. MacDonald survived critical scorn and became a leader of the Group of Seven." *Weekend Magazine,* No. 46 (1965), 26–30.

Mastin, Catharine M., et al.
The Group of Seven in Western Canada. Toronto: Key Porter Books, 2002.

McKee, Bill, and Georgeen Klassen.
Trail of Iron: The CPR and the Birth of the West, 1880–1930. Vancouver: Douglas & McIntyre, 1983.

Mellen, Peter.
The Group of Seven. Toronto: McClelland and Stewart Limited, 1970.

Patton, Brian.
Parkways of the Canadian Rockies: A Road Guide. 4th ed. Banff: Summerthought Ltd., 1995.

Patton, Brian, and Bart Robinson. *The Canadian Rockies Trail Guide: A Hiker's Manual to the National Parks.* 6th ed. Canmore: Devil's Head Press, 1994.

Pole, Graeme. *Classic Hikes in the Canadian Rockies.* Canmore: Altitude Publishing Canada Ltd., 1994.

—. *The Spiral Tunnels and the Big Hill: A Canadian Railway Adventure.* Canmore: Altitude Publishing Canada Ltd., 1995.

—. *Walks and Easy Hikes in the Canadian Rockies.* Canmore: Altitude Publishing Canada Ltd., 1992.

Porsild, A. E. *Rocky Mountain Wildflowers.* Ottawa: National Museum of Natural Sciences, 1979.

Pringle, Donald Allen. "Artists of the Canadian Pacific Railroad." Masters thesis, Department of Art History, Concordia University, Montreal, 1983.

Putnam, William L., Glen W. Boles, and Roger W. Laurilla. *Place Names of the Canadian Alps.* Revelstoke: Footprint Publishing, 1990.

Reid, Dennis. *A Bibliography of the Group of Seven.* Ottawa: The National Gallery of Canada, 1971.

Robertson, Nancy E. *In Search of Our Native Landscape.* Toronto: Art Gallery of Toronto, nd.

—. *J. E. H. MacDonald, R. C. A., 1873–1932.* Toronto: Art Gallery of Toronto, 1965.

Robson, Albert H. *Canadian Landscape Painters.* Toronto: The Ryerson Press, 1932.

—. *J. E. H. MacDonald, R. C. A.* Toronto: The Ryerson Press, 1937.

Russell, Bruce Hugh. "John Singer Sargent." *The Beaver,* Vol. 77, No. 6 (December 1997/January 1998): 4–11.

Salinger, Jehanne Bietry. "Behind Canadian Art: Comments on Art." *The Canadian Forum,* Vol. X, No. 116 (May 1930): 287–288.

—. "Comment and Digressions on Art." *The Canadian Forum,* Vol. X, No. 111 (December 1929): 90–91.

—. "The Group of Seven: Comment on Art." *The Canadian Forum,* Vol. XII, No. 136 (January 1932): 142–143.

Sandford, R. W. *High Ideals: Canadian Pacific's Swiss Guides, 1899–1999.* Canmore: The Alpine Club of Canada, 1999.

—. *Yoho: A History and Celebration of Yoho National Park.* Canmore: Altitude Publishing Canada Ltd., 1993.

Siddal, Catherine D. *The Prevailing Influence, Hart House and the Group of Seven 1919–1953.* Oakville: Oakville Galleries, 1988.

Sokoloff, Carol Ann. *Eternal Lake O'Hara.* Banff: Ekstasis Editions, 1993.

Stacey, Robert, and Hunter Bishop. *J. E. H. MacDonald, Designer: An Anthology of Graphic Design, Illustration and Lettering.* Toronto: Archives of Canadian Art, An Imprint of Carleton University Press, 1996.

Stouck, David, and Myler Wilkinson, eds. *Genius of Place: Writing About British Columbia.* Vancouver: Polestar Book Publishers, 2000.

Vickery, Jim Dale. *Wilderness Visionaries.* Minocqua: North World Press, 1994.

Whiteman, Bruce. *J. E. H. MacDonald.* Kingston: Quarry Press, 1995.

Whyte, Jon. *Tommy and Lawrence: The Ways and the Trails of Lake O'Hara.* Banff: The Lake O'Hara Trails Club, 1983.

Whyte, Jon, and Edward Cavell. *Mountain Glory: The Art of Peter and Catharine Whyte.* Banff: The Whyte Museum of the Canadian Rockies, 1988.

Wilkin, Karen. *The Group of Seven in the Rockies.* Edmonton: The Edmonton Art Gallery, 1974.

ARCHIVAL SOURCES

The Archives of the Whyte Museum of the Canadian Rockies, Banff
 J. E. H. MacDonald Papers
 George K. K. Link Papers
 Catharine Robb Whyte Papers
 Peter Whyte Papers
 Oral History Tape S 37/IS7 (A & B) George K. K. Link
 Lake O'Hara Maps C6 - 4.4 j-l George K. K. Link
National Archives of Canada, Ottawa
 J. E. H. MacDonald Papers (30 D 111 Vol. 3)
 J. E. H. MacDonald Journals (30 D 111 Vol. 1)

OTHER SOURCES

Lake O'Hara Lodge Guest Registry, Library, and Photograph Collection, Lake O'Hara, Yoho National Park, British Columbia
Conversation with Ivan Ivankovitch, 2000–2002
Conversation with Doug MacLean, 2002
Conversation with Alison Millar, 2001, 2002
Conversation with Bruce Millar, 2001, 2002
Conversation with Chic Scott, 2002

1. Stacey, Robert, and Hunter Bishop, *J. E. H. MacDonald: Designer* (Toronto: Archives of Canadian Art, An Imprint of Carleton University Press, 1996), 3.

2. A. H. Robson, *Canadian Landscape Painters* (Toronto: The Ryerson Press, 1932), 137.

3. The elevation of the city of Toronto varies from between 74 and 198 metres above sea level.

4. J. E. H. MacDonald Journals, National Archives of Canada 30 D 111 (hereafter cited as MacDonald Journals), Vol. 1-8, 2 September 1925.

5. MacDonald Journals, Vol. 1-8, 23 August 1925.

6. MacDonald Journals, Vol. 1-8, 24 August 1925.

7. MacDonald Journals, Vol. 1-8, 30 August 1925.

8. For an excellent discussion of this, see Winnifred Gallagher, *The Power of Place: How Our Surroundings Shape Our Thoughts, Emotions, and Actions* (New York: HarperCollins Publishers, Inc., HarperPerennial, 1993), 66–78.

9. Gallagher, *The Power of Place*, 73–74.

10. Thoreau MacDonald, 1939, as quoted in E. R. Hunter, *J. E. H. MacDonald: A Biography and Catalogue of his Work* (Toronto: The Ryerson Press, 1940), xiii.

11. Thoreau MacDonald, 1939, as quoted in Hunter, *J. E. H. MacDonald*, xii.

12. Thoreau MacDonald, 1939, as quoted in Hunter, *J. E. H. MacDonald*, xii.

13. J. E. H. MacDonald, "A Glimpse of the West," *The Canadian Bookman*, Vol. VI, No. 11 (November 1924), 229–231.

14. A full version of this manuscript can be found in original longhand in the MacDonald Papers, National Archives of Canada, 30 D 111 (hereafter cited as MacDonald Papers), Vol. 3, files 36: 2–3, or in published form as cited prior.

15. Max Stern, *J. E. H. MacDonald, Memorial Exhibition Leaflet* (Montreal: The Dominion Gallery, 1947), 1.

16. Includes the Cataract Creek access and Wapta and Sherbrooke Lakes regions.

17. For an excellent discussion of the Swiss Guides, see R. W. Sandford, *High Ideals: Canadian Pacific's Swiss Guides, 1899–1999* (Canmore: The Alpine Club of Canada, 1999).

18. The present lodge has eight rooms, yet MacDonald's journal and the lodge guest registry clearly state room #9. Bruce Millar speculates that a small room once existed at the top of the stairs.

19. The Neil Colgan Hut in the Valley of the Ten Peaks is higher, at an elevation of 2,940 metres.

20. Illustrated in Lisa Christensen, *A Hiker's Guide to Art of the Canadian Rockies* (Calgary, Fifth House Ltd., 1999), 64–65.

21. Catharine Whyte to Tommy Link (5 September 1960), Catharine Robb Whyte Papers, Archives of the Whyte Museum of the Canadian Rockies.

22. Oral History Tape S 37/IS7 (A & B), George K. K. Link fonds, Archives of the Whyte Museum of the Canadian Rockies.

23. MacDonald Papers, Vol. 3, file 3-32, untitled general art notes, c.1924–32.

24. MacDonald recorded the street name incorrectly here—Beaver Lodge is, and always has been, on Beaver Street.

25. J. E. H. MacDonald, "A Glimpse of the West," (see n.13), 229.

26. Dorothy Hoover, *J. W. Beatty* (Toronto: The Ryerson Press, 1948), 20.

27. Stacey and Bishop, *J. E. H. MacDonald, Designer* (see n.1), 6.

28. MacDonald Journals, Wednesday, 2 September 1925.

29. The actual date of construction of this trail is uncertain. Sylvia Brewster managed the Lake O'Hara Camp in 1920 and 1921. She married Sidney Graves in 1930 and together they are credited with building this trail, yet it is known to have been there before 1925, probably as more of a goat path, when the Alpine Club of Canada used it to gain access to the plateau for its summer camp.

30. Jon Whyte, *Tommy and Lawrence: The Ways and the Trails of Lake O'Hara* (Banff: The Lake O'Hara Trails Club, 1983), np.

31. J. E. H. MacDonald, "A Glimpse of the West" (see n.13), 229.

32. Robert Ayre, "The Magic is Still There," *Montreal Star*, 12 February 1966, a-b.

33. See Christensen, *Art of the Canadian Rockies* (see n.20), 83.

34. Thoreau MacDonald, *J. E. H. MacDonald: 1873–1932* (Hamilton: The Art Gallery of Hamilton, 1957), np.

35. E. R. Hunter, *J. E. H. MacDonald: A Biography and Catalogue of his Work* (Toronto: The Ryerson Press, 1940), 10.

36. Thoreau MacDonald, as quoted in Robert Marjoribanks, "Talent from the Tangled Garden," *Weekend Magazine*, No. 46 (1965), 26.

37. See Christensen, *Art of the Canadian Rockies* (see n.20), 83.

38. Hunter, *J. E. H. MacDonald* (see n.35), xii.

39. Charles C. Hill, *The Group of Seven: Art for a Nation* (Ottawa: The National Gallery of Canada, McClelland and Stewart Inc., 1995), 156.

40. Lynda Jessup, "Canadian Artists, Railways, The State and 'The Business of Becoming a Nation,'" Ph.D. thesis, Department of Art History, University of Toronto, Toronto, 1992.

41. MacDonald Journals, Vol. 1, file 1-8, 1925.

42. Jessup, "Canadian Artists" (see n.40), 76.

43. Jessup, "Canadian Artists," 81.

44. There is some evidence that J. E. H. MacDonald and Lawren Harris were at Lake O'Hara at the same time in 1926, yet it is inconclusive. We know that Harris and MacDonald both had a CPR pass to travel west that summer, but no dates are stated. The most reliable sources, the guest registries from the Lake O'Hara Lodge, are also uncertain. Harris's registration entry is undated and appears to have been written on a separate page, as if the Harris family (all went that year) missed signing in and were added later, so that the names appear out of sync. MacDonald's entry is clearly dated 23 August and notes that he arrived alone. His wife, Joan, arrived two weeks later. The third likely source, MacDonald's 1926 journal, is mostly poetry, and it makes no mention of sketching with Harris.

45. MacDonald would also paint the view again, in a small sketch titled *Mount Owen from Lake McArthur*, now in an unknown collection.

46. MacDonald Journals, Vol. 1, file 1-8, Tuesday, 1 September 1925.

47. MacDonald Journals, Vol. 1, file 1-8, Wednesday, 9 September 1925.

48. Anonymous (C. P .S.), "The sketch room," *The Varsity*, Vol. 45, No. 1 (30 September 1925): 2.

49. Anonymous. "Sketch Room," 2.

50. Anonymous. "Sketch Room," 2.

51. Anonymous, "Would send every easterner to west to discover beauty." *The Varsity*, Vol. 45, No. 1 (13 October 1925): 2.

52. Lake O'Hara Lodge Guest Registry, 1926, Lake O'Hara Lodge Library.

53. Lake O'Hara Lodge Guest Registry, 1926.

54. See Christensen, *Art of the Canadian Rockies* (see n.20), 72.

55. MacDonald Papers, Vol. 3, file 3-20, p. 4.

56. MacDonald Papers, Vol. 3, file 3-20, p. 6.

57. MacDonald Papers, Vol. 3, file 3-20, pp. 2, 5.

58. MacDonald Journals, Vol. 1, file 1-9, 1926–27.

59. MacDonald Journals, Vol. 1, file 1-9, 1926–27.

60. See Lisa Christensen, *A Hiker's Guide to the Rocky Mountain Art of Lawren Harris* (Calgary: Fifth House Ltd., 2000), 76–81, for a full discussion of this brochure.

61. Stacey and Bishop, *J. E. H. MacDonald: Designer* (see n.1), 26.

62. E. Robert Hunter, "J. E. H. MacDonald," *Educational Record*, Vol. LXXX, No. 3 (July-September 1954), 162.

63. Harris had been to O'Hara at least once, perhaps twice before: in 1926 with his wife, two children, and a nurse, and perhaps in 1924, when he might have stayed at the Bungalow Camp with J. E. H. MacDonald. However, the source for this latter information, a taped interview with Tommy Link, is unreliable, as stated by Link himself. Oral History S 37/IS7 (A & B), George K. K. Link fonds, Archives of the Whyte Museum of the Canadian Rockies.

64. MacDonald Journals, Vol. 1, file 1-10, 1928, p. 2.

65. Peter Whyte to Catharine Whyte (12 September 1928), Catharine Robb Whyte Papers, Archives of the Whyte Museum of the Canadian Rockies.

66. MacDonald Journals, Vol. 1, file 1-10, 1928, p. 4.

67. MacDonald Journals, Vol. 1, file 1-10, 1928, p. 8.

68. MacDonald Journals, Vol. 1, file 1-10, 1928, pp. 9–10.

69. MacDonald Journals, Vol. 1, file 1-10, 1928, pp. 13–14.

70. Whyte, *Tommy and Lawrence* (see n.30), np.

71. Larches in nearby Larch Valley, a few passes east near Moraine Lake, are thought to be as old as 400 years or more.

72. See Christensen, *Art of the Canadian Rockies* (see n.20), 74.

73. George K. K. Link, Oral History (see n.22).

74. George K. K. Link, Oral History.

75. George K. K. Link, Oral History.

76. Thoreau MacDonald, as cited in Marjoribanks, "Tangled Garden" (see n.36).

77. Thoreau MacDonald, as cited in Marjoribanks, "Tangled Garden."

78. Thoreau MacDonald notebook, as cited in Bruce Whiteman, *J. E. H. MacDonald* (Kingston: Quarry Press, 1995), 76.

79. George K. K. Link to Catharine Whyte (14 September 1960), George K. K. Link fonds, Archives of the Whyte Museum of the Canadian Rockies.

80. Catharine Whyte to George K. K. Link (4 September 1960), Catharine Robb Whyte Papers, Archives of the Whyte Museum of the Canadian Rockies.

81. George Link to Catharine Whyte (14 September 1960), George K. K. Link fonds, Archives of the Whyte Museum of the Canadian Rockies.

82. Peter Whyte to Catharine Whyte (12 September 1928), Catharine Robb Whyte Papers, Archives of the Whyte Museum of the Canadian Rockies.

83. MacDonald Journals, Vol. 1, file 1-11, p. 10.

84. MacDonald Journals, Vol. 1, file 1-11, p. 10.

85. MacDonald Journals, Vol. 1, file 1-11, p. 10.

86. MacDonald Journals, Vol. 1, file 1-11, p. 10.

87. MacDonald Journals, Vol. 1, file 1-11, p. 13.

88. MacDonald Journals, Vol. 1, file 1-11, p. 10.

89. Joey Ambrosi, *Fly Fishing in the Canadian Rockies* (Calgary: Rocky Mountain Books, 1987), 150.

90. MacDonald Journals, Vol. 1, file 1-11, p. 28.

91. MacDonald Journals, Vol. 1, file 1-11, p. 15.

92. MacDonald Journals, Vol. 1, file 1-11, p. 14.

93. MacDonald Journals, Vol. 1, file 1-11, p. 14.

94. Whyte, *Tommy and Lawrence* (see n.30), np.

95. Whyte, *Tommy and Lawrence*, np.

96. MacDonald Journals, Vol. 1, file, 1-11, p. 22.

97. MacDonald Journals, Vol. 1, file 1-11, p. 21.

98. MacDonald Journals, Vol. 1, file 1-11, p. 22.

99. MacDonald Journals, Vol. 1, file 1-11, p. 14.

100. George K. K. Link, Oral History (see n.22).

101. George K. K. Link, Oral History.

102. MacDonald Journals, Vol. 1, file 1-11, p. 17.

103. Catharine Whyte to George K. K. Link (6 September 1960), Catharine Robb Whyte Papers, Archives of the Whyte Museum of the Canadian Rockies.

104. MacDonald Journals, Vol. 1, file 1-11, p. 16.

105. MacDonald Journals, Vol. 1, file 1-12, p. 2.

106. MacDonald Journals, Vol. 1, file 1-12, p. 2.

107. MacDonald Journals, Vol. 1, file 1-12, p. 4.

108. MacDonald Journals, Vol. 1, file 1-12, part 2, np.

109. J. E. H. MacDonald to Peter Whyte (27 September 1930), Peter Whyte Papers, Archives of the Whyte Museum of the Canadian Rockies.

110. J. E. H. MacDonald to Peter Whyte (27 September 1930), Peter Whyte Papers.

111. See Christensen, *Art of the Canadian Rockies* (see n.20), 39–40, for a discussion of this.

112. MacDonald Journals, Vol. 1, file 1-10 (11 September 1928).

113. Stacey and Bishop, *J. E. H. MacDonald: Designer* (see n.1), 5.

114. Albert H. Robson, *Canadian Landscape Painters* (see n.2), 138.

115. Thoreau MacDonald, as quoted in Marjoribanks, "Tangled Garden" (see n.36), 20.

116. J. E. H. MacDonald to Peter Whyte (23 June 1931), Peter Whyte Papers, Archives of the Whyte Museum of the Canadian Rockies.

117. Whyte, *Tommy and Lawrence* (see n.30) np.

118. Whyte, *Tommy and Lawrence*, np.

119. Catharine Whyte to Edith Robb (undated), Catharine Robb Whyte Papers, Archives of the Whyte Museum of the Canadian Rockies.

ABOUT FIFTH HOUSE BOOKS

Fifth House Publishers, a Fitzhenry & Whiteside company, is a proudly western-Canadian press. Our publishing specialty is non-fiction as we believe that every community must possess a positive understanding of its worth and place if it is to remain vital and progressive. Fifth House is committed to "bringing the West to the rest" by publishing approximately twenty books a year about the land and people who make this region unique. Our books are selected for their quality, saleability, and contribution to the understanding of Western Canadian (and Canadian) history, culture, and environment.

Look for these unique art books from Fifth House at your favourite bookstore.

A Hiker's Guide to Art of the Canadian Rockies, by Lisa Christensen, $29.95

A Hiker's Guide to the Rocky Mountain Art of Lawren Harris, by Lisa Christensen, $29.95

The Urban Prairie by Dan Ring, Guy Vanderhaeghe, and George Melnyk, $40.00

Where the Meadowlark Sang: Cherished Scenes from an Artist's Childhood by Hazel Litzgus, $27.95